D1556580

90710 000 483 753

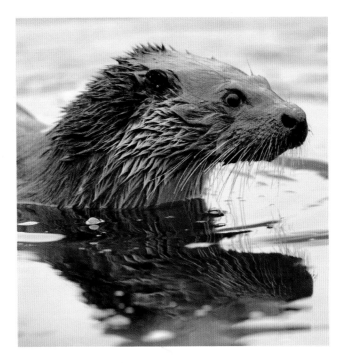

Ripples on the River

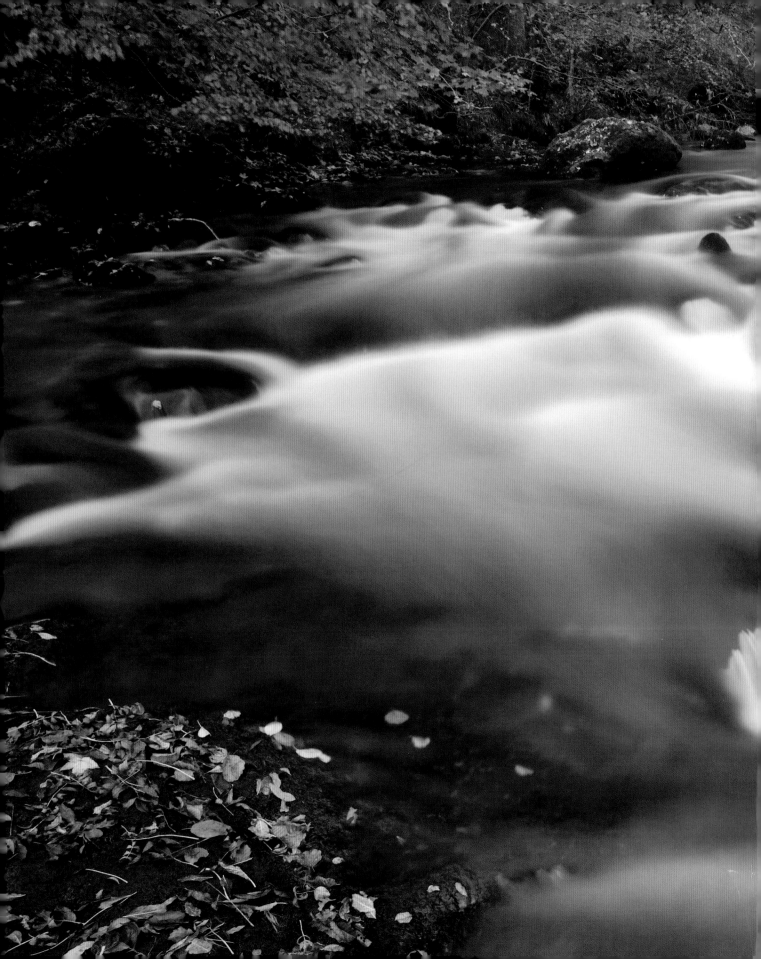

LAURIE CAMPBELL and ANNA LEVIN

Ripples on the River

Celebrating the Return of the Otter

BLOOMSBURY

TO MY GRANDFATHER, COLIN CHISAM
WITH THANKS TO DEREK ROBESON AND ROGER MANNING
LC

FOR ROB MEIJER, WITH LOVE AND THANKS
AL

BLOOMSBURY WILDLIFE

Bloomsbury Publishing Plc
50 Bedford Square, London, WC1B 3DP, UK
29 Earlsfort Terrace, Dublin 2, Ireland

BLOOMSBURY, BLOOMSBURY WILDLIFE and the Diana logo
are trademarks of Bloomsbury Publishing Plc

First published in Great Britain 2021

Text copyright © Laurie Campbell and Anna Levin, 2021
Photographs copyright © Laurie Campbell, 2021

A catalogue record for this book is available
from the British Library
Library of Congress Cataloguing-in-
Publication data has been applied for

ISBN: HB: 978-1-4729-8915-4
 ePDF: 978-1-4729-9127-0
 ePub: 978-1-4729-8916-1

10 9 8 7 6 5 4 3 2 1

Designed by Austin Taylor
Printed and bound in India by
Replika Press Pvt. Ltd.

MIX
Paper from
responsible sources
FSC® C016779
FSC
www.fsc.org

To find out more about
our authors and books visit
www.bloomsbury.com and
sign up for our newsletters

CONTENTS

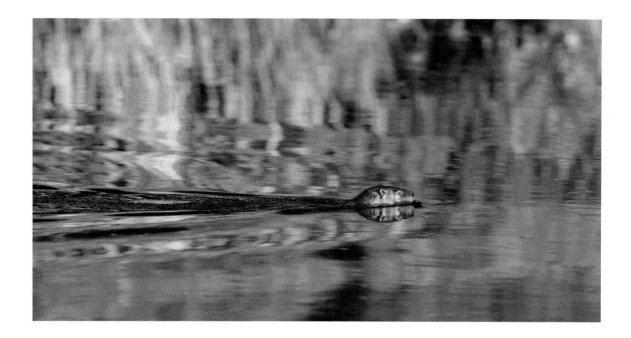

FOREWORD

BY SIR JOHN LISTER-KAYE OBE
House of Aigas

IT WAS THE LATE Eileen Soper, the celebrated 1960s wildlife artist whose delicate sketches gave her books such enduring charm, who famously wrote: 'Badger watchers are not entirely human.' She was right, as much of herself as of other naturalists who have striven to become one with their wild subjects. She might just as well have been speaking of Laurie Campbell. It was Laurie's wife, Margaret, who told me that she couldn't remember when Laurie was last on time for supper. I don't think she was joking.

In admiration of dazzling wildlife photography people often say to me 'Oh, he must have such patience!' And, yes, patience is an important ingredient, but imagining that all you have to do is sit still and the rest will fall into place, grossly underrates the reality. You could sit on

a riverbank for the rest of your life and never see an otter unless you also knew what you were doing, far less take a sequence of photographs to match the exquisite work of the immensely skilled perfectionist in these pages. And there I go again – it isn't just perfectionism or technical skill or patience or knowledge or enthusiasm or experience – although, of course, to some degree all of those are important. You could possess any combination of those faculties and still fail dismally to produce images like Laurie's. No, it's what Eileen Soper was referring to: that exceptional ability to slough off human-ness and blend seamlessly and invisibly into the wild world – to become a part of it – so that it accepts you and opens up to you.

I'm a point-and-press man. My photographic achievements equate to the holiday efforts of an

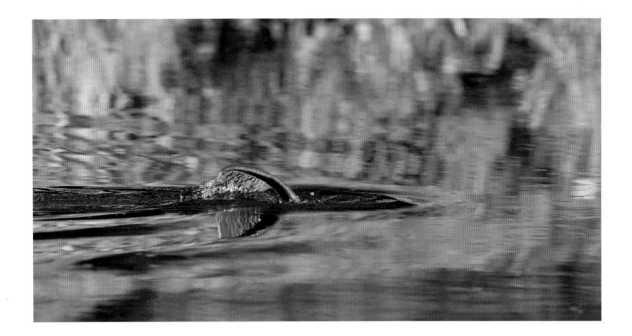

impetuous twelve-year-old. But I am a field naturalist who has spent many thousands of hours trying to be 'at one' with wildlife. So I think I understand Laurie's technique, his route into the private world of the otter or the badger, the kingfisher or the roe deer, even the wildwood or the river itself.

In Anna Levin's luminous text the sense of Laurie being guided by an unspoken intuition crops up over and over again, and rightly so. Laurie's approach is perhaps as much as or more than 50 percent intuition: a sixth sense that has been honed to razor keenness by the hours, days, months, years – now decades – he has spent out there, alone, shedding his human self, watching, listening, learning, just being there. Wordsworth expressed it brilliantly: *'I have felt a presence that disturbs me with the joy of elevated thoughts . . . '* It's a sense that rings in Laurie's head when he knows that something is right: a place, a time, a moment, a presence . . . and, sure enough, there is the otter. That's when all the rest kick into play: the technical skill, the patience,

the years of experience, the hunkering down as still as a rock for hours on end, the perfectionism. But the intuition has to come first.

I have known Laurie for many years; every summer he stays with us in the Highlands, although I would never presume to join him on his secretive forays into the wild. I know very well what it is to work with nature, work that must be done alone. That is why I think it was so courageous of them both to have Anna Levin tagging along with her eagle eye and her notebook. But I am very glad that they pulled it off. In clean, unfussy prose as crisp as the photographs, Anna has caught the master at his trade and the rippling River Tweed and its lissom otters and blended them together in these pages so that we can all be out there, with the dew forming on Laurie's long vigils, silent as snow, watching, watching . . .

How splendid that the otter has returned to the Tweed, but I'm afraid there's no sign of improvement; Laurie is still always late for supper.

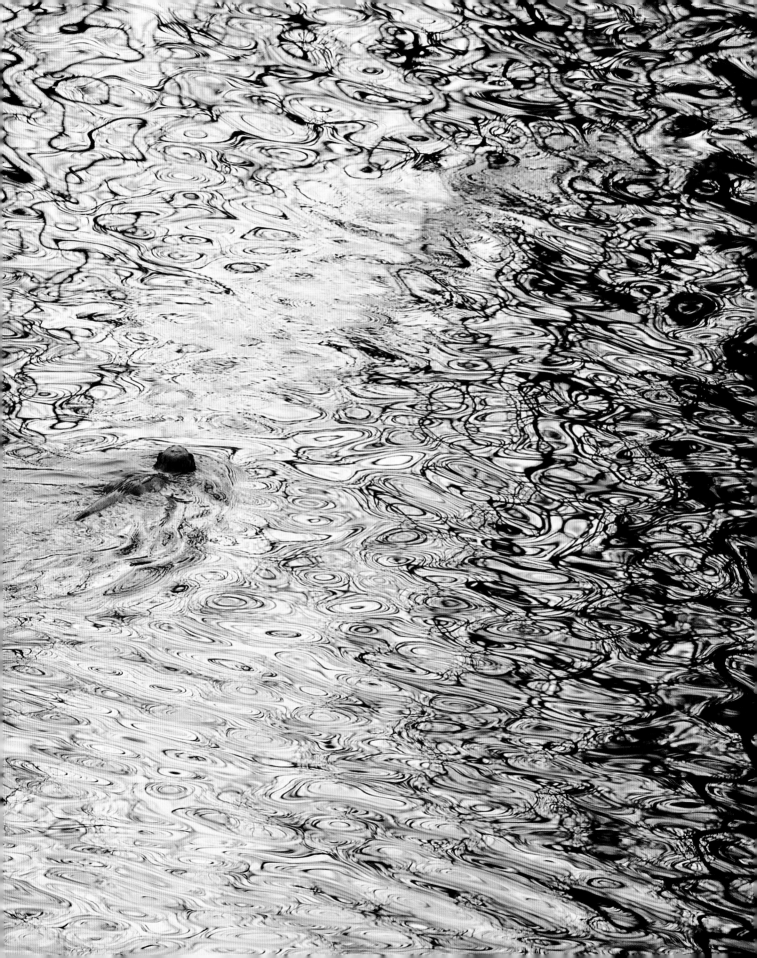

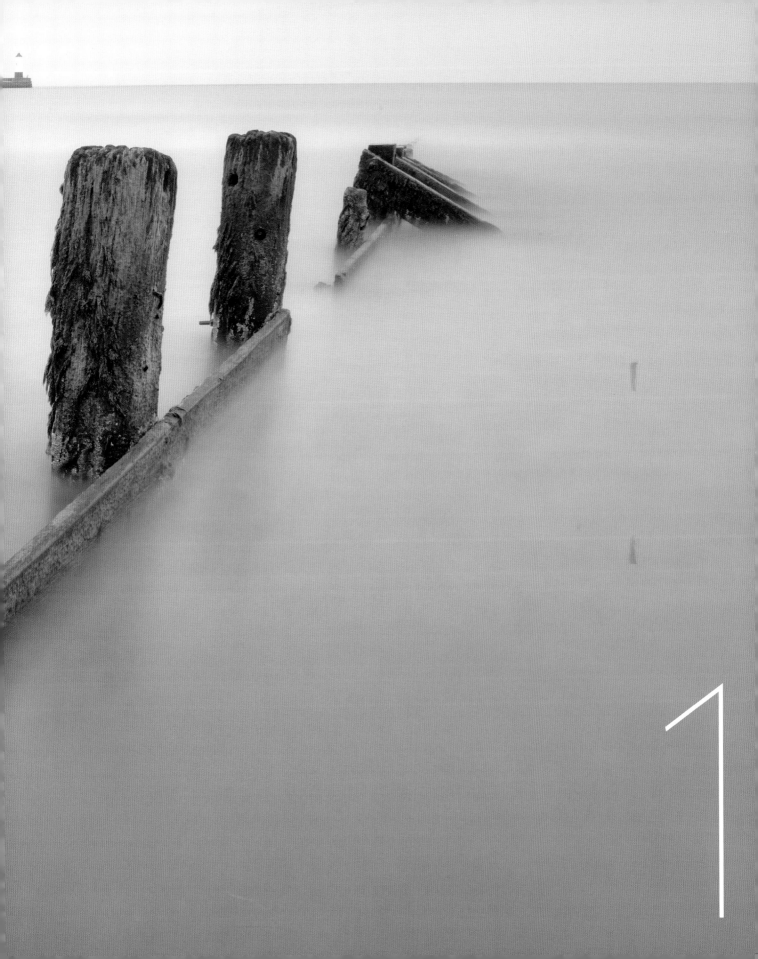

1

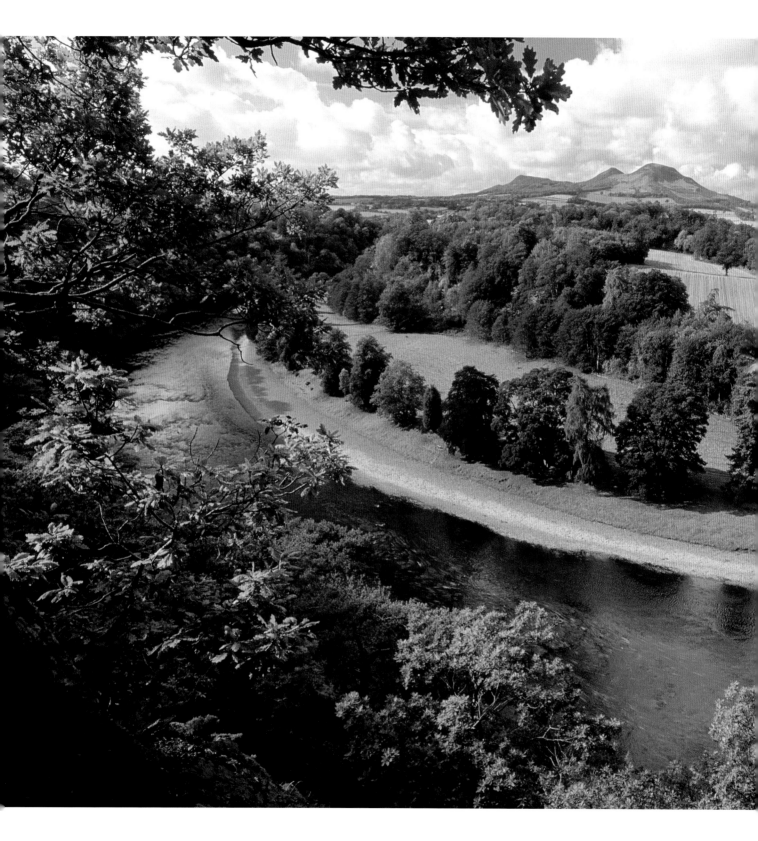

ABOVE Looking over the Tweed from a popular viewpoint known as Scott's View, into the patchwork river valley.
PREVIOUS PAGES Looking across the estuary to the pier at Berwick-upon-Tweed.

1

THE
BIGGER
PICTURE

THIS IS A STORY about a man, a wild animal and a river. Their narratives overlap and intertwine, looping around each other like otters at play. They are part of a bigger picture – as all stories are – tugged by tides and swept up in wider currents, and, in turn, their stories reach others far beyond their own, their ripples flowing outwards in concentric circles.

This particular river is the Tweed, which curves through southern Scotland and flows into the North Sea at the northernmost town in England. What happened here is a microcosm of a broader tale that has played out in different versions in so many other rivers throughout Europe.

The Tweed itself rises from Silurian bedrock high in Scotland's Southern Uplands. Its many tributaries pour down from surrounding hills and swell the main artery throughout its 100-mile-long journey to the North Sea. It gathers strength as it tumbles down from the moors towards the

fertile plain below, rolling over red sandstone and winding its way eastwards, curving under bridges and through the Borders towns, forming the long-contested border between Scotland and England for most of its last 20 miles. In its lower reaches it settles and broadens over limestone, then slows and spreads, salty now, into the estuary at Berwick-upon-Tweed. It is world-renowned for its salmon: records from the Bronze Age suggest that as long as people have lived beside the Tweed, they have been fishing salmon there.

The wild animal is the Eurasian otter *Lutra lutra*, the only native otter in Europe. As reflected in its English name, its geographical range stretches throughout Europe and Asia, from

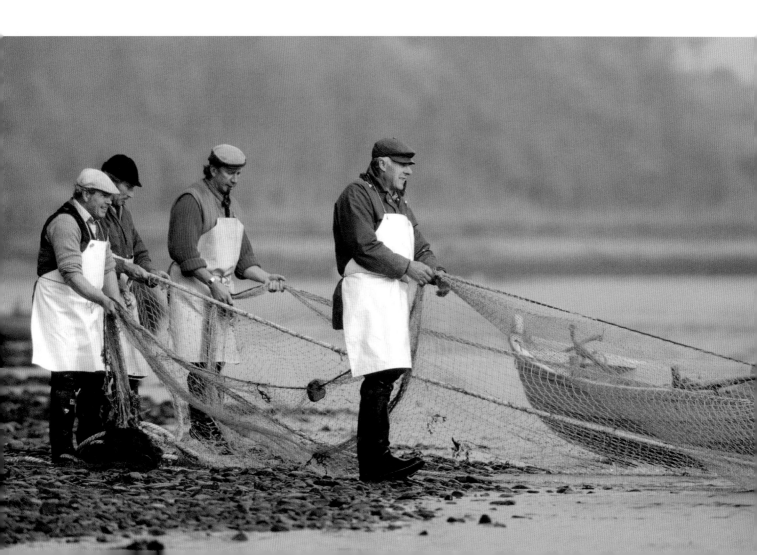

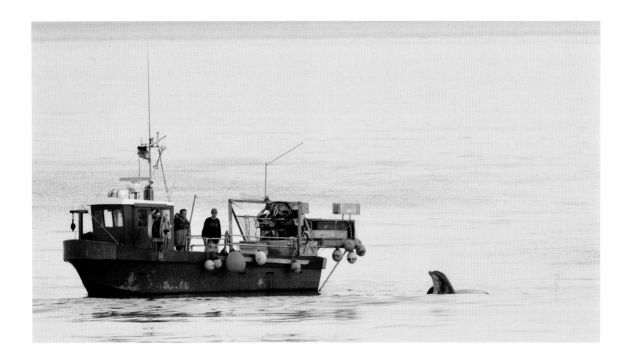

Ireland to eastern Russia, and also extends to the tip of North Africa, thereby occupying the largest area of any otter species. *Lutra lutra* is part of a worldwide family of otters comprising thirteen species, including the two-metre-long giant otters of the Amazon and the popular sea otters of the Californian coastline, as well as more obscure members such as the hairy-nosed and Congo clawless otters. All are members of the weasel family of carnivores, the Mustelidae, which includes badgers, polecats, martens, stoats and mink. Otters share some physical traits with their

mustelid relations, such as long bodies, short legs, strong jaws and sharp teeth.

Once upon a time *Lutra lutra* was widespread in the British Isles and throughout its expansive range. Though elusive by nature, being mostly nocturnal and solitary, the otter was an integral part of the landscape at the water's edge, whether lake or wetland, river or sea. Its presence in Britain was neatly captured in Kenneth Grahame's 1908 novel *The Wind in the Willows*: while Ratty, Mole, Toad and Badger take centre stage on the riverbank, Otter appears and disappears – sometimes mid-sentence! – a strong, yet mysterious character on the sidelines.

Otters have been hunted by people since ancient times, for their rich fur coats, for the protection of fish stocks and for sport. Hunting otters was a popular sporting activity in the British Isles in the nineteenth and twentieth

ABOVE Bottlenose dolphins from the Moray Firth population are ranging further south along the east coast and are increasingly sighted in the Tweed Estuary.

OPPOSITE Known as 'net and coble', this ancient style of fishing was still a familiar sight when Laurie was young.

centuries: otterhounds were bred especially for this purpose, with local hunts organised throughout the country. In the novel *Tarka the Otter*, published in 1927, Henry Williamson vividly describes the ever-present threat of the hunt in the life of a British otter.

The otter hunters were among the first to notice that otters were disappearing from Britain's waterways in the early 1960s. The hunts were out searching for signs of their presence in the places they had always been and it became evident that there were far fewer otters around. The hunts restricted their kills, but otter populations continued to decline. And it wasn't just the otter that was disappearing; huge numbers of birds were dying, too, especially birds of prey such as peregrine falcons and sparrowhawks.

The main culprit was found to be the accumulation of toxic chemicals that had been introduced in the 1950s and were widely used across most of Western Europe. These included PCBs (polychlorinated biphenyl) used in the electronics industry, the pesticide DDT and organochlorines such as aldrin and dieldrin that

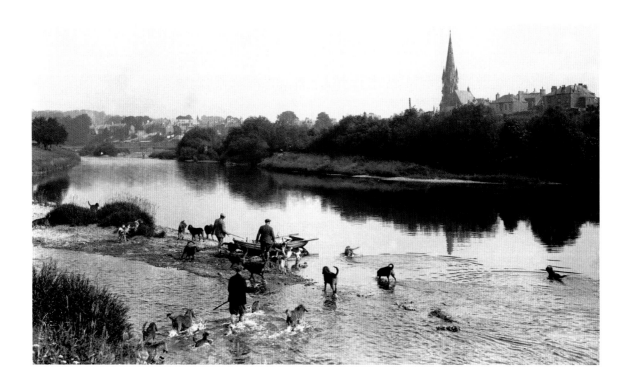

were used in pesticides for sheep dips and seed dressings, among many other applications. Small songbirds were poisoned directly by feeding on dressed seed, and predators were poisoned by feeding on the seed-eaters. Many birds and animals also suffered the insidious effects of sub-lethal poisoning, where the build-up of toxins affected their physiology, behaviour and reproduction.

Residues from the fields and sheep dips were washed into the rivers and watercourses and began to accumulate in the food chain, from microorganisms to small fish to large fish and on to fish-eating birds and mammals. As top predators, otters were receiving the greatest concentrations. These substances are known as 'persistent organic pollutants' (POPs) as they don't break down

RIGHT A partly-eaten thornback ray left by an otter on the shore of Lewis, the Outer Hebrides.

OPPOSITE TOP The two layers of an otter's rich coat: long guard hairs hold the drops of water away from the soft, warm underfur.

OPPOSITE BOTTOM Otter hunting on the Tweed at Kelso's Junction Pool. Hunting with hounds continued into the 1970s – otters received legal protection in England and Wales in 1978 and then in Scotland in 1982.

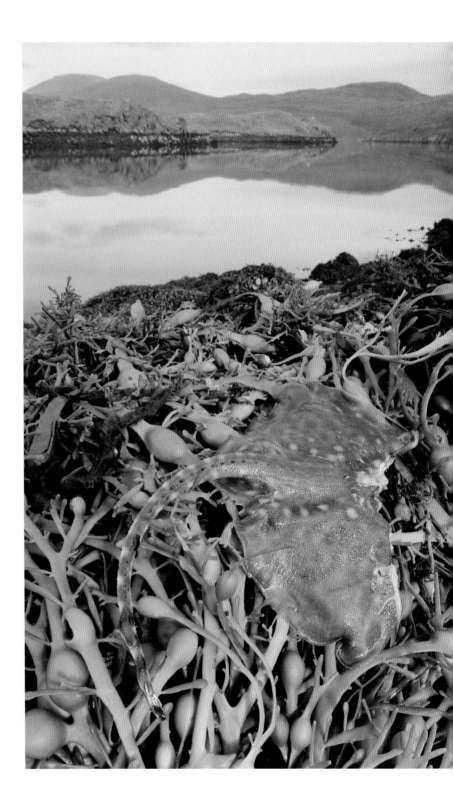

and so last a long time in the environment; they accumulate in the body and intensify in the food chain, and they are highly toxic. Hit by this triple-whammy of chemical effects, the British otter population crashed to less than a tenth of its former size.

A similar story was taking place across much of Western Europe – the once widespread otter was going or gone. The chemical load combined with many other pressures facing otters: direct hunting and persecution, loss of wetland as rivers were straightened and built up, declining fish stocks and increasing road deaths. Each took its toll, with different factors more prominent in some places and times. In many countries, the otter was already in trouble long before the pesticide pollution. Already in the nineteenth century, growing human populations and a mass programme to canalise rivers across Europe resulted in widespread loss of riverside habitat. Human attitudes have played a major role, too, with periods where otters have been demonised and persecuted for competing for dwindling fish supplies. In Switzerland in the 1880s there were significant bounties offered for killing otters, and the first legislation to protect fish stocks proposed the total eradication of otters. The fate of otters has been intertwined with human politics in unintended ways, too; for example the reunification of Germany resulted in a decline in the otter populations of the former East Germany as the increase in traffic resulted in more road casualties.

The combination of all these diverse pressures culminated in ever more fragmented and less resilient otter populations, and local extinction in many countries. By the late 1980s, a growing patch in the centre of the map of Europe was otter-less. Otters were gone entirely from the Netherlands, Belgium, Luxembourg and Switzerland, and were missing from most of France and what was then West Germany. Areas of otter habitat survived, however, in Eastern Europe and Scandinavia. Ireland remained an otter stronghold, as did pockets of Europe's western Atlantic coast, from Scotland and Wales through France and Spain to Portugal.

It took time for the effects of the chemical pollutants to be understood and the extent of the massacre to be acknowledged, then for the legislative wheels to turn and for the use of these

LEFT Road deaths remain one of the biggest threats to otter populations today.

OPPOSITE In the middle of an autumn day, Laurie spotted this otter on a hydro dam on the River Beauly.

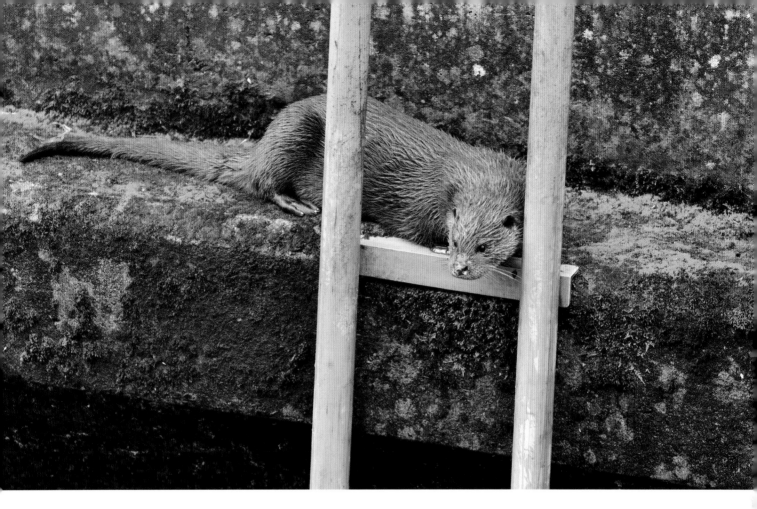

substances to be banned. It took longer still for the levels of toxins to slowly reduce in the bodies of predators; however, over many generations the effects diminished, birds of prey returned to the skies and fish returned to the rivers.

Otters were slower to recover. But the loss of otters caused widespread concern at a time of growing environmental awareness, and a raft of measures were put in place to save them from the threat of local extinction. Otters were given increasing legal protection. In Britain, first hunting was banned in 1978, and later the otters' place of shelter was protected from disturbance in 1981. Levels and timings of legal protection varied in different countries, but in 1992, the otter was listed as a European Protected Species under

EU-wide law that forbids capturing or killing a protected animal, or any significant disturbance, especially to its place of shelter or when rearing young. In many countries, waterways were cleaned up, special otter habitats were created and attempts were made to modify eel nets and crayfish traps to prevent entanglements. There were also attempts to address the problem of road deaths with tunnels, culverts and fencing to direct otters to safer routes.

In some areas captive-bred otters were released into the wild in reintroduction programmes to assist their recovery. In the Netherlands, for example, a concerted effort was made to restore healthy otter habitat in response to the local extinction that was recognised in 1988.

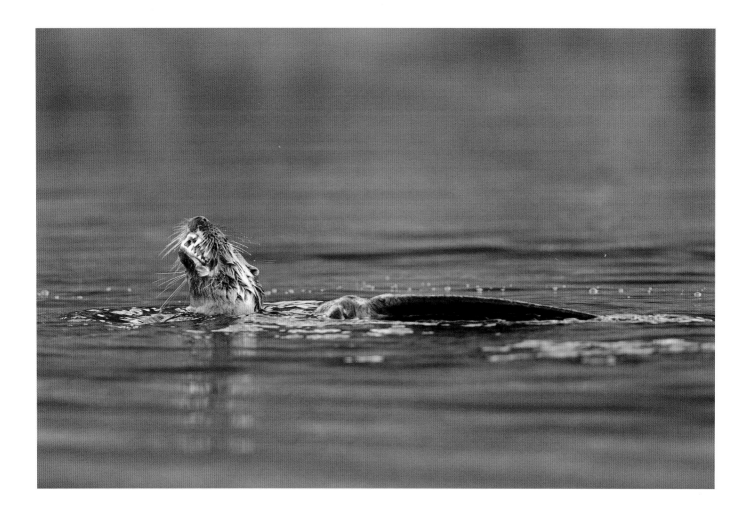

Waterways were cleaned up and linked up and there was significant investment in otter-friendly infrastructure of tunnels and fences, ready for a reintroduction programme to begin in the early 2000s. It was thought at the time that it would take too long for otters to naturally recolonise the Netherlands from the wild populations in the east of Germany, Poland and the Czech Republic. The first reintroduction project brought 32 otters from thriving populations in Belarus and Latvia and released them in restored and enlarged wetland environments in the Netherlands.

Gradually – as the pesticide load reduced, the water quality improved and the fish supply increased – many of Europe's rivers became fit for otters again. And so they made their own watery way back, spreading west from the many lakes and wetlands of Eastern Europe, and east from the Atlantic coastline. They followed the rivers, linking up populations in different countries, shrinking that otter-less space in between. Signs of their presence appeared more frequently and were more widespread: a flick of a tail on the Rhone; a trail of silver bubbles at the edge of the Rhine; tracks in the snow in the eastern Alps as otters followed the Inn from Austria into Switzerland. Otters even made their own way back to the Netherlands, crossing Germany sooner than expected and bringing welcome genetic diversity to the reintroduced Dutch population.

In Britain, otters spread east throughout the country, sending ripples of excitement along the

rivers. Although it was a cause of concern to some anglers and freshwater fisheries, the return of the otter was greeted with delight by the general public. Otters had been largely unseen for a generation, yet the species had only gained in popularity, reaching something akin to celebrity status in the animal world. In a *BBC Wildlife Magazine* poll in 2008, otters beat even badgers and dolphins to the top spot of Britain's favourite mammal. Though they share a hint of menace with their mustelid cousins, otters are much admired for their good looks and charm, and the utter grace and beauty of their movement in the water. Stories, both fiction and non-fiction, have played a part in their popularity. Among others, Williamson's *Tarka the Otter*, and Gavin Maxwell's pets, described in his 1960 memoir, *Ring of Bright Water*, have given otters a special place in the storyland of our hearts.

Otters continued to reclaim their place in Britain's waterways, steadily re-colonising their former sites. In 2011, the government's Environment Agency made a jubilant announcement that otters had returned to every county in England, proclaiming Kent as the last piece in the jigsaw of otter recovery. In the years since, it seems otters have grown ever bolder, being seen more often in daylight hours and settling in to surprisingly busy urban environments. Both direct sightings and footage from CCTV cameras are revealing incongruous scenes. This animal that has long been a symbol of elusive wildness and pristine nature is roaming Bristol's parks and Birmingham's canals, raiding dustbins in Newcastle and even nipping through a railway station in Edinburgh. Otters are back amongst us, and living closer than we expect.

Yet many scientists warn against complacency when celebrating the return of the otter. Estimates of numbers may be exaggerated – otters are notoriously difficult to count as they are so secretive and still mostly nocturnal. There is also a fear that

RIGHT A mother with her two grown cubs, photographed in the middle of a Saturday afternoon from the seventeenth-century road bridge in the centre of Berwick-upon-Tweed.

OPPOSITE As it lifted its head in the morning sunlight to bite down a small fish, the otter's powerful hunting equipment was revealed: long sensitive whiskers and very sharp teeth.

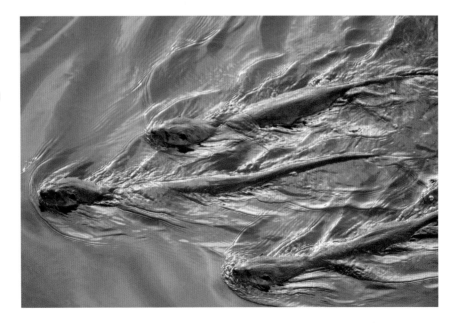

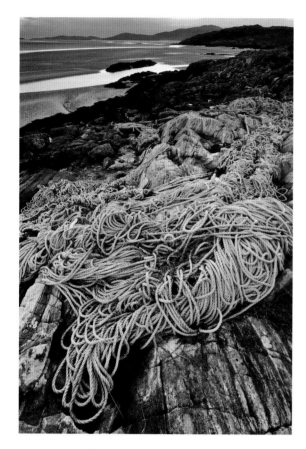

Though otters are officially protected throughout Europe, illegal hunting and trapping continue, and in Austria and Bavaria licences have been issued for legal culls to protect fish stocks from otters. Even the increasing presence of urban otters is ambiguous. Is this a welcome sign of growing populations and cleaner habitat – a reminder that these feisty, intelligent predators need only sufficient food and shelter to adapt to new situations? Or is it an indication that otters are having to travel further to find food and so are exploring and settling in to less suitable habitats?

Above all, there is again an insidious and invisible threat. In recent years, post mortems have been revealing disturbing findings about the chemical load that otters still carry within their bodies. Firstly, those persistent organic pollutants (POPs) are, as the name describes, persistent – they do not go away from the environment when they are legislated away from the market. Indeed the story of chemicals in European agricultural and industrial policy can be read in the tissues of dead otters. Decades after they were banned, toxins such as DDT, dieldrin and PCBs are still present in otters' livers. The concentration of these chemicals is falling year by year after a global ban. However, scientists are noticing increasing problems with the health of otters, which do not correlate with declining levels of these historic pollutants. There are changes and increasing abnormalities in the reproductive organs of male otters, which

overplaying the otters' return could provoke a backlash, particularly from those managing valuable fish stocks, and that this could challenge the legal protection that otters have gained.

Otter populations throughout Europe are still fragile. As with the crash in the last century, many factors contribute to this ongoing vulnerability. Road deaths are high across Europe, and entanglement in fishing gear is a continuing problem. Food sources vary and may be precarious – eels, for example, were once the primary food source for otters in British rivers, but are now critically endangered themselves. The number of young eels reaching Europe has fallen by 95 percent in the past 40 years. And climate chaos is disrupting ecosystems in every habitat.

ABOVE Discarded fishing gear poses a threat to otters and other marine life. This fishing net, on Harris in the Outer Hebrides, probably washed ashore after it was entangled and cut free.

OPPOSITE Asian short-clawed otters are the species most likely to be seen in zoos and wildlife parks as they adapt better to captivity than our native *Lutra lutra*.

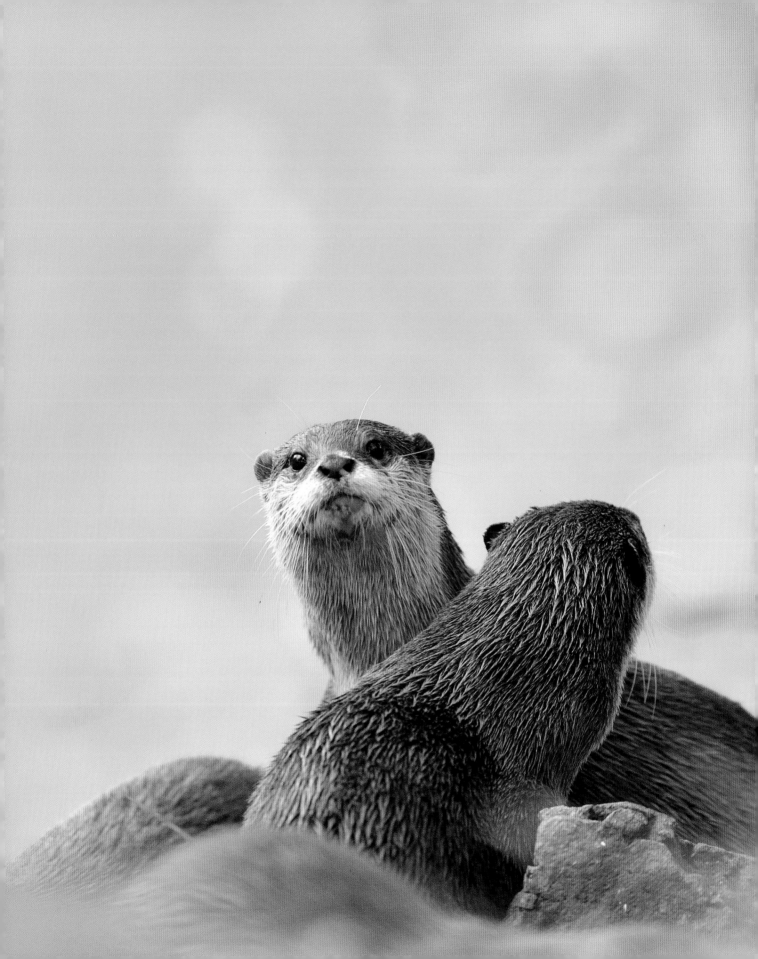

are associated with increasing levels of a newer threat: hormone-disrupting chemicals in the environment. Known as Endocrine Disrupting Chemicals (EDCs), these come from a group of substances used variously in cosmetics, as water repellents and in flame retardants. Tiny amounts of these chemicals can disrupt the normal workings of hormones, which in turn disrupt the nervous system, immune system and reproduction. EDCs have been linked to many hormone changes in wildlife, such as male fish producing female egg proteins and the lack of reproduction among killer whales around the UK.

Even otters from the seemingly pristine Hebridean islands of Scotland are found to contain worrying levels of heavy metals, including mercury. And there are growing concerns around the world about pharmaceutical pollution, from human and veterinary medicine, increasing in the waterways and affecting aquatic life. In the Baltic Sea, salmon have been found to contain the synthetic hormones used in contraceptive pills. Swedish perch are contaminated with

———

BELOW A lucky moment from a filling station forecourt in Broadford, Isle of Skye – just as Laurie stopped for fuel, this otter popped its head out of the blue sea close by.

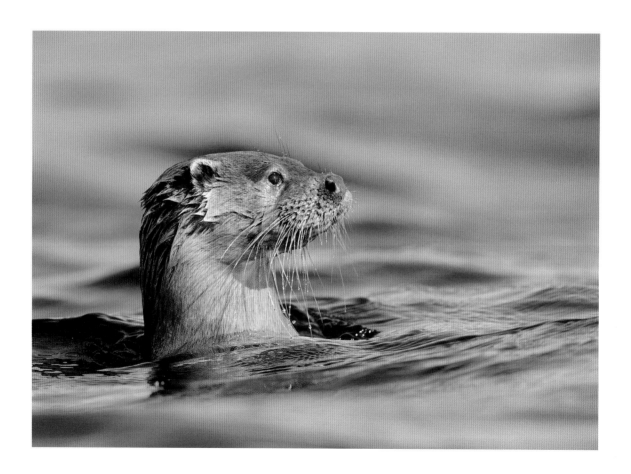

anti-depressants and antibiotics, among many other medicines. In England, traces of anti-inflammatories and painkillers have been detected in the fur of otters.

While levels of specific chemicals are lower than the load that caused the population crash, there are now many more diverse pollutants in our waters. Many new substances are not monitored in the environment, and it is not yet known how these various chemicals combine and affect each other, or what the long-term effects of this chemical cocktail will be.

It may well be that having recovered from one era of toxic pollutants, otters now face the threat of another. So while it seems that otters are back on our rivers, continued vigilance and careful research is needed to ensure that they remain so. As otters belong to both land and water, they are valuable barometers of the overall health of both realms.

Meanwhile, back on the Tweed, the river system has fared well in the big clean-up of the early decades of the twenty-first century. An unusual confluence of geography and local government has meant that most of the river catchment is under the management of one authority, enabling integrated planning of the land and water as a whole. A range of environmental organisations is also working in partnership with farmers and landowners to restore a more natural river system: opening up salmon routes; restoring natural curves in the tributaries; establishing woodlands, wetlands, hedges, meadows and ponds. Flood-prevention work has led to a greater awareness that river management begins high in the hills. Native trees are being planted to help provide shade for the rivers to keep them cool as climate change causes rising water temperatures. All this and

more contribute to a river system better able to regulate itself and to support wildlife. Otters returned and thrived here.

And so into these bigger stories of geology, ecology, history and politics, steps the photographer Laurie Campbell. Born a stone's throw from the Tweed, he spent much of his childhood investigating the river and its wildlife. From a very young age, Laurie would set out alone and walk for miles along the riverside, exploring with restless energy and intense curiosity, always wanting to know what was round the next corner. He knew this landscape intimately, from the lichens on the riverside trees to the badgers in the woods and the birdlife on the river. He knew there were no otters; indeed, otters seemed a remote and almost mythical creature back then. At school, Laurie paid attention to biology and nature study, and was fascinated by the interconnections of the natural world. Armed with an array of natural history guides, he began his lifelong study of Scotland's wildlife and wild places, starting where he stood in his native habitat of Berwickshire. He looked carefully at each little piece in the jigsaw of habitat and began to see how it all fitted together, how each species affected the others; how it changed.

Laurie has stayed closely connected to the Tweed all his life. Though he's travelled the length and breadth of Scotland as a professional nature photographer, he always returns to his home river. He became well acquainted with *Lutra lutra* when his work took him to the then strongholds of Scotland's Hebridean islands and western shores. When otters found their way back to the rich waters of the Tweed and its tributaries, Laurie was there, ready and waiting – senses finely tuned and camera poised – to tell their story.

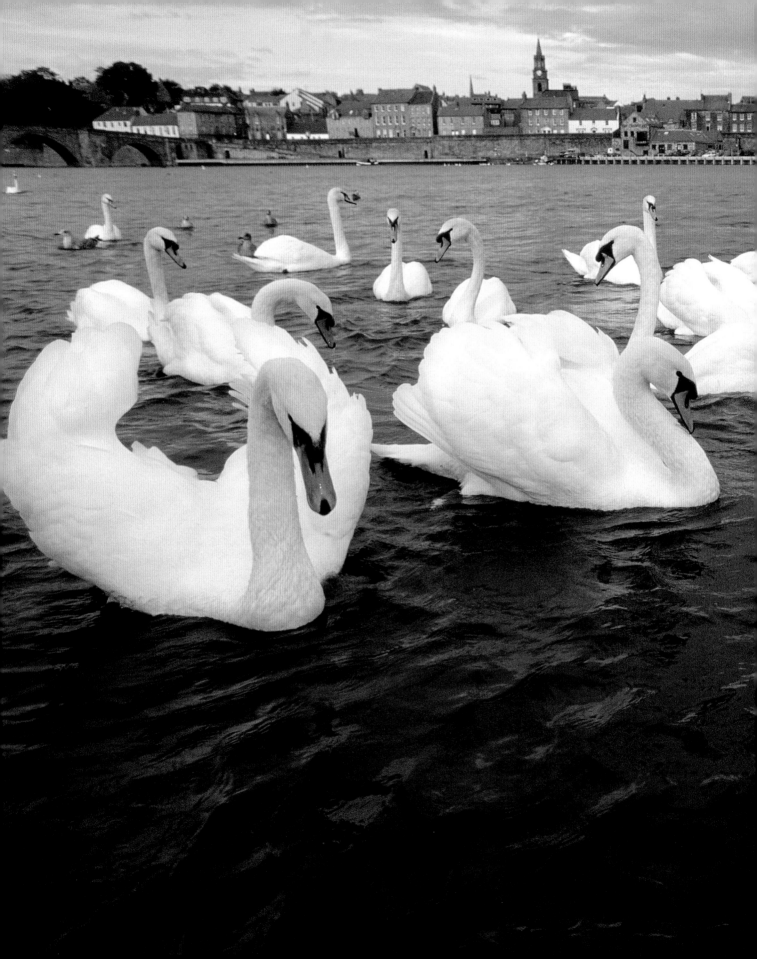

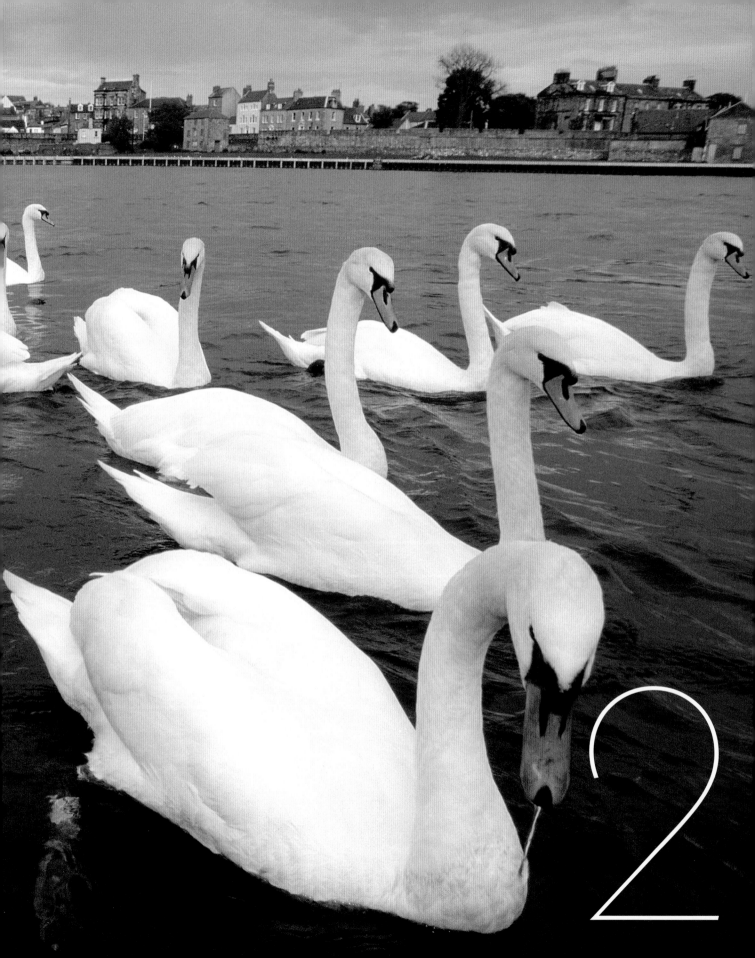

2

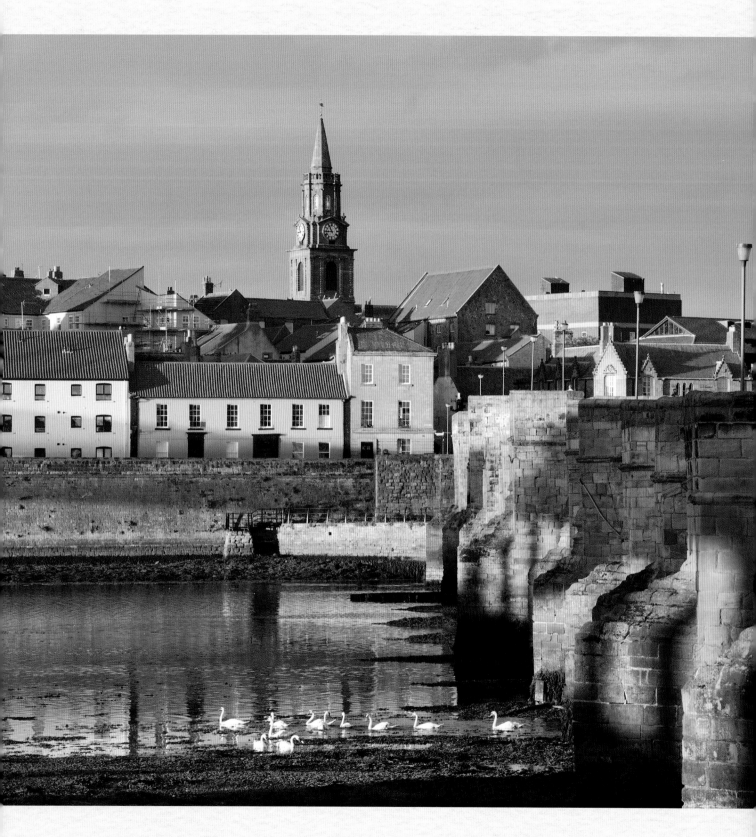

ABOVE Laurie was born within the frame of this photograph, in the centre of Berwick-upon-Tweed.
PREVIOUS PAGES The Tweed estuary is home to the second largest herd of mute swans in Britain.

New Road

We walk the path along the north bank of the Tweed, known locally as the 'New Road', which follows the river out of town. It leads us from the centre of Berwick-upon-Tweed, a stone's throw from the house where Laurie was born, past the house and garages his grandfather built, then under the three bridges that span the bright river, and on and on upstream.

Today the river is brilliant blue and picturesque, with the town's rowing club out in force on the water and groups of elegant mute swans drifting by. As we walk – alert and scanning for signs of otters – this moment in time feels like just the surface of something deeper. When you've known a landscape for a long time, you see it as if in layers superimposed: what is now and what used to be.

Laurie has walked this path and known this river all his life. As a schoolboy he was already going to lengths others didn't go to – walking further, staying up later, waiting longer. As a result, he witnessed events that others rarely saw: the heavy grace of herons flying in to roost in a field

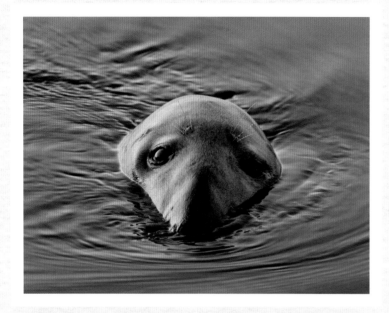

Road, Laurie parts the dense ivy that falls like a curtain over the rocks by the riverbank, revealing the secret space behind where, as a boy, he could watch from a natural hide. We pass the ruins of the thirteenth-century castle and note the crevice in the eroded sandstone of the rock where Laurie used to see tiny wrens roosting at night, huddled together for shelter. Further along is a cottage with no road or track to it. It's always been occupied, and the lights in the windows would give some orientation as he walked home in the darkness after long hours of badger watching. Once, on a dark night, he was spooked by strange gasps carried on the wind from the water, then he realised it was the breath of grey seals that had followed the salmon up the river.

at dawn; gatherings of over-wintering long-eared owls roosting in a blackthorn thicket on the riverside; badger cubs first emerging from their setts. Even then he saw the magic in tiny transient moments, ones others might have missed: the gleam of sunlight on birch bark, raindrops on an upturned oak leaf.

He moved like a shaman between the mundane world of school and home, and the enchanted realm of the riverside. But he wanted to bring some-thing back. He was thrilled by his experiences but frustrated by his attempts to share them with others: neither drawing nor talking could adequately convey what he had witnessed or why it was so special. The solution

came from his grandmother, who presented the 12-year-old boy with the gift of a camera. He took to it immediately; this was the medium he'd been looking for to tell the stories of his adventures.

As we set out along the New

Laurie can't remember when his interest in the natural world began; it has simply always been there. Children are naturally curious, he says, always picking things up, collecting, exploring, questioning. Laurie simply didn't grow out of it. He describes his parents as interested, though not expert, but times were different then and children had more freedom to explore outside. The natural world was closer. There were chores to be done on his father's allotment, fishing trips with his grandfather, family outings to collect rosehips, field mushrooms, brambles and conkers.

Walking now, we glimpse those layers of what used to be. There's a field beside a stream that was once a rich marshy wetland, bright with irises and marsh marigolds and dragonflies; there were swathes of watercress on the banks and water voles in the burn. Laurie explains that when they built the Berwick bypass in the early 1970s, the land was filled in with spoil from nearby road cuttings, bringing this living, marshy world to an abrupt end. It was his first awareness that his outdoor playground was threatened – something darker and duller was encroaching from the world beyond.

A few miles upriver we scramble up a nettle-covered grassy bank. There's a large beech here, with some planks attached about 10 metres up, across a fork in the tree. It's the remains of a hide that Laurie built nearly 40 years ago to get level with a kestrel's nest on an old oak just below it. We sit in the sun looking up at it, Laurie remembering how he used to spend eight or ten hours at a time up there. He would watch the kestrels coming and going, waiting for the right moment in just the right light to get the photograph he wanted.

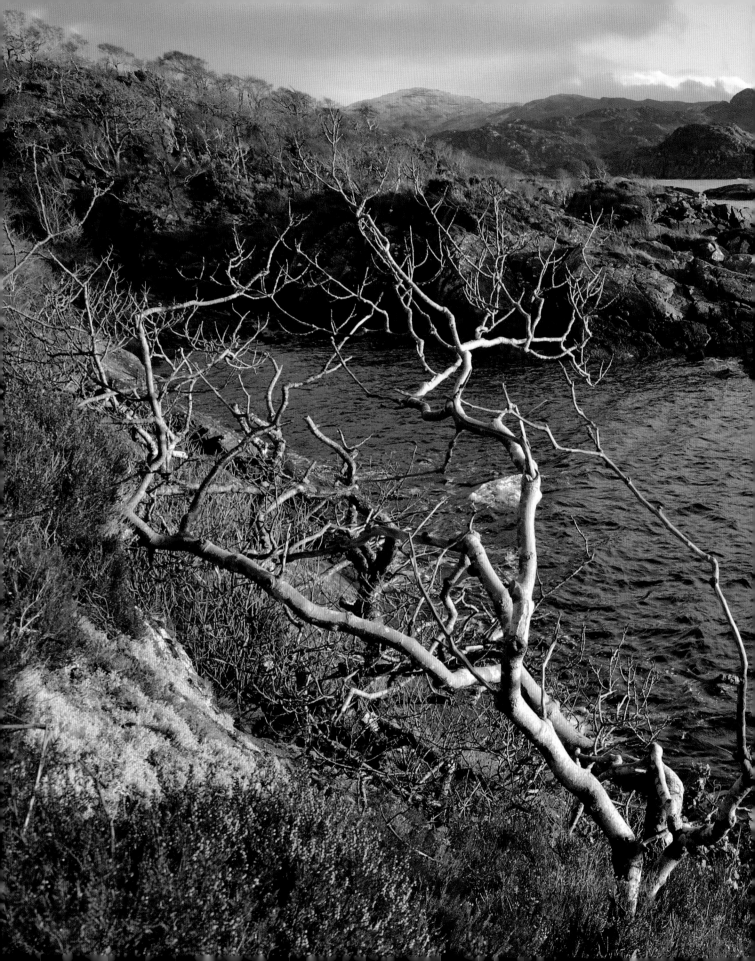

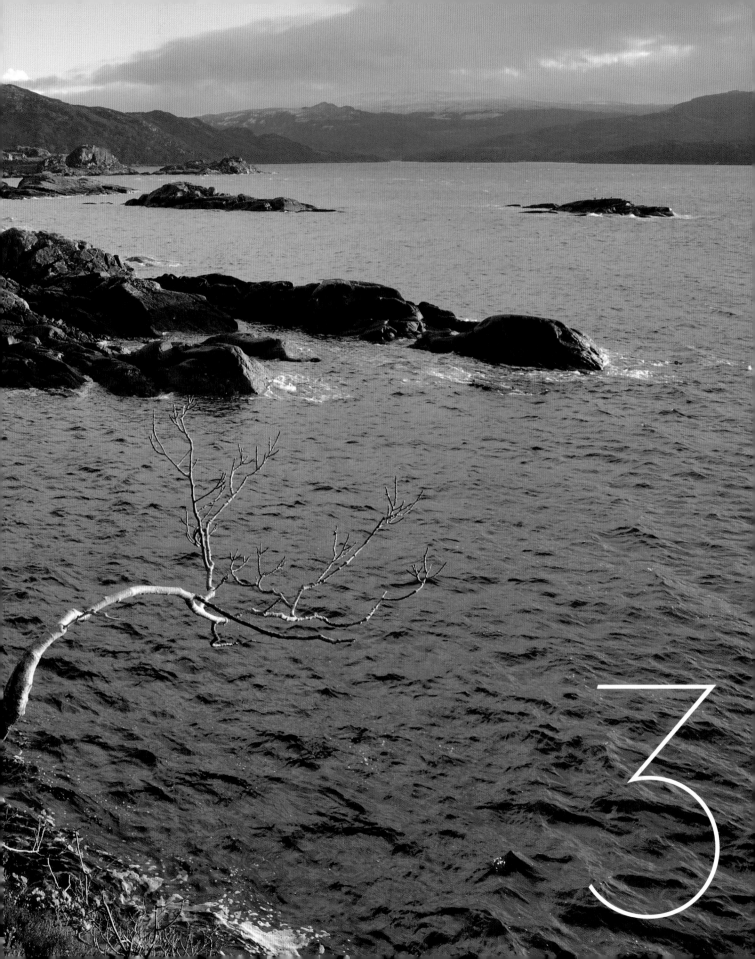

3

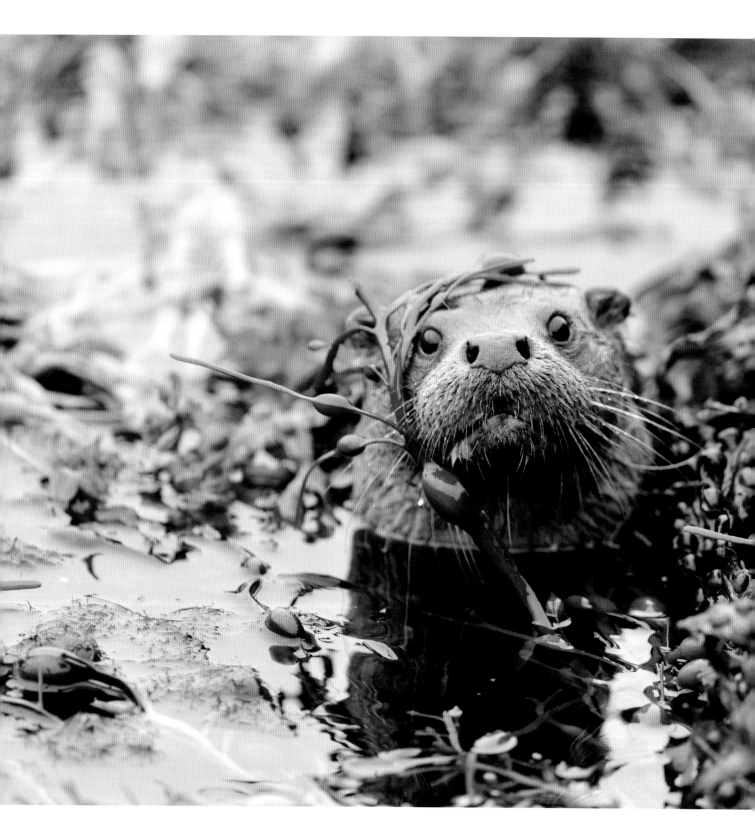

ABOVE Laurie was lying on the shore under camouflage netting when this otter came to check him out under its own camouflage.
PREVIOUS PAGES Loch Sunart in Ardnamurchan, where Laurie first saw a wild otter on a childhood holiday in the 1960s.

3

OTTERS ON THE WESTERN SHORES

IN THE EARLY 1980S, Laurie established both a business and a genre, becoming Scotland's first full-time professional nature photographer. He took the plunge to see if he could make a living doing what he'd always done: exploring ever further into the wild world, capturing fleeting moments of natural light on wild beauty, and bringing them back to show and to share. He ploughed his own furrow many years before advances in digital technology helped to make wildlife photography both the international industry and the popular pastime that it is today. As his pictures appeared in a range of magazines and publications, greetings cards and calendars, he quickly gained recognition for his own distinctive style. The photography built on his depth of understanding as a naturalist, showing wildlife in its context, animals at ease in their natural habitat; each picture was a celebration of the beauty of natural light.

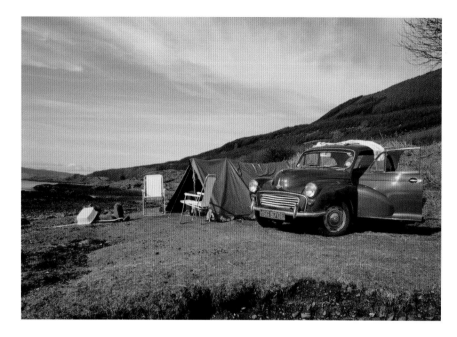

From his Berwickshire home, Laurie would head off for month-long field trips to remote locations in the Highlands and Islands, initially in a Morris Minor with a small tent, later in the relative luxury of a motorhome. His working life soon fell into a pattern that he calls 'commuting' – alternating between stints of work in his home beat and long trips to the north and west – that would continue for the next 40 years.

Laurie has always preferred to work under his own steam, exploring at his own pace and steadily building up a picture library with as comprehensive coverage as possible of Scotland's natural world. Some trips would target a particular species or habitat, but he'd always be happily distracted by whatever else intrigued him along the way. While lugging a dead deer up a mountain to bait golden eagles, for example, he came up with the idea of placing his camera in a fish tank in a mountain stream

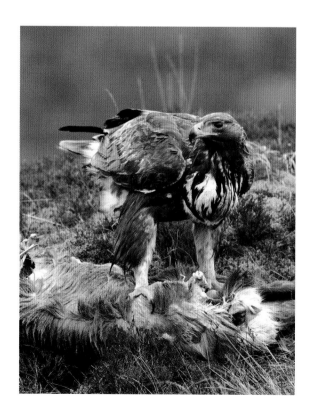

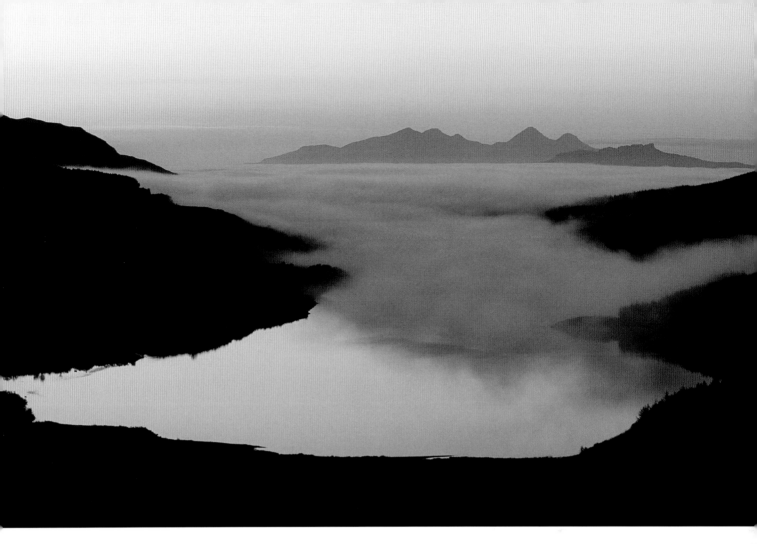

to capture the spectacle of spawning salmon that he had noticed in the same glen. While filming oystercatchers on the seashore, he took the time to photograph the intricate patterns of lichen on the rocks. Each piece of the jigsaw is equally relevant when your aim is to see the whole picture. By systematically returning to a range of habitats throughout Scotland, he has gathered more pieces and tried to improve on those he had, looking for greater detail or other aspects of behaviour, always searching for a new way to see a subject.

Otters were an appealing subject from the early days of Laurie's work. He has always found it an irresistible challenge to work on something that has rarely been photographed before and there were very few pictures of wild otters available at that time. Most images that adorned calendars or greetings cards had been taken in wildlife parks or other captive situations.

In setting out to photograph otters in the wild, the obvious first step was to return to the scene of early otter sightings from childhood holidays. Family trips camping in the Highlands and Islands had provided inspirational glimpses into the wild beauty of Scotland's more rugged landscapes. One particularly memorable trip was to the shores of Argyll's Ardnamurchan Peninsula,

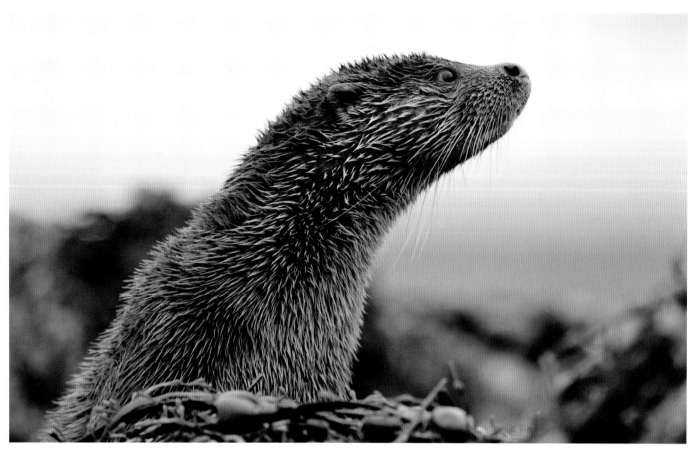
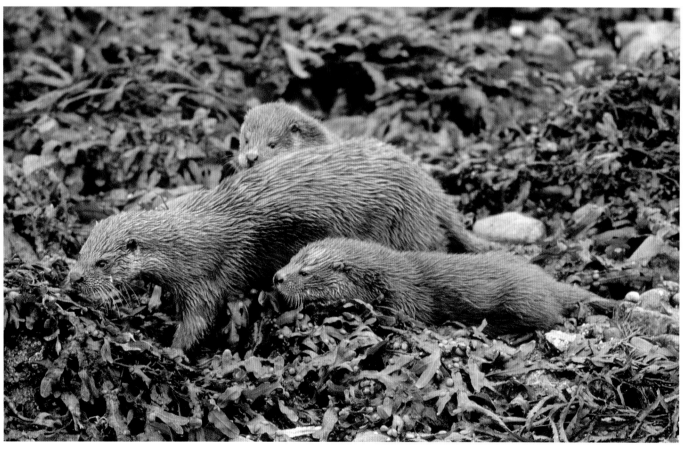

a wild, rugged arm of land that reaches into the Atlantic at the most westerly point of the British mainland.

Out exploring, Laurie looked down and saw a 'something' in the water and realised it wasn't a seal. The something looped and rolled in the turquoise sea and disappeared with a flick of a tapered tail: it was his first sighting of an otter.

OPPOSITE TOP An inquisitive otter on a Hebridean shore checking the air for the scent of photographer!

OPPOSITE BOTTOM A mother and her cubs on the shores of Loch Linnhe in late September.

BELOW Low light on the western shore of Harris, Outer Hebrides. These expansive sandy beaches are perfect for prints, but the rocky eastern shores are better otter habitat.

Away from the main tourist routes through the Highlands, Ardnamurchan retains a feeling of wild remoteness, a sense of virgin territory. With no roads reaching much of the northern shore, you have to walk to explore its isolated sandy bays and miles of windswept, rocky coastline. Returning again as a professional photographer, Laurie was aware that this is ideal otter territory, but it makes for tricky terrain for photography. Exploration involved scrambling with heavy camera equipment over miles of rocky or boggy terrain and through dense rhododendron scrub. He had to cover a lot of ground in search of otters and then move fast to keep up with them. But in time his perseverance paid off and he was rewarded with his first 'usable' photographs of wild otters.

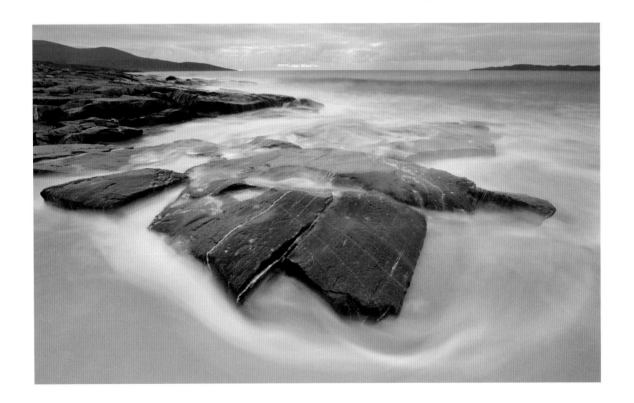

Laurie returned many times to Ardnamurchan, sometimes bringing his young family, and he managed to find and photograph otters on every trip. Through hours of patient observation, he developed his radar for spotting otters on the shore. He learnt to work with the rhythm of the tides, and to go looking for otters when the tide was falling or rising and the rocks and kelp beds were exposed. He learnt to spot their sleek forms in the sea or on shore, to anticipate their movements and to read the wider landscape for signs of an otter's presence. Scanning a shoreline towards low tide, he could pick out the furry ball of an otter curled up like a cat, fast asleep on the seaweed-draped rocks.

In 1984, the wildlife film-maker Hugh Miles launched his seminal film and book *The Track of the Wild Otter*, the result of three years of filming otters on the shores of the Shetland Islands. When Miles embarked on the project, to film wild otters was considered 'an impossible task', but he eventually achieved it by getting out early, scouring the coast for days on end in all weathers, and working on a mixture of hunches, acts of faith and skilful observations. Laurie bought the book as soon as it came out and read it by paraffin lamp in his tent while camping in Ardnamurchan one winter. He found himself smiling and nodding as he read; Miles's vivid descriptions of the otters' lives and the challenges of finding and photographing them resonated with his own experiences.

The skills honed in Ardnamurchan gave Laurie an intuitive feel for the right habitat, time of day and state of tide in which to find otters. He found this could be applied to pretty much any sea loch

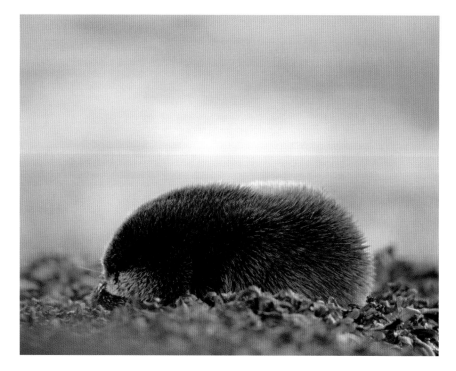

LEFT The furry ball of an otter curled up like a cat, fast asleep on the seaweed-draped rocks.

OPPOSITE While waiting for otters and lying low close to the shore, there is always plenty else to see and photograph, so Laurie ensures he's always kitted out for close-ups. (*Clockwise from top left:* carrageen seaweed, breadcrumb sponge, oarweed and a seashell mixture including cowrie shell). Sometimes Laurie is engrossed in photographing such details when an otter comes along...

on Scotland's western seaboard, wherever his work took him. In the mid-1980s, for example, he made a series of long trips to the Outer Hebrides to photograph the landscape, flora and breeding birds of the machair – the flower-rich grassland that fringes the white sand beaches of the islands' western coast. But while the gleaming beaches may have borne the prints of passing otters, this expansive setting wasn't rich otter habitat. So he would also take time to explore the rocky inlets of the east coast, and in this more rugged setting of rock pools and tangles of seaweed, he would find otters.

While Laurie mostly followed his muse, occasionally his travels were directed by commissions. For the American Museum of Natural History, he travelled to the Isle of Rum, one of the Small Isles of the Inner Hebrides, to photograph feral goats living high on the sea cliffs. He later returned to the island to capture the landscape

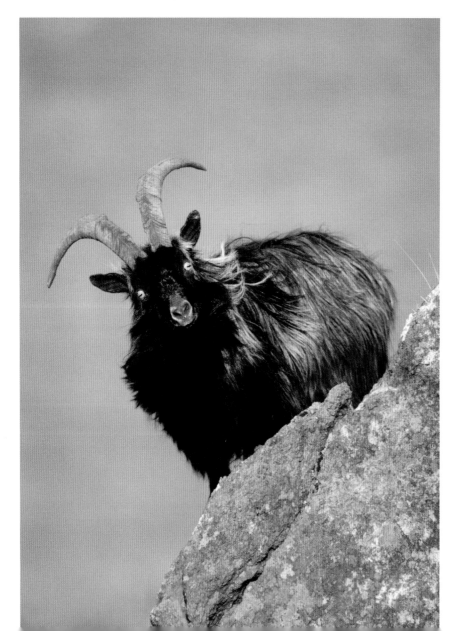

LEFT Scotland's feral goats are descended from domestic stock but 'rewild' through the generations, growing shaggier coats and longer horns.

OPPOSITE A red deer on the Isle of Rum takes a break from feeding on seaweed to add its voice to the roars of the rutting season.

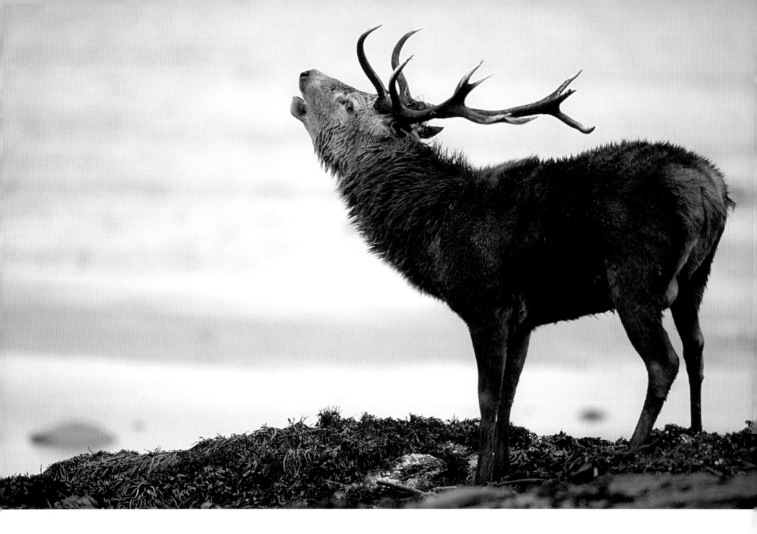

and wildlife over the course of a year for Scottish Natural Heritage. More recently Laurie was commissioned by the North Harris Trust in the Outer Hebrides to photograph their estate – one of the largest community-owned lands in Scotland – throughout the changing seasons. He used these opportunities to enhance his collection of wild otter pictures. In between tracking red deer on Rum or watching a golden eagle's eyrie on Harris, he would seek out otter habitats and photograph them – whether grooming, resting or play-fighting on the shore, peering out from under the kelp or up on a rock munching a butterfish.

When Laurie's second son was born, he realised that with a growing family and a growing image library to find space for, it was time to move house. As a successful nature photographer, he could have lived anywhere in Scotland, and considered moving north to the Highlands, with the appealing prospect of a wilder landscape and species such as pine martens and golden eagles on his home beat. But after much deliberation the family moved 50 metres, to a larger house in the same village. There's enough here, he decided, and still so much to explore and discover. There was pioneering work to be done in photography, not by travelling further but by looking ever closer.

So in between trips throughout Scotland, and very occasional forays abroad – often to lecture on the benefits of working close to home – Laurie

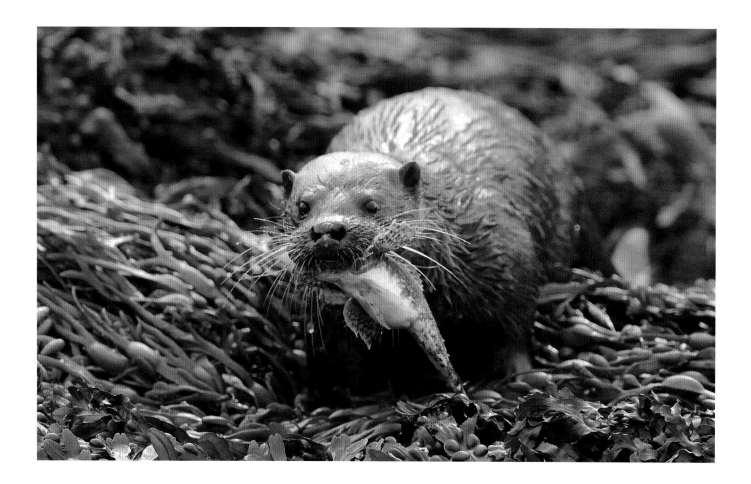

continues to work mostly on his home turf. He studied the long golden stretches of dune-backed beaches where he'd collected common lizards as a child, the rivers where he'd watched the grey herons, mute swans and kingfishers, and the woodlands with their badgers, bats and tawny owls. He focused even closer on the birds, plants and pondlife in his own garden – realising you don't have to go anywhere to achieve the aim of seeing things in a new way.

Watching a habitat so intensely over a period of time means you're well placed to notice changes in the natural world. Nature photographers are often inadvertently documenting these changes, recording the impact of climate change as some species creep north; of intensive farming practices as other species decline; or sometimes

of the benefits of conservation efforts as species recover.

Over the course of Laurie's work, he's noticed how the water voles and cuckoos have largely disappeared from his home region, while buzzards, once unknown, are now an everyday sight. Marsh tits were once relatively common but are now rarely seen. He has also been able to document new species reaching Scotland from the south, including banded demoiselle damselflies and bee orchids. Watching one area over such a long period puts a photographer in an ideal position to notice the small incremental changes that occur in the natural world.

Back in the early 1990s, he began to hear rumours and barely dared to believe that they were true – could there be otters on the Tweed again?

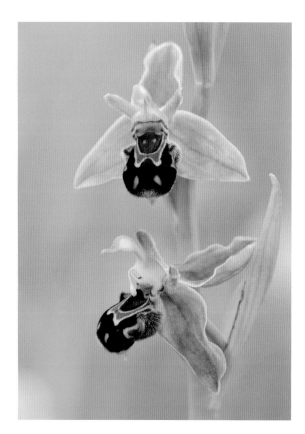

ABOVE Bee orchids, which mimic a female bee in appearance, texture and even scent, are slowly moving north.

RIGHT On first sight, Laurie knew that this banded demoiselle damselfly was something new to his home beat.

OPPOSITE TOP An otter landed a scorpionfish just beneath the busy Kessock Bridge near Inverness.

OPPOSITE BELOW From 1975, the style of this grey heron photographed through vegetation was a landmark image.

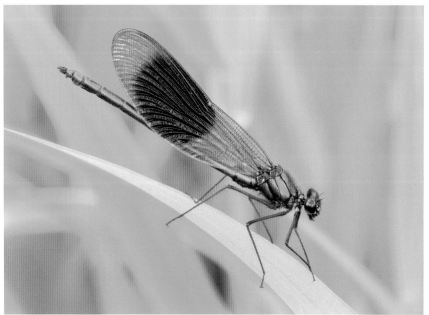

4

ABOVE Common pipistrelle bat, photographed over the front hedge of Laurie's home.
PREVIOUS PAGES Barn owl, photographed 40 minutes after sunset, in the indigo remains of the light.

4

Evening

On a still evening we head out to meet the River Whiteadder, which curves around the village near Laurie's home. It's a short drive but packed full of information; it seems there's a wildlife story for every twist and turn in the road. He shows me the corner where once he stood in the dark watching pipistrelle bats, trying to capture their darting flight and learning by trial and error how many thousandths of a second of flash duration were required. Over there are the fields where brown hare, grey partridge, barn owl or woodcock were photographed, from hides built all around surrounding farmlands.

We leave the car and wade through a mass of three-cornered leek flowers, which cover the wooded slopes down to the river, scenting the evening air. Two roe deer are grazing; they startle and bound away as we approach, leaving glimpses of white rumps as they disappear through the trees. Laurie continues his softly spoken commentary, naming

The soft mud by the water's edge forms a perfect mould. It's just wet enough to hold the story of its recent visitors, dry enough not to smudge the prints: the two slots of roe deer; the wider pads of badger, with straight rows of four forward-facing toes; and – the thing we are searching for – the five rounded toes and webbed pads of otter. They're here.

Laurie points to a moss-covered log nearby – it holds a squidge of oily black otter spraint. We crouch down to examine the spraint through a hand lens, looking for the white glint of fish scales – it's moist, and so otters have been here recently.

the plants and the bird calls, explaining that this secret place tucked into the river valley has a microclimate all of its own. He points out the striped hairs that show where badgers have been scratching. We pass by the ash trees where one winter he photographed orange ladybirds, clustered in their hundreds on the shady north side of the olive-grey tree trunks.

Silently, we follow the loop of the river, Laurie striding ahead. He walks like a predator, lifting his feet and placing them down, soft and deliberate as a big cat – a leopard perhaps, all senses alert, scanning around, taking everything in, listening, feeling the direction of the wind. He carries a tripod over one shoulder and a heavy bag of photographic kit on the other, but he glides along totally unencumbered by it all, ducking under branches and moving through dense vegetation, stepping over fences, always off the beaten path.

We stop suddenly. 'There,' says Laurie quietly, and my eyes dart to the water, scanning for otters, but it's a kingfisher – an iridescent streak of brilliant turquoise and just a moment of russet. It's startlingly bright, the colours incongruous against the soft greys and browns and muted greens of rock, river, mud and trees.

We settle a while on the riverbank, watching. The water stays bright as the sky around us darkens. In the stillness, silver rings appear on the surface as trout rise. It makes me start, as does movement on the water upstream, but Laurie has clocked it all in his peripheral vision and doesn't stir – it's just the clumsy

bow wave of a passing duck, not the streamlined V of an otter's wake. The wind's behind us, he says, so there's not much chance of a sighting; the otters are still shy here, where nobody much goes. But he points out the kestrel roost over on the cliffs and the places where Daubenton's bats skim low over the water. A tawny owl calls.

Much of the land around here has been tamed by years of intensive agriculture, but where the river twists through these steep-sided cliffs there are remnants of natural woodland, which form a rich, wild habitat. As we head home through the almost-dark, Laurie points to where roe deer have nipped the emerging buds of the butterbur flowers. Such an in-depth knowledge of habitat, he says, is the reward you get for working so close to home.

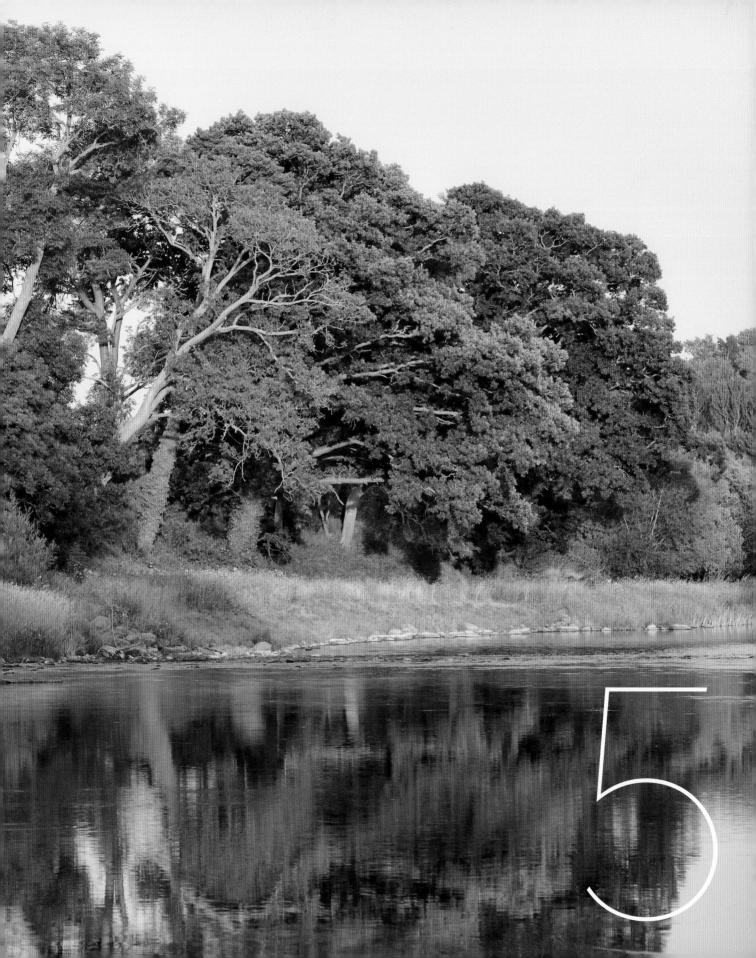

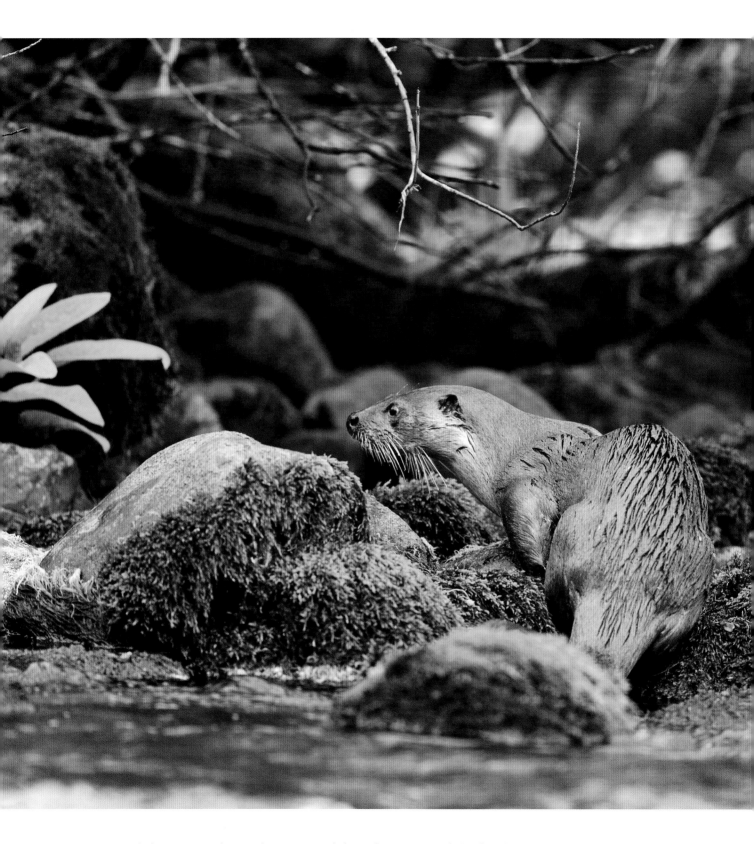

ABOVE Clad in neoprene chest waders, Laurie waded into the river to watch this female coming ashore.
PREVIOUS PAGES A still summer's evening on the River Teviot as Laurie sets out otter watching.

5

RETURN TO THE RIVER

LATE ONE MAY EVENING in 1993, Laurie was heading out with a friend to look for badgers in a wooded gully beside the Tweed. They were making their way along the dusky riverside path, still some distance from the wood, when they noticed a mallard suddenly fly up in alarm on the opposite bank. Laurie lifted his binoculars and slowly scanned the river's surface from bank to bank to find out what had disturbed it. There in the distance, in the last of the light, he spotted something moving in the water, working its way alongside the bank, slipping in and out of the plants at the water's edge. There was just enough light to catch a glimpse of a small head and the arch of a sleek back before it disappeared from view.

It was enough to confirm what he had barely dared to hope – otters had returned to the Tweed. The species that had enchanted him on so many visits to Scotland's west coast was now living right here on his own home river. There wasn't enough

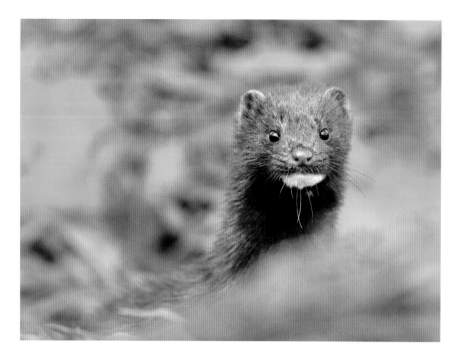

light to record that first encounter on camera, but it captivated him and launched him on a new quest: to get acquainted with these river-dwelling otters and to create a photographic record of their lives.

Laurie wondered how long otters had been there before he first saw one, and whether he might have passed by their sleek forms in the dusky river, unknowingly. He had heard reports of otter sightings in the area but had taken them with a pinch of salt, presuming people had seen feral American mink, which were more widespread at the time and were often misidentified. But now he remembered moments when he had heard something unseen on the riverbank – a sudden rustle in the rushes, a plop and a splash in the water, a sense of a large-ish, heavy animal moving away through the dense vegetation on the banks – could these have been otters?

When another friend pointed out a small, dark mound of spraint on a rock in shallow water, Laurie realised why he might have missed some tell-tale signs of the otters' presence. After two decades of tracking otters in the West Highlands he was well acquainted with the field signs left by those inhabiting the seashore. But these river-

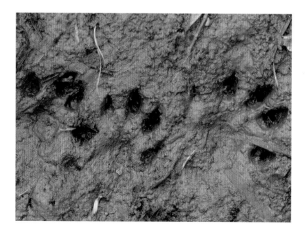

dwellers seemed an altogether different beast. For a start, their diet wasn't the same, therefore neither was their spraint. He knew otter spraint from the shore – it looked kind of 'crunchy', full of little white bits that are the remains of crustaceans – and so he had missed the spraint on the riverbank, which was smooth, black and tar-like. And while coastal otters are out and about in the daytime, their lives governed by the turn of the tides, these river denizens slipped out at dawn and dusk, moving secretively in the half-light, easily melting into the dark river or disappearing into the riverbank.

'Getting your eye in' is a favourite expression of Laurie's; to him, it is the key to the process of learning to spot wildlife in its context, of the watery world coming into focus as you get a sense of scale and begin to discern the difference, for example, in splashes and ripples and the way the water's surface responds after being disturbed by a fish or a duck or an otter. He realised he was going to have to go through the process of 'getting your eye in' all over again.

Now that he knew, he started to see the subtle signs of their presence more regularly, such as that dark spraint, as well as tracks in the mud by the water's edge and flattened areas of grass on secluded patches of riverbank where otters would emerge to roll around and dry themselves. By watching silently, keeping downwind at quiet

moments of dawn and dusk, he began to see the otters themselves more often.

Over time his search widened along the Tweed and its tributaries. As well as developing his own field craft, Laurie discovered where otters were present by talking to anyone he met who also spent time at the river at odd hours – dog walkers, joggers, anglers, salmon poachers and water bailiffs alike. He found signs of otters along the whole length of the river, high in the hills and right down to the brackish waters of the estuary.

He was delighted to find otters on Whiteadder Water, one of the Tweed's many tributaries that flows down from the Lammermuir Hills and curves around behind his home village before joining the larger river near the estuary. Meandering through the Berwickshire landscape, the Whiteadder has stretches of steep-sided banks cut over millennia by the river, where small pockets of native woodland remain. Living between the two rivers, he chose to spend more time watching the Whiteadder because it has a more intimate feel than the nearby Tweed, which is broader and tidal in its lower reaches.

On the Whiteadder, Laurie found an ideal site for a concentrated otter-watch: a quiet,

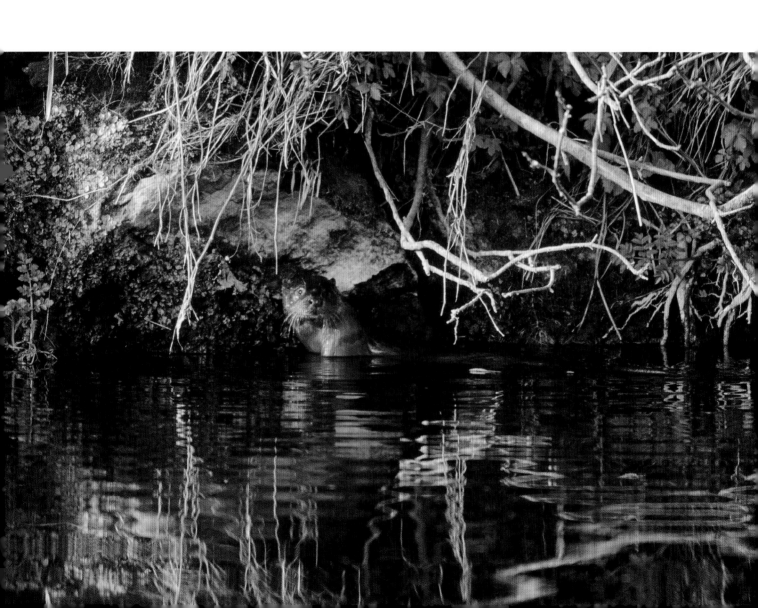

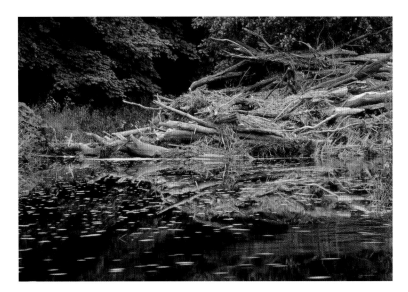

first sightings were mostly at night and occasionally in the half-light of dusk and dawn, photography was almost impossible. But still he watched, learning to get the scale of an otter's head in the new context of this landscape and to discern the sleek form of a rolling brown otter against the rolling brown river.

Gradually, Laurie began to recognise individual otters through their distinctive markings and scars. There was a female with a pale patch of fur on her chin. He discovered her holt hidden in a pile of woody debris that had washed down the river and lodged in the remains of a weir. For two years in succession, Laurie watched her raise her cubs.

This was a long-term project, stretching over

wild, wooded place, where you would rarely see another person. It was the kind of secret, silent spot where roe deer like to lie up in the daytime. And it was within a few minutes' walking distance from his home. Laurie watched this site diligently and began to see otters more regularly. As these

ABOVE A log pile created by winter spates on the river forms an ideal location for an otter holt.

RIGHT The Lammermuir Hills – the source of the Whiteadder – look idyllic in summer when the heather is flowering, but this is still an entirely human-made landscape.

OPPOSITE A photo from the early 1990s when Laurie first saw otters on the Tweed. It was taken at 8.00 a.m. – as late in the day as Laurie had seen otters back then.

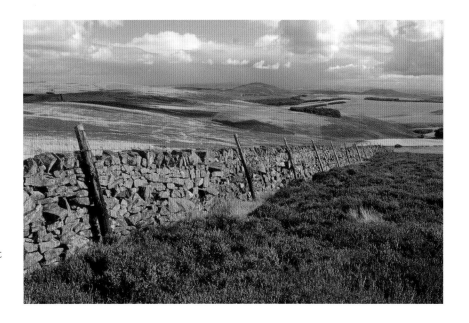

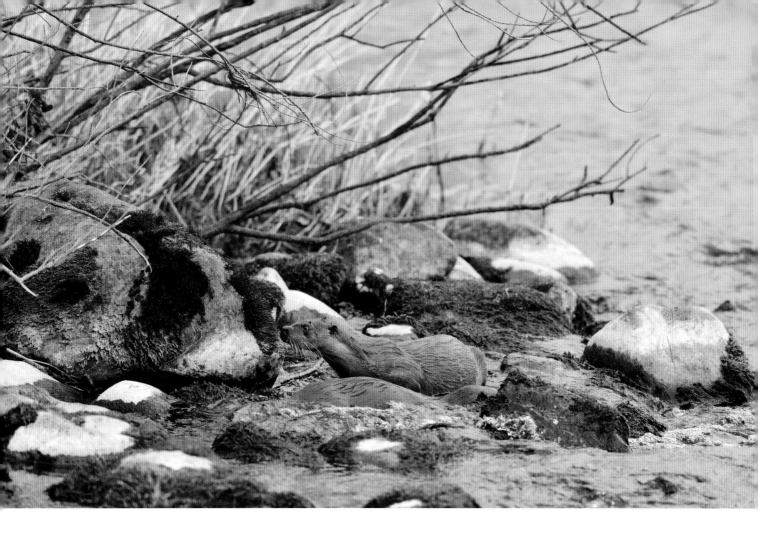

years, steadily accumulating observations, testing techniques by trial and error and building a body of knowledge about the otters' lives and how to photograph them. Laurie had to work around the demands of other projects, sometimes even frustrated to be interrupted by the call of a trip to the north when he was engrossed in the riverside at home. When he had the opportunity to watch certain areas intensively, he came to recognise other individual animals, to know the patterns of their days and the boundaries of their territories. One spring he watched two females with young cubs that lived less than a mile apart and he noticed how they set off in opposite directions each evening so as not to cross into each other's

territory. He got to know favoured feeding spots, homing in on rocky areas where the otters would root around, nudging the rocks to disturb small fish beneath.

The more he learnt about the otters' lives and habitat, the more opportunities for photography arose. In summer he would often be out on the

ABOVE Otters have gradually become less wary and are more often seen out and about in the daytime, and Laurie has learnt to spot an otter (or two) at a glance on the riverbank.

OPPOSITE Bridges offer ideal vantage points for photographing otters, such as this pair of grown cubs on a spring morning.

riverbank before five in the morning. The otters might still have been out and about and feeding in the first light, but they would then be heading back to their holts by seven or eight o'clock, when the rest of the human world was waking up. Some nights he slept out on the riverbank, stirring in the first light to see an otter gliding past beside him, or hearing the peeping call in the darkness that confirmed the presence of cubs.

Laurie developed a range of strategies to get himself into the right position for the photographs. Sometimes he would settle into a recess in the riverbank, wearing camouflage clothing, including dark gloves and face netting. Other times he would hang over a bridge, ready and waiting for otters passing underneath. He would note exactly when the shadow of the

bridge left the pool of deep water below, so as to maximise the chances of being in the right place at the right time to catch his subject swimming below in the clear morning light.

He became aware of the different modes of swimming that otters would adopt: purposefully travelling when returning to their holts after a prolonged hunting and feeding session; loitering and investigating when feeding; and the arching, looping, splashing of play and courtship. Otters are powerful swimmers and can cover quite a distance when they're on the move. It can be a challenge to keep up with them on a riverbank, especially when laden with photographic equipment. The trick, then, is to get ahead of the animal and to lie in wait. Sometimes Laurie would don chest waders and wait in the middle of the

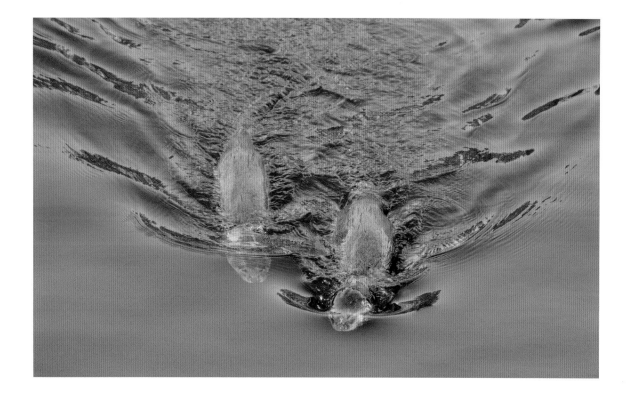

river. The otters seemed less concerned by a low form in the water than a tall shape on the bank.

Many 'otter tracking' skills were transferable from coast to river. An awareness of the animal's keen senses was paramount. This meant keeping a low profile below the skyline, using a backdrop of trees or rock or riverbank to disguise the shape of a human silhouette from the otter's eye view. He also paid close attention to the wind direction and would not approach an otter when the wind was behind him, in case it betrayed his unfamiliar scent to the otter's acute sense of smell.

There was a certain etiquette, Laurie discovered, to riverside otter watching. With appropriate behaviour and keeping at a certain distance, the otters might know he was there but would be comfortable with his presence. He often

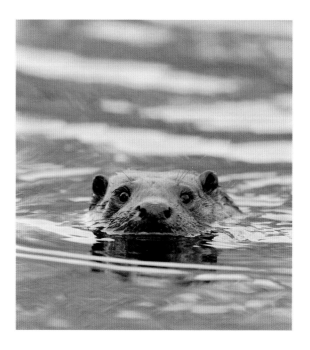

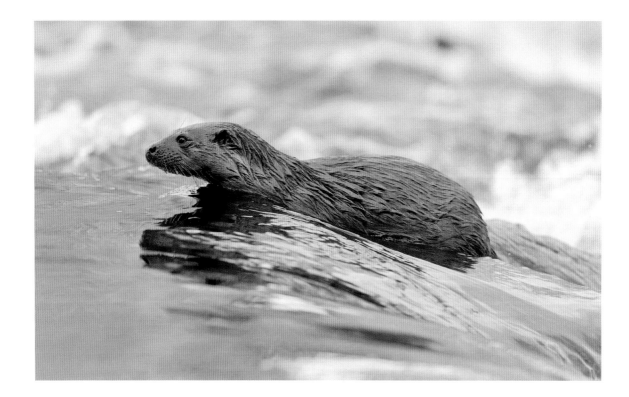

felt as if he were being monitored in some way. An otter would regularly glance in his direction and then, when satisfied he wasn't doing anything too strange or threatening, it would simply carry on with whatever it was doing.

As the years went by, Laurie noticed a steady increase in otter numbers throughout the entire river system of the Tweed and its tributaries, and a gradual change in behaviour. There was no

doubt the otters were getting bolder, becoming more active in daylight and more tolerant of limited disturbance. In the early days of the project, they were utterly elusive and virtually nocturnal, melting back into the river and disappearing completely at the slightest hint of a strange sight, sound or scent. Nearly three decades later it's not unusual to see otters out fishing in the daytime, aware of but unperturbed by people passing by. Fishermen building a landing stage were regularly 'visited' by a curious otter as they worked, and in one Borders town, which the Tweed loops around like a bypass, CCTV cameras have revealed otters taking a short cut right through the town centre at night. On busy stretches of river, where the road passes close by or the riverside paths are well used by walkers

OPPOSITE The brilliant green of springtime trees reflected in the water as this otter paused on a rock at the top of the weir and waited for her cubs to catch up.

BELOW A mother and cub pass under a bridge as they head upstream, utterly unaware of Laurie hanging off the bridge to photograph them. Like many animals, otters rarely look up.

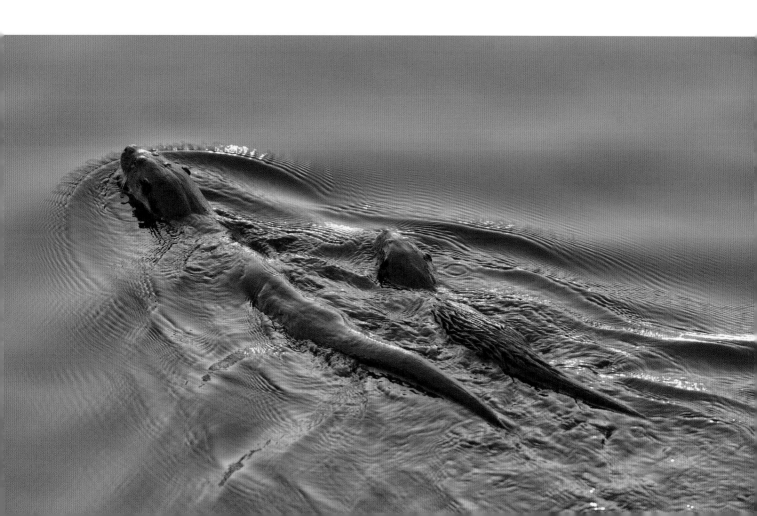

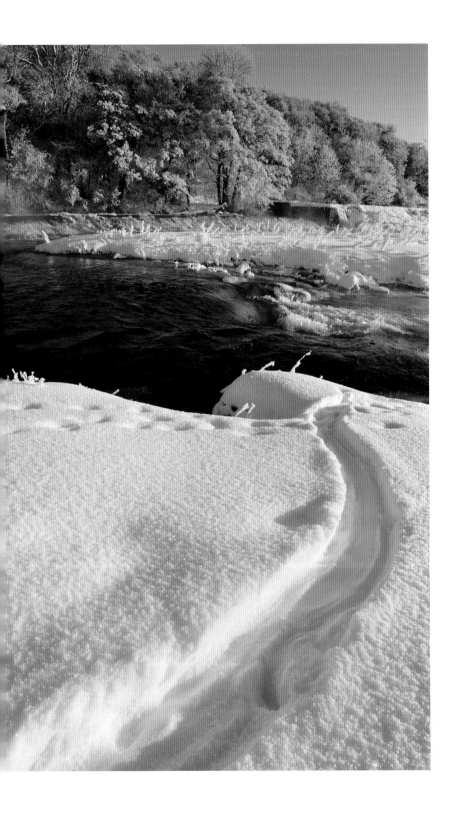

and fishermen, the regular comings and goings of people have become part of the otter's familiar landscape. Generations of otters were growing up in these sites accustomed to human presence, realising that nothing threatening was happening and so becoming less wary than their predecessors.

These changes in otter behaviour increased and enhanced the opportunities for photography. By a happy coincidence, photography itself was rapidly evolving through this time. Developments in digital photography created cameras that could record images in marginal lighting conditions, opening up a whole new range of possibilities for working further into either end of the day – just when the otters were active.

This serendipitous combination of changes in both subject and medium has assisted Laurie with his quest. And now, nearly 30 years since he first

LEFT Laurie watched for four consecutive days when he found this slide in the snow, but a shot of an otter sliding is still on his wish list.

OPPOSITE In the pre-digital days, Laurie would watch this holt for hours, longing for a head to pop out in this dreamy light, but it always did when too dark to photograph.

glimpsed an otter on the Tweed, he has amassed thousands of hours of otter watches and taken as many photographs. It's time for the pictures to tell their story – of these lithe, fierce, graceful carnivores claiming the river once more, of their mornings out fishing, their calls to their cubs and their tracks in the snow, of the plants and birdlife and other animals that are an inextricable part of their habitat, and of the morning mist and evening light that envelops their world.

Yet this work is not finished and never will be. Laurie will always want one more season, one more year, to capture another aspect of behaviour or to re-shoot a scene in a new light. He's got many more pictures in his mind's eye.

Some are scenes that he has witnessed but not yet managed to photograph; others are things he hasn't yet seen but knows they occur: an otter sliding in the snow; rolling itself dry inside a hollow log; or, that holy grail of wild otter photography – a *dry* otter!

The need to realise the pictures in his mind, to make them tangible, is what drives Laurie to get out of bed before four in the morning, or to stay up all night on the riverbank, or to hold out for one more hour on a bitterly cold winter's day. These images will continue to inspire and frustrate him, to distract him from whatever else he is working on and compel him time and time again to return to his home river.

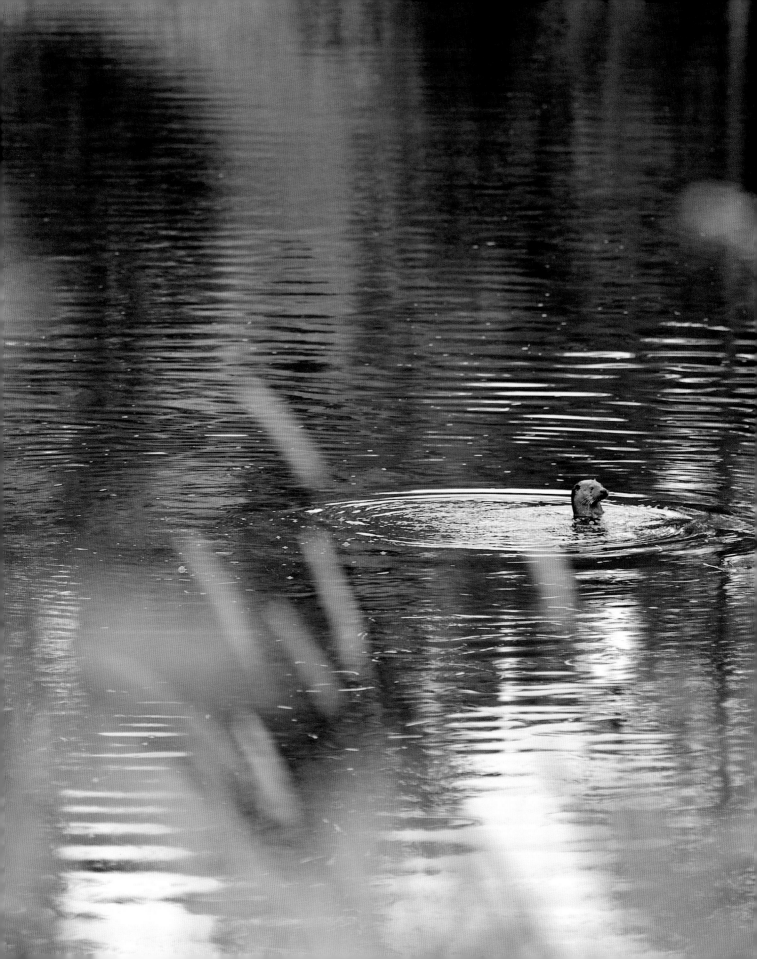

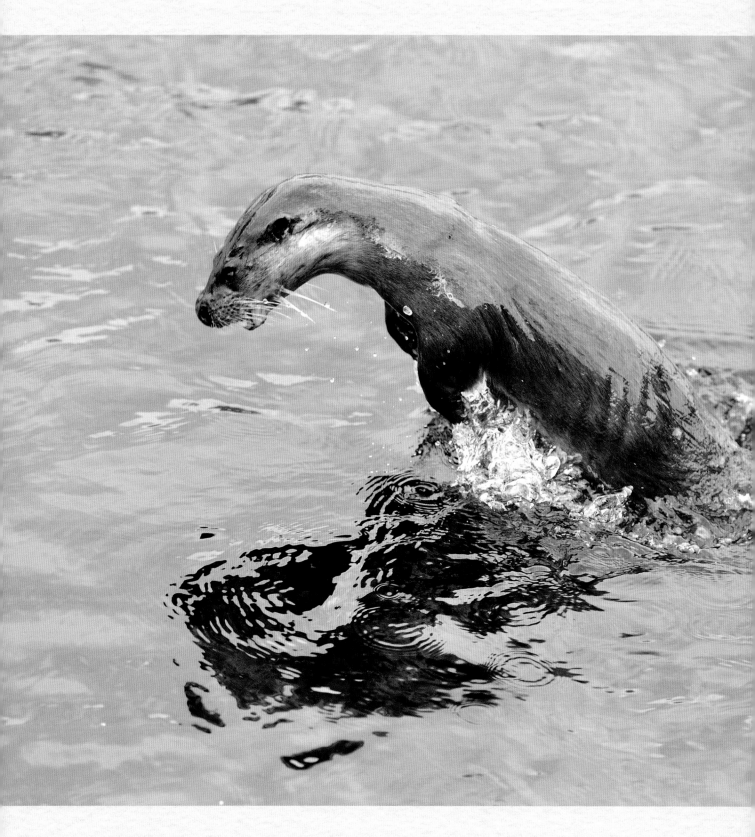

ABOVE 'Pouncing' through the water can be an efficient way to get down to the riverbed.
PREVIOUS PAGES In summer, otters can be harder to spot through the dense bank-side vegetation.

Glimpse

It's 6.30 a.m. and we're up on the bridge, gazing down at the great sweep of the river below. I peer through my binoculars at details: ducks and ripples, rocks and edges. Laurie crosses to the other side, stops suddenly, checks through his binoculars: 'Got one!' he says triumphantly.

I dash across the bridge but can only see rock and river below. Laurie points and I lift my binoculars, hardly daring to hope, but there it is . . . some distance away, tucked in against a small, rocky cliff by the river-bank . . . a brown head, then a splash. An otter! Then again, a brown head and a splash. It's porpoising, diving over and over again in the same spot.

We hurry across the bridge and down the verge at the side of the road, scrambling over the crash barrier to peer at the river below. The otter is lying in the water, a long brown back and long dark tail stretched out on the surface like a dog on a rug. It looks straight up at us and holds our gaze for a moment – then returns to its pouncing and div-ing, twisting its body and sliding into the water with a flourish of its elegant, tapered tail.

Sunbeams are playing in the river, brightening the rocks and making amber-coloured pools of light on the riverbed. There's a glimpse, a gleam of gold as the otter sleeks through a shaft of light and the sunlight catches its coat. We wait and watch and hope, Laurie's camera poised, but we don't see it surface. It's vanished.

We make our way down towards the river, where we can watch at water level from the shelter of the scrub on the rocky shore. Then we settle on a small, island-like spit, with a perfect angle over the cliff wall and the river tumbling over the rocks.

Laurie sets me the task of keeping my binoculars trained on the gaps in the rocks, looking for a wee whiskery face peeping out. Then he sets to work constructing a small stone wall as a makeshift hide, something to shelter behind in future visits to this vantage point. He works deliberately, selecting the stones, weighing them in his hands, placing them together with a calm expertise. For a moment, he's both a man on a mission and a boy on the beach.

It's 8.30 already and I'm aware of the steady crescendo of the noise of the day – cars zooming past, dogs barking – joining the constant voice of the chattering river. It's OK to talk here, says Laurie, there's plenty of other noise and the otters are accustomed to it. A handsome male goosander is lifted and rocked by the busy water, revealing its shining white belly as it is bounced down the rapids on a small weir. I'm scanning the gaps in the rocks, but there's still no sign of an ottery face.

We make for the angler's car

park, where the motorhome and kettle are waiting. But, on the way, we take a detour to check out the opposite river-bank. The patterns of light and shade and the wind direction determine which bank Laurie chooses to explore, but he has a hunch that our otter is living nearby – he's often seen one here at dawn or dusk, slipping in and out of the woody debris. Ducking under branches and stepping over fallen trees, we explore the shingle bank.

'There!' says Laurie, as if we've found hidden treasure. At the water's edge, near a tangle of driftwood and branches, there is a large mound of spraint on a rock, the moss burnt yellow all around it. This is more exciting to Laurie than a fleeting glimpse of an otter itself – spraint on this scale is not an otter passing by but a 'latrine' or otter toilet. It means the holt is close. Otters are living nearby.

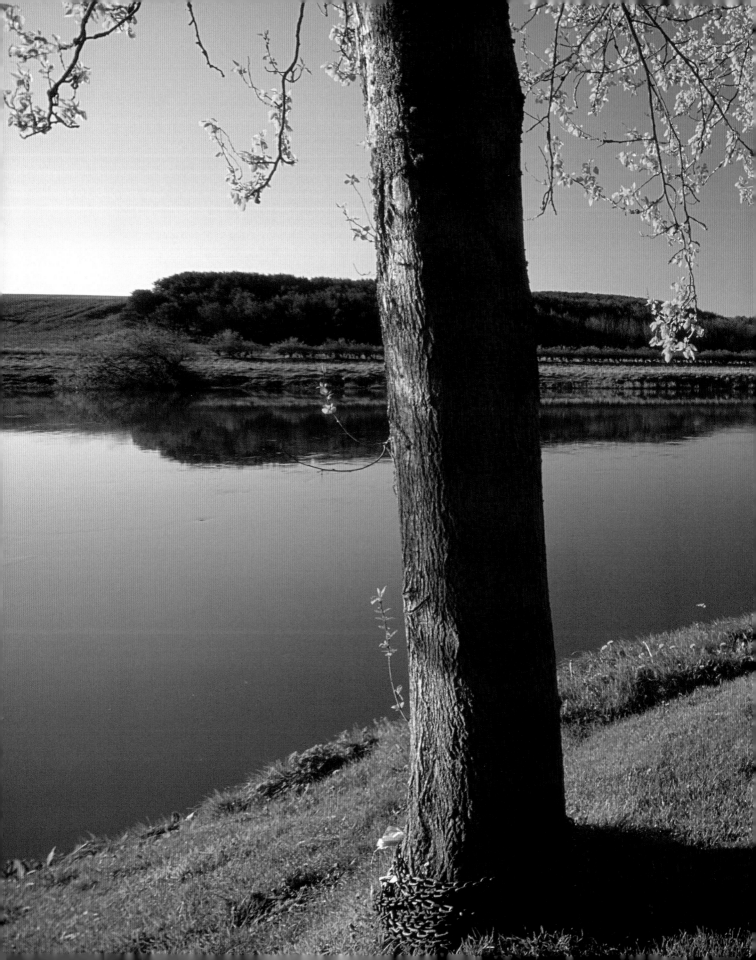

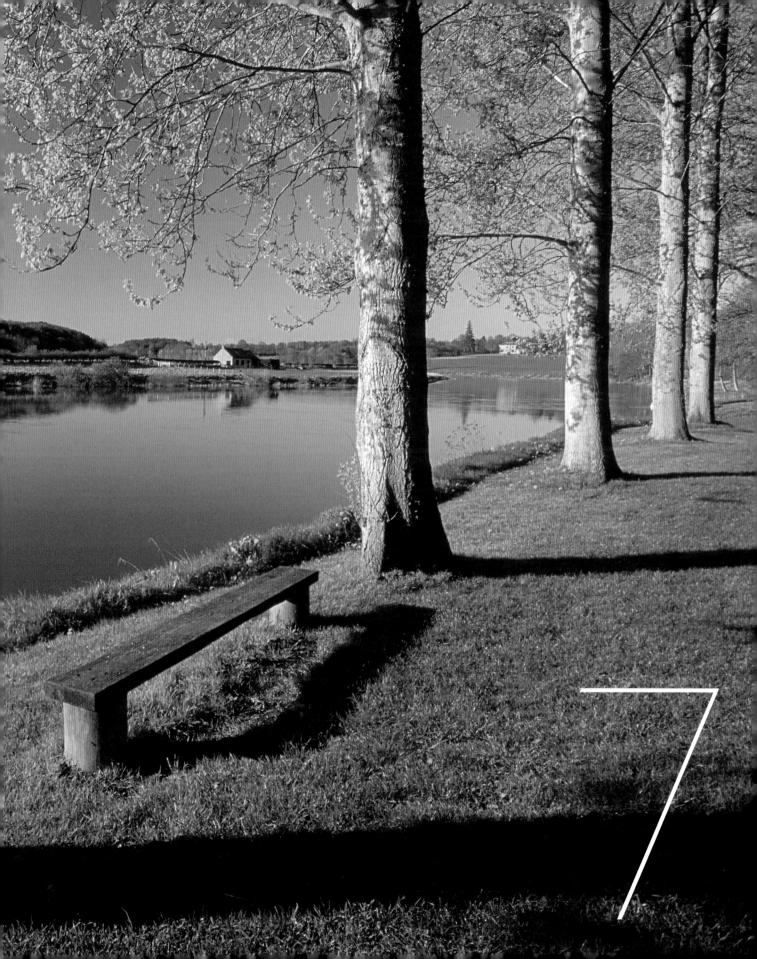

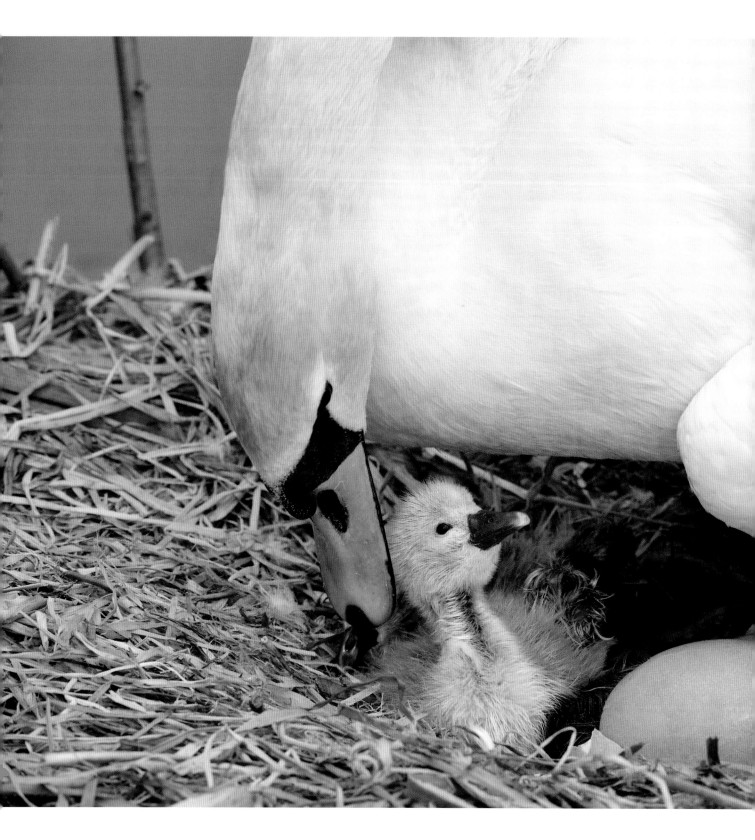

ABOVE Laurie spent 14 hours watching this entire brood of mute swans hatch.

PREVIOUS PAGES The water frontage at Paxton House Estate where the Tweed forms the border between Scotland and England.

SPRING

SPRING SUMMONS A RUSH of new life, bringing sounds, colours and vibrant activity to the river. As the days get longer and lighter, plant life takes off as if a race is starting, and the riverbanks are bright with the fresh greens of new growth.

There is new life among the otter families, too, with young cubs out and about, sticking close to their mothers as they learn to master their watery environment.

As well as a wide range of fish species, the otters are feeding on seasonal windfalls such as frogs, common toads, birds' eggs and ducklings.

It's a time of plenty for a nature photographer as well – a wealth of light and time after the short days of winter, and there is much to keep Laurie occupied as he watches and waits for otters. He often sees oystercatchers hanging around in pairs – they have moved inland from the coast some weeks before to stake their

claim on favoured breeding territories. The male mallards are noisy, squabbling and fighting over mates, then by late April, there are noticeably fewer female mallards on the river, as by then they're sitting on eggs. Willow catkins by the water attract the first bumblebees, and as the temperature rises, honeybees also become active and are drawn to this early source of nectar. The humming buzz of bees is a backdrop to spring days on the river, along with the sweet, melodious songs of summer migrants such as willow warblers and sedge warblers.

The tone of light changes through the spring, with the middle of the day becoming less 'useful' for photography. But the best of the light at the beginning and end of the day coincides well with the best time for watching animal behaviour, otters included, and for hearing birdsong.

It's a lovely time for photography, with the bank-side vegetation coming through. The new foliage and trees coming into leaf all create a backdrop of shiny new, vivid green. There's a tangible sense of optimism in the air and an opportunity to capture that feeling of promise.

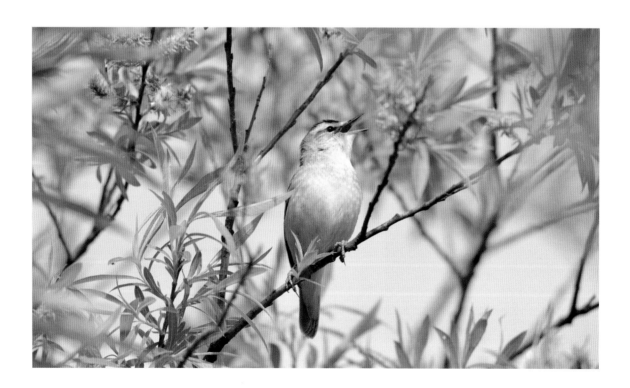

▲ YETHOLM LOCH The search for otters takes Laurie not just to rivers but also to inland wetlands. He has spent many a peaceful early morning here at Yetholm Loch, a small inland loch at the edge of the Cheviot Hills managed by the Scottish Wildlife Trust. It's a wonderfully tranquil spot worth visiting at any time of year – in autumn there are greylag and pink-footed geese flying in at dusk, and in springtime sedge warblers and reed buntings are singing away. He hasn't had a clear sighting of a water rail yet, but has heard them, and osprey sightings are increasing here, too.

There is an active logbook in the hide, which is invaluable for getting a sense of the recent activity of otters and other wildlife. Records of sightings of otters are invariably accompanied by exclamation marks! Checking the logbook is the first thing Laurie does when settling into the hide for a comfortable morning in this tranquil place.

▼ COMMON FROG Gathering to spawn in springtime a few weeks before the common toads, frogs also offer rich pickings for otters. Without the poisonous skin glands of common toads, frogs are a more palatable food source and so are taken by a wider range of predators, including foxes, grey herons and common buzzards.

Photographing close-ups of field signs can tell a story in a new way. Laurie enjoys capturing a few square inches of nature and presenting them in a way that makes people hesitate, look more closely and seek to

understand and appreciate.

For Laurie, frogs are symbolic of spring. They bring back childhood memories of going out with jam jars to collect

frogspawn (*pictured above*) and bringing it home to watch in rapt fascination as the transformation takes place from blobs to wriggling tadpoles to tiny frogs.

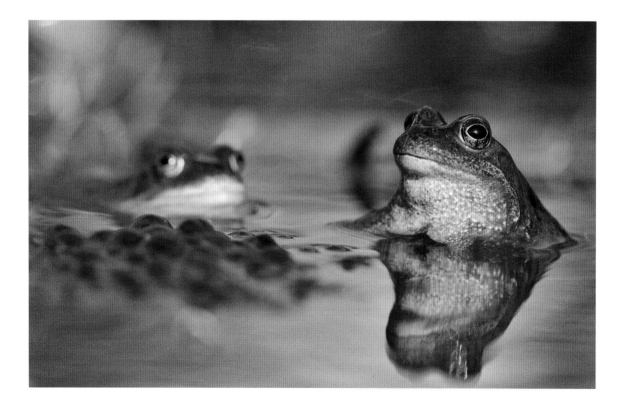

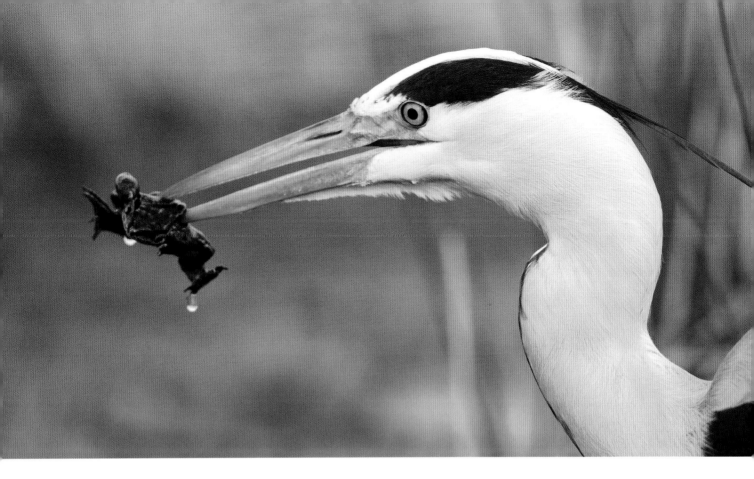

▲ GREY HERON There's a farm pond surrounded by boggy ground close to his home village where Laurie has established a semi-permanent wooden hide. Here he can photograph common snipe from autumn to spring. Over the years he's noticed that such important wetlands have become increasingly rare, as once wild corners are taken into production for intensive agriculture.

This pond contains a healthy population of amphibians, including great crested newts, which are nationally rare and so are protected. Laurie often stays overnight in his hide to avoid disturbing the snipe, and one morning he awoke to the sight of a grey heron snatching a common frog less than five metres away.

The farmer says he's seen otters running across nearby grass fields and straight through a paddock – much to the consternation and curiosity of the horses there – to get to this pond for its frogs.

▼ COMMON TOADS gather in large congregations for spawning, and otters – ever the opportunists – add them to their spring menu. Toads have poisonous skin glands around the head and neck, which deter most predators, but agile otters have found a way around this. The remains of toads that have been caught by otters reveal the otters' technique: they eat the hind legs but 'peel' them, leaving the toxic skin behind.

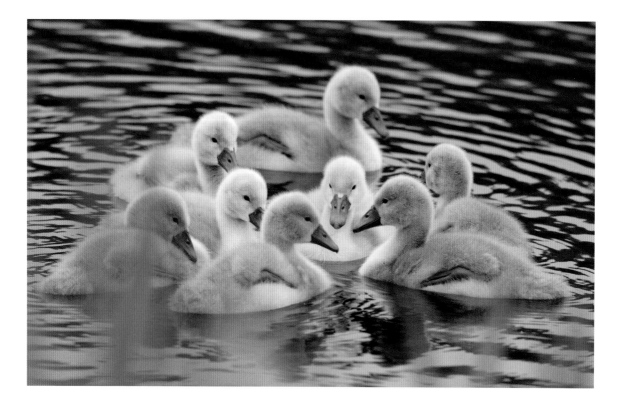

▲▶ MUTE SWAN Through the winter, the mute swans are quite sociable and remain together in groups. But in early spring, in preparation for nesting, they start to disperse, pairing off to select and defend breeding territories. They begin to build their large nests with rushes, grass and vegetation two to three weeks before the eggs are laid.

Having often watched water birds rear up and flap their wings dry after bathing, Laurie was ready to capture the moment when this 'off duty' swan lifted its wings in a ballet-like pose.

One May morning, Laurie set off early in search of otters. At this time of year, the dawn comes along before the night has had a chance to get dark, so he was up and settled by the loch at 4.30 a.m.

By seven o'clock, he still hadn't seen an otter and was ready to pack it in for the day and go home for breakfast. Then he came across a pair of mute swans on their nest; as he watched, the first egg cracked. The pen (female) became visibly excited as the first straggly cygnet slowly emerged. Laurie settled down to watch and wait

until another hatched . . . and then another . . .

It was late in the evening by the time all the eggs had hatched, and the eight fluffy cygnets had taken to the water; he'd been there 14 hours. He got by with a bottle of water, an apple and a Mars bar – 'breakfast' only came when he arrived home that night!

Laurie has been photographing the Tweed's famous herd of mute swans for many years, but this was the first time he had ever sat and watched a whole brood hatch out – a nice little section of a life story in a day.

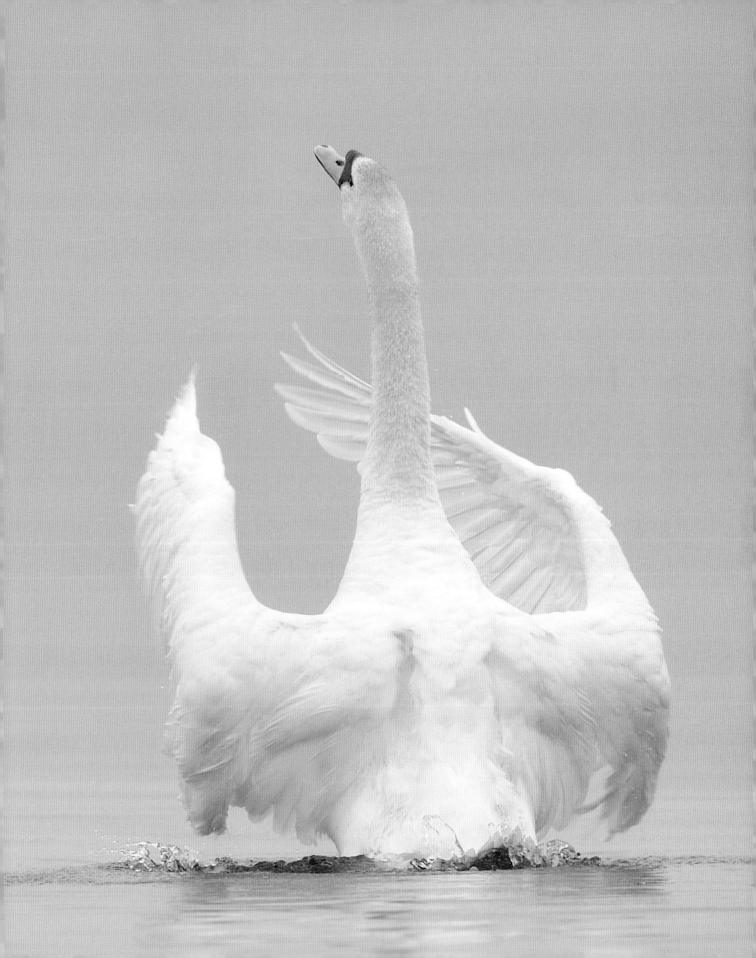

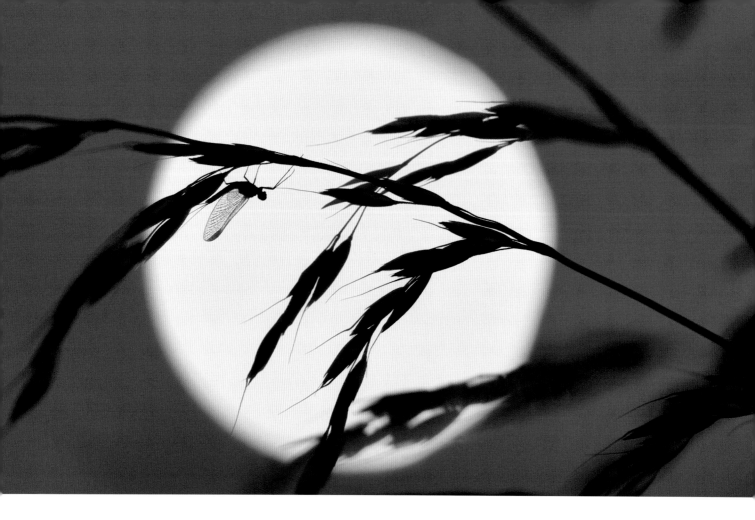

▲ MAYFLY Laurie's work involves being out at odd hours, which often means he encounters something unusual or unexpected – and he gets quite easily sidetracked. On this occasion, he noticed a mayfly had settled for the night on a single grass stem, so he stayed with it and ended up photographing it silhouetted against a rising full moon before retiring to sleep on the riverbank to await the dawn.

Sunny days in spring can result in a big hatch, and the air will suddenly be filled with mayflies, gnats and other invertebrates. This bounty provides plenty of food for bats and fledgling birds, and it's good news for the fish, too. It results in what fishermen call a 'rise' when fish feed at the surface. And, in turn, a healthy population of fish means good times for the otters.

▼ GREEN-VEINED WHITE BUTTERFLY Find cuckooflowers early in the morning to spot the green-veined white butterfly. These flowers thrive in damp grassland and provide a roost for adult butterflies, a place to lay their eggs, and a food plant for the caterpillars.

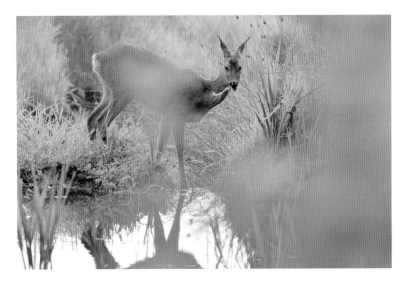

◄ ROE DEER Seen through the spring vegetation, this roe deer was feeding in the early morning down by the water where the damp ground offers the lushest vegetation. The bright tones of its early summer coat can be glimpsed. Roe deer change colour from a duller, grey-brown winter coat to warm chestnut red in summer.

► FLOWERING RUSH This detail of a flowering rush (*Butomus umbellatus*) shows what is a relatively common plant in the area, but Laurie sometimes wonders why people don't pause long enough to admire them and to notice the beauty in the detail of such wildflowers.

▼ HIMALAYAN BALSAM The thumbnail-sized beginnings of Himalayan balsam (*Impatiens glandulifera*) show how efficiently this invasive plant covers the ground. By midsummer, these can reach almost two metres in height, with clusters of deep pink flowers.

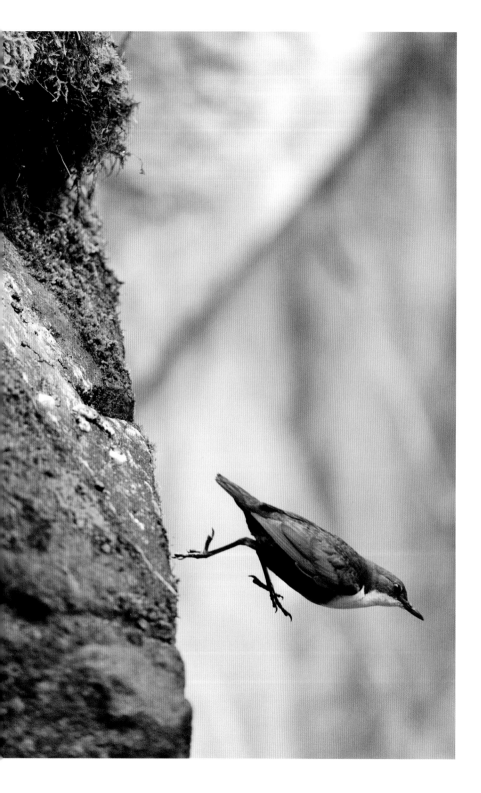

◄ DIPPER Dippers are often Laurie's companions on the smaller rivers, as he searches and waits for otters. They are handsome birds, sporting shining white bibs and dark brown backs. Dippers breed early, normally building nests in March, and have their first brood away by the end of April. He watched this one and its mate flying back and forth, feeding their young in a dome-shaped nest built on the abutment of a bridge.

They're present all year round, like the kingfishers, but whereas kingfisher numbers fluctuate, dropping drastically after hard winters, dippers are more resilient.

► MALLARDS A late brood of ducklings following their mum in single file: this was probably the full complement, but their numbers will diminish through the spring. Ducklings are vulnerable to many predators, including herons, crows (when they're on the shore) and otters. Otters do take adult ducks and other waterbirds, but they mostly target the young in spring and summer. They will sometimes take ducklings by swimming underneath and snatching them in the water, as well as by raiding nests.

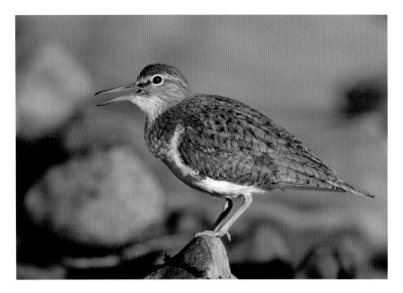

▶ COMMON SANDPIPER

The high-pitched piping call of common sandpipers is equivalent to the arrival of the first cuckoo and to Laurie it epitomises the sound of spring.

He once visited the Scottish naturalist John Morton Boyd, who was working on his autobiographical book *The Song of the Sandpiper*. They shared stories about their respective experiences in the Highlands and Boyd told of his field trips decades earlier, when he would sleep in the back of a Land Rover while surveying tracts of land to establish which areas ought to become Scotland's very first National Nature Reserves.

One of the things that he mentioned was that sandpipers seemed omnipresent, not just in Scotland but in so many other parts of the world as well. Boyd was widely travelled and sandpipers gave him a feeling of connection, as he'd hear that familiar call wherever he went.

Laurie only met him once, but often thinks about their meeting when he hears the sandpiper's distinctive call.

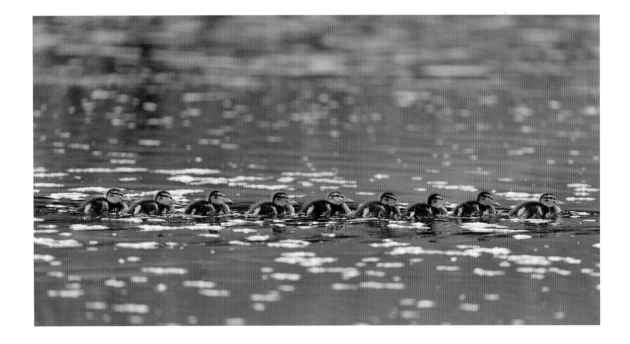

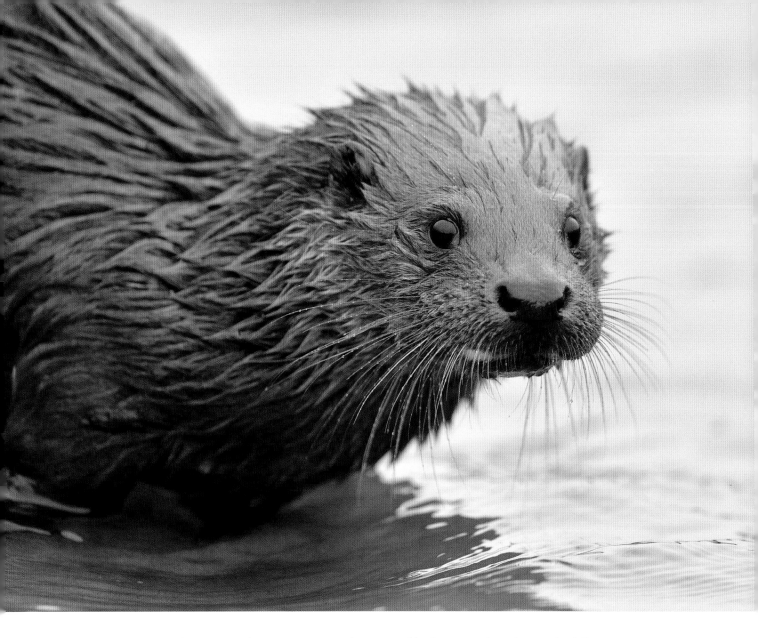

▲ **CLOSE-UP** This young cub popped up close to the riverside footpath where Laurie was sitting; it came closer than his lens would focus, and so he had to move back to take the photo. For a photographer, it's a lucky break to have such an unexpected close encounter, but Laurie adds a cautionary note: 'Young otter cubs can be curious and naïve, and badger cubs likewise. It's important to remember that they are still legally protected as 'dependent young', it's not just the holt that is protected but the cubs at this stage, and they must not be disturbed.

Field guides will tell you that otters can have young in any month of the year, but Laurie has observed a difference between those living in marine environments and those in freshwater habitats. Here, on the rivers, he has consistently seen the first young emerge in late February, whereas on the seashore in the West Highlands and the Hebrides, he has tended to see the first otter cubs late in the summer.

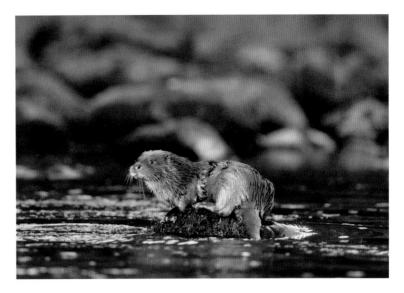

CUBS In both marine and river environments, the young otter cubs stay close to their mum and make a lot of noise when they get parted. The high-pitched peeping sound of cubs is almost incessant when they're small. There are times when Laurie has been out looking for otters and has found them purely through sound. Other times he has slept out on the riverbank and heard otters calling in the darkness, confirming the presence of cubs.

One morning he spotted this otter cub perched on a rock midstream. It was about half the length of its mother, who was fishing nearby. Whenever the mother disappeared from view for any length of time, the youngster would start calling until she appeared and edged closer to reassure it.

Laurie watched the pair for more than an hour until they retreated to their holt. He was watching from 20 metres away, and she knew he was there – but at this distance, she made no attempt to move the cub away.

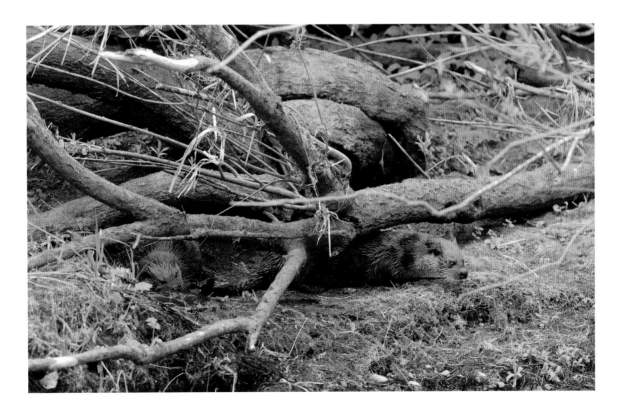

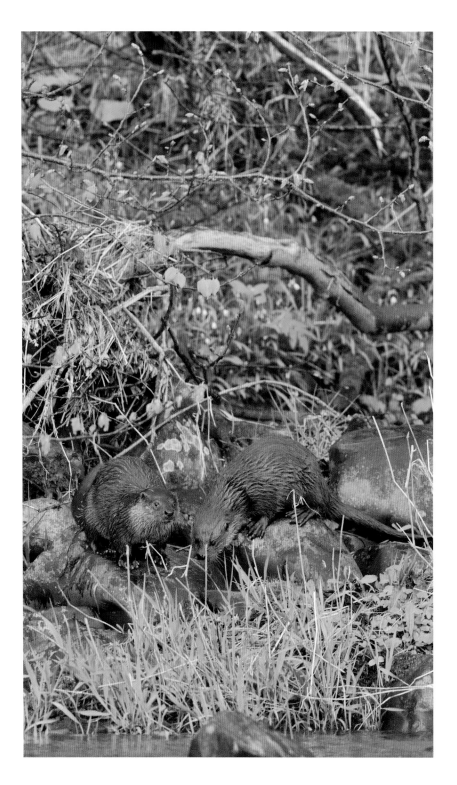

◄ **ON THE BANK**
An hour before sunset one overcast evening in early April, Laurie watched an otter family emerge from their island holt and head downstream. Once the mother got ahead, the cubs left the river and ran along the bank to catch up with her. They paused for a moment amongst the backdrop of three-cornered leek in flower before diving in to join her.

▶ **CALLING** This female was returning home to her calling cubs. Her whole body seemed intent on reaching them; she propelled herself forward, revealing a sleek outline of glossy muscle.

Female otters raise their cubs without the male, encouraging them into the water and staying close together as they venture out hunting. They will bring the cubs food until they learn to catch it themselves.

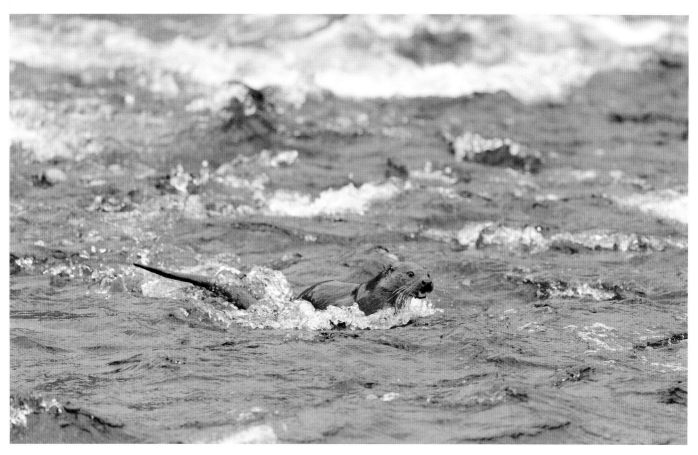

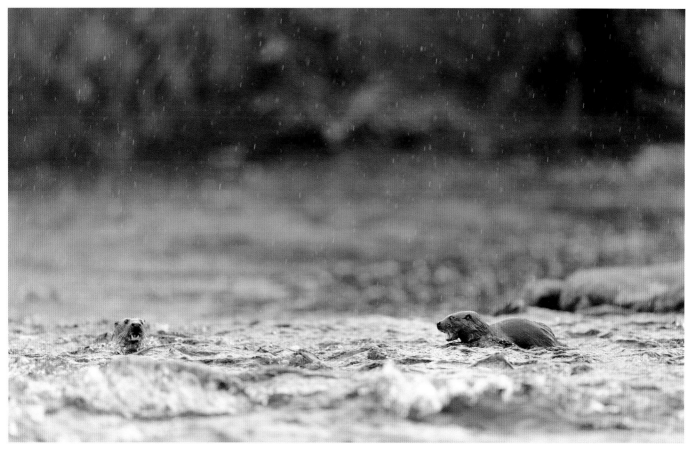

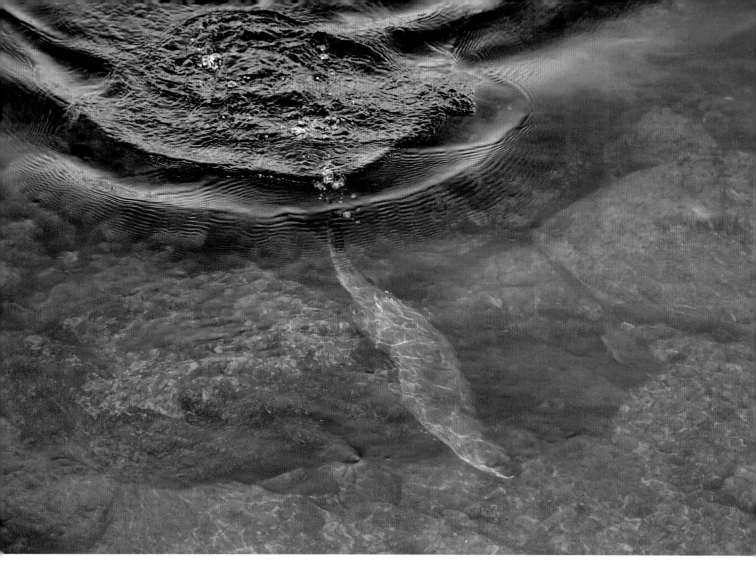

▲ SLIPSTREAM When Laurie is able to spend time regularly working on the river, he gets to know the pattern of the otters' daily movements and therefore has a starting point when he sets out to search the river. If he knows where the holt is, and sees otters going up the river, he knows they'll be coming back – what goes upstream must come down! He can then count them out and count them back in again.

This adult female was setting off from her holt one early May evening for a night's fishing and Laurie was leaning over the parapet of a bridge waiting for her. He watched her glide beneath the bridge, swimming through pools of sunlight on the rocky riverbed, her coat gleaming in the light.

Crisp sunlight doesn't offer the easiest of conditions for photographing a subject beneath the water, and he used a polarising filter on his camera's lens to remove the glare from the surface. Clean, clear water, long after rain, when the sediment has had time to settle and 'flush through', allows the best opportunity to photograph an otter underwater – a fitting way to show an animal so perfectly adapted for an aquatic life in its element.

▸ **MESSAGE** Otter spraint is an important signal to mark territory and communicate information. They are very deliberate about where they leave their spraint and spend quite some time investigating the scents of others. This site was a good fishing ground and so important territory.

▾ **CATCH** A young cub proudly coming ashore with its catch, probably a minnow. The mother will stay in sight as cubs start to fend for themselves and catch their first food.

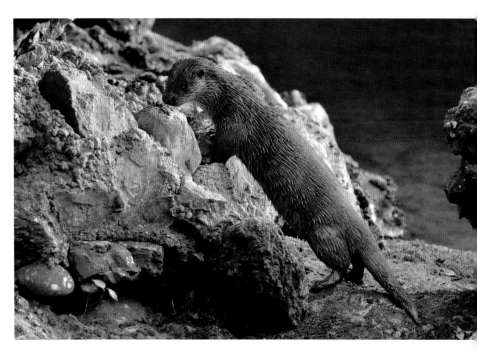

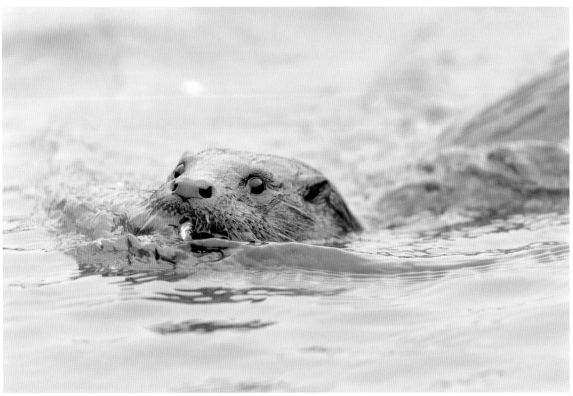

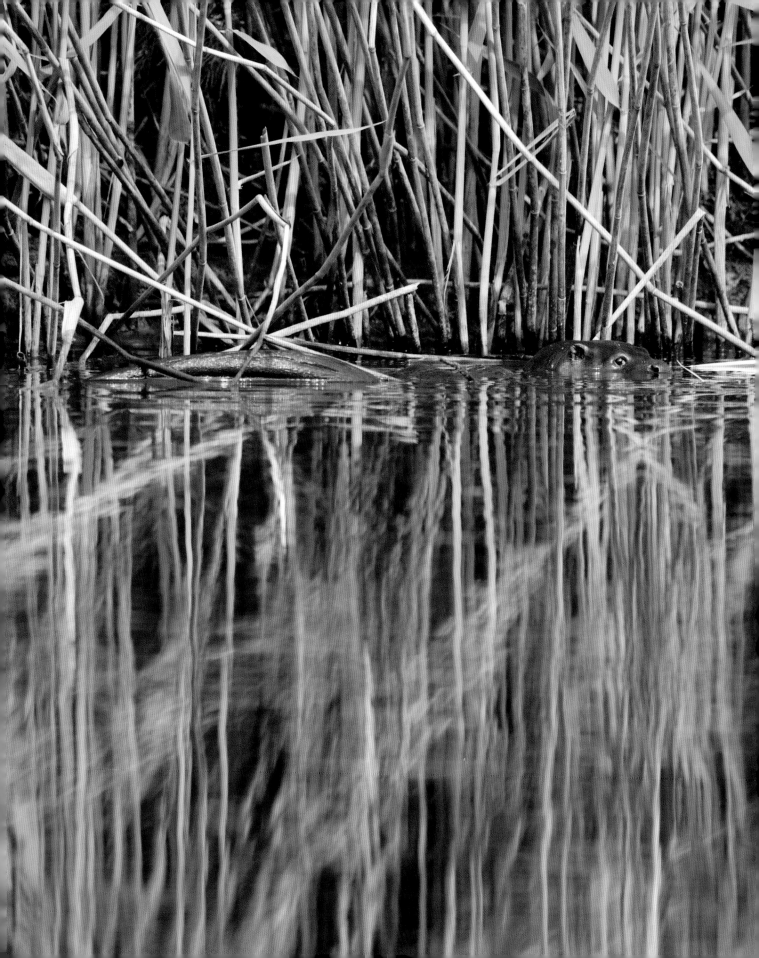

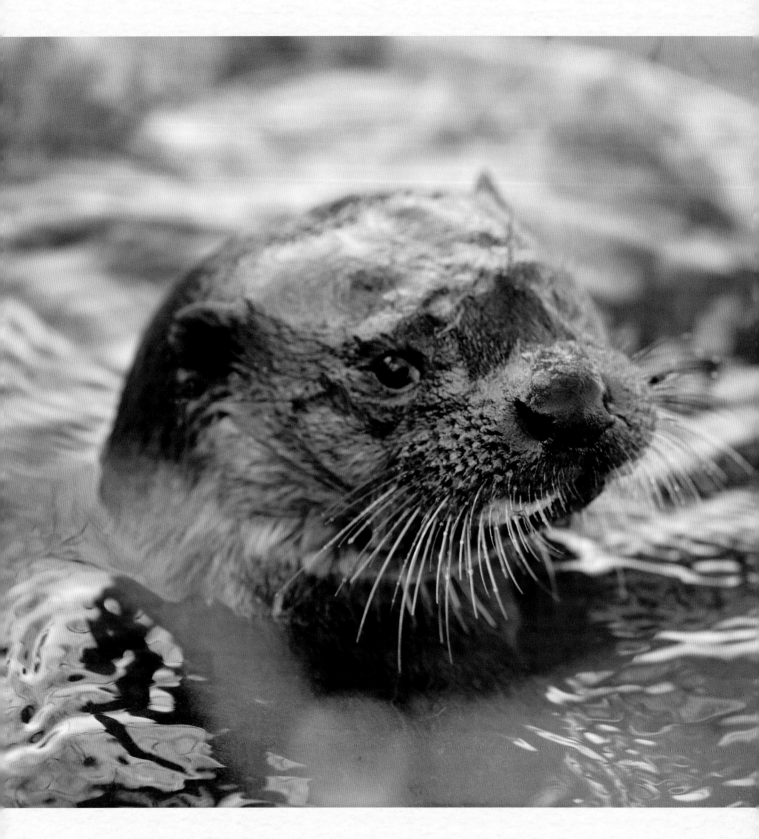

ABOVE Rummaging in the riverbed, this otter had stirred up a lot of sediment – hence the sandy nose.
PREVIOUS PAGES An otter lying low on the water's surface at the base of the reedbed.

Reeds

It's 6 a.m. and so bright already. I'd expected a softer tint of morning light, but the colours of the river and trees below me are all precise in the clear daylight. I'm waiting for Laurie on the bridge and scanning the river with my binoculars, looking for otter clues. He appears behind me, tripod over his shoulder, beanbag around his waist.

He's spent the night on the riverbank, falling asleep to the sound of the river rushing by, and waking at 4 a.m. to see an otter swimming past – a sleek head on the water, dark against the morning light on the surface. But the otter was heading downstream, travelling purposefully back to its holt. It could have done its fishing already and be heading home to sleep through the day. Laurie's looking worried. Is this early hour already too late?

We scan the river from both sides of the bridge, then set off to try our luck further along the riverside path, where sunlight is streaming through the trees. The vegetation is lush and thick along the banks, so dense you can't see through to the river, though you can hear its

constant babble. But there are gaps, like windows framed with green, and we stop and scan the river at each one.

I'd imagined that accompanying Laurie would involve long hours of sitting in silence, but mostly I'm trying to keep up; he covers a lot of ground with a long stride. For a guy who can spend 11 hours cramped in a tiny eagle hide on a cliff side, he seems barely able to sit still. He just pauses, crouches down sometimes, listens, scans, and then strides on. When you've 'got your eye in' to that extent, a glance is all it takes to detect an otter's head low on the water, or a trail of bubbles, or a sudden splash, to make the decision whether to wait and watch or to move on.

We move on, striding through the green corridor, spotlights of sunshine sneaking through the canopy and leaving quivering circles of light on the path as we walk. I'm resisting the urge to jump between them.

'See that otter?' Laurie has reached the next window. Then I see it, too. A tail, then a hump, then a raised lump of body, in and out of the rocks. A sleek, dark, fluid shape as if a bit of the river itself is moving along the bank. Then it loops and rolls and the long tail waves as it pushes down into the water. Then it vanishes. A mallard family comes pootling along, six young ducklings following each other, seeming unconcerned and with no sign of alarm or indication that there's a fierce predator close by. We wait and watch and Laurie scans his expert scan, but the otter has gone, utterly gone, leaving no trace, as if the otter were just a river spirit, taking form momentarily and then

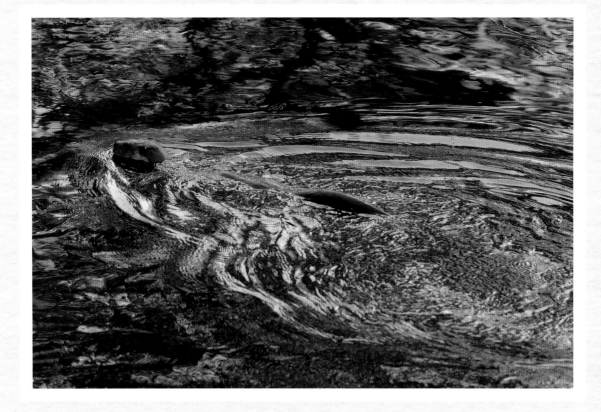

dissolving back into the water and becoming river again. Laurie points to a sparrowhawk overhead; it glints in the sunlight.

We move on upstream, hoping for a longer encounter and the opportunity to photograph it. We're changed by the glimpse of otter, uplifted now and walking alert and full of hope as we peer round each twist and turn in the river. The enchanted corridor opens out as we follow the river's gentle curves. Here willows are stretching over the water and the air is full of birdsong and river chatter. I start at sudden splashes midstream, but it's only fish jumping. You'd think otters would plop and splash, and fish would be silent and mysterious, and it makes me smile that it's the other way round.

Some miles upstream we reach a small weir. The river's very low here, dancing and bubbling around moss-covered rocks. Laurie says this is where he'd settle if he had the chance to spend 24 hours in one spot by the riverside. He'd had a successful encounter here the year before – had taken some of the best images – and the scene of such a meeting seems to hold its enchantment, the landscape imprinted with blessed memories. But it's past

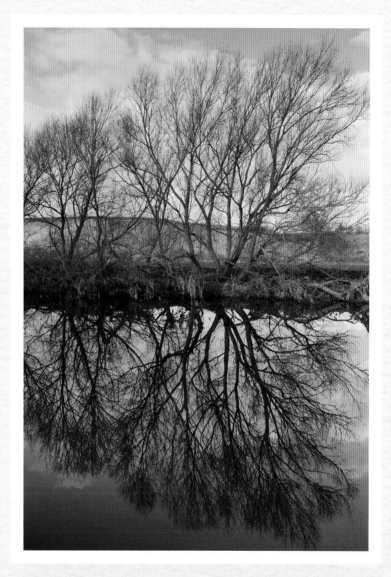

nine o'clock now, and the sun is bright and hot. We'll just linger for a moment, then call it a day, head back to the motorhome for breakfast and cups of tea and . . .

'There's an otter.' As if on cue. As Laurie says the words, he's already down on the ground, adjusting lenses, keeping low. I follow his gaze to the opposite bank, where the reeds are moving and twitching. Then I see it, almost flat in the river, just where the streaks of yellow and green reeds meet their reflections in the water. I can make out a head, a low

length of body and a long, flat tail floating like a twig on the surface.

There's a small path leading down through the long grass to the river, and we follow it and settle amongst the plants by the water's edge. While Laurie swiftly organises tripod, cameras and lenses, I watch through my binoculars. The otter rolls itself into the water, then comes bursting up; it has caught something and is chomping down on it, throwing its head back and opening its mouth wide and biting down. Then it rolls and loops again.

Laurie's got a fancy gadget, an eye-piece that attaches to the camera lens, effectively turning it into a powerful telescope. I take a look through it and gasp. The otter is astoundingly close. I can see its long whiskers . . . and its white dagger teeth as it bites . . . the spikes of fur on its head and the almost pinkish underside of its cream throat . . .

It rolls underwater, then the head erupts surprisingly far out of the water, then the body loops where the head was, then there's just a tail, which flicks and curves and waves, a lithe, eel-like creature with a life of its own. A head bursts up again, where the tail was. I wonder for a moment if there's more than one animal there.

It's rummaging – rummaging at the base of the reeds, some-times flicking stones up or dislodging bits of wood that float around on the surface. Then it surfaces with the fur on its face all muddy spikes. Then

dives and pounces again. We're trying to figure out what it's feeding on, something small, but it's difficult to see what. And we're trying to think of the word for when pigs do that kind of rummaging. Then we chuckle when we find it: truffling – such an undignified, un-ottery word for such a graceful creature, but still, our otter is truffling in the reed bed.

The reeds are a gift, holding our otter in the frame and keeping it diving on the same spot. I alternate between my binoculars and the naked eye, watching the brown shape bobbing and looping, the streaky, straw-like vertical layers of colour in the reeds, the yellow of the fields behind and the blue sky beyond that. When I lose sight of the otter for a moment, the reeds twitch obligingly to reveal where it is feeding.

A jogger in a cerise top comes pounding and panting along the path opposite us, oblivious to the wild animal hidden on the other side of the reed bed. The otter glances up but continues its chomping and looping and truffling, unconcerned by the thudding footsteps.

On and on and on it feeds and rummages, loops and swirls, turns and dives, bursts out of the water and twists back in

again, working its way slowly along the reeds. An hour passes by. It seems to know we're here, shoots the occasional glance in our direction, but is not troubled by our presence. We move downstream a bit to get ahead of it and into a good position to take photographs should it reach the end of the reed bed and decide to leave the water and come up onto the grassy bank – Laurie is still after photographs of a whole otter, as most of the time in the water you see just the top of the head and back and tail.

Then there's a human shout and a collie comes bounding down the path, barking. It hasn't seen the otter, just two

strange human forms crouching low in the long grass by the water's edge. It woofs at us, then gallops into the water, then doubles back to investigate us, all wet fur and wagging tail and hot breath.

An apologetic owner retrieves the dog and hauls it back. We look to the other bank, but our otter has vanished. We wait and watch for a while, but it's gone. We scan the river. The only movement is the water leaping and dancing over the weir and the sunlight playing on the surface.

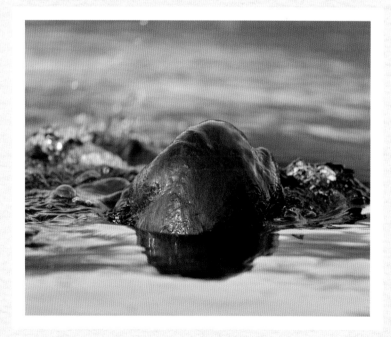

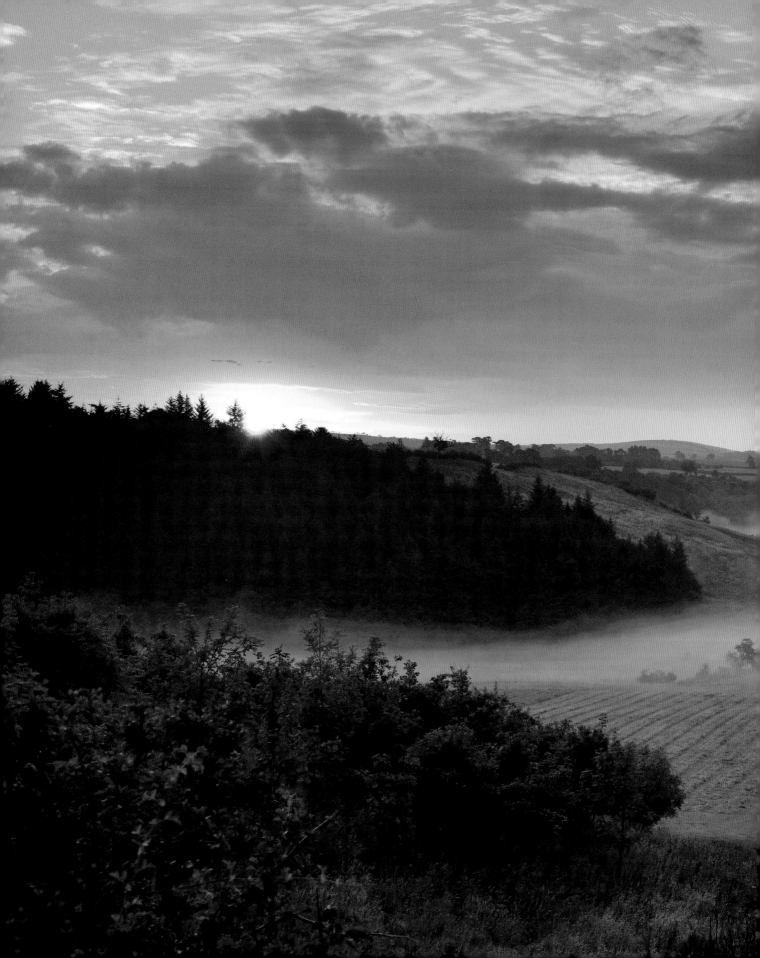

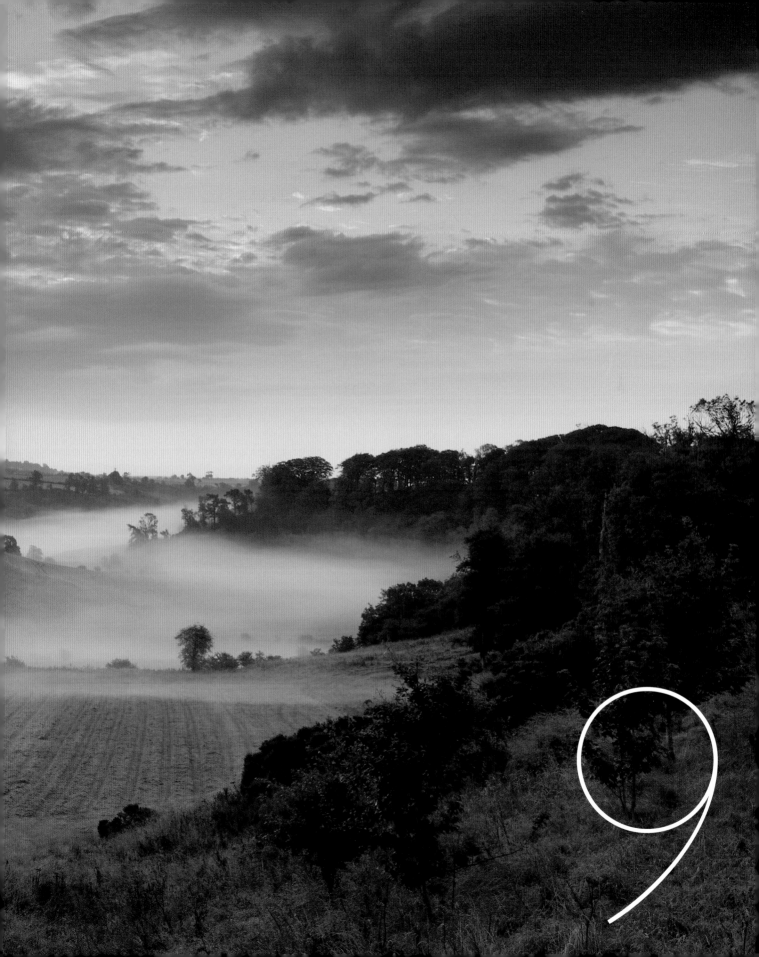

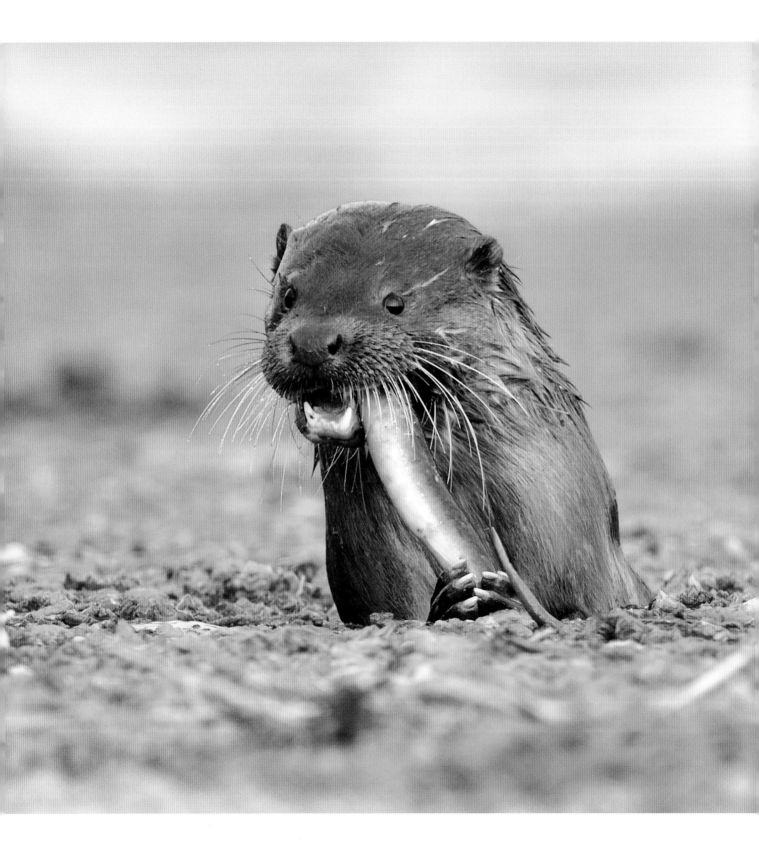

ABOVE Eels are a favourite food and a summer treat for otters.
PREVIOUS PAGES The magical effect of mist rising on the river is one of the rewards for getting up early to look for otters.

SUMMER

SUMMER IS THE SEASON when the plant kingdom claims the riverbank for itself, forming walls of brilliant green between the bank-side paths and the river. The trees are rich and resplendent, and beneath there's a vibrant jungle of comfreys, nettles and mints, with bursts of frothy meadowsweet, magenta spikes of purple loosestrife and the pinks of flowering rushes.

In some areas the large, invasive species dominate. Huge stands of Japanese knotweed, Himalayan balsam and giant hogweed can render parts of the riverbank virtually impenetrable in summer. This makes life difficult for walkers, anglers and nature photographers trying to get to the river, but I suspect that the dense shelter is ideal habitat for an otter to lie up in and safely snooze in peace. So the otters – out and about now, with growing cubs – are less dependent on their holts for shelter and 'bivvy out' more, making a couch in the vegetation by the riverside.

The birdlife on the river has calmed after the crescendo of spring, and it's quieter now, but people are out in force – there are ramblers and anglers, dog walkers and joggers on the bank-side paths.

The abundance of light in summer means the opportunities for otter spotting begin long before most people are awake and stretch long into the evenings. Dawn comes so early that Laurie often prefers to 'bivvy out' too, waking on the riverbank ready and waiting to catch otters in the early morning light.

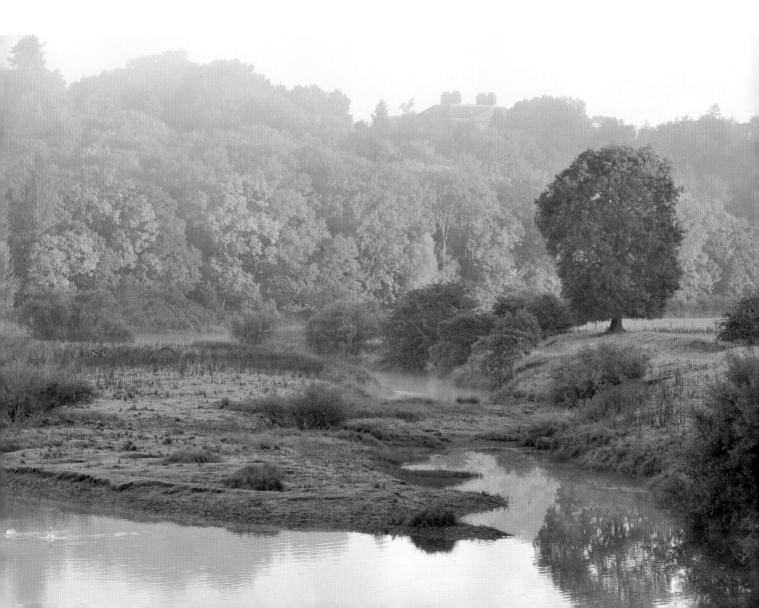

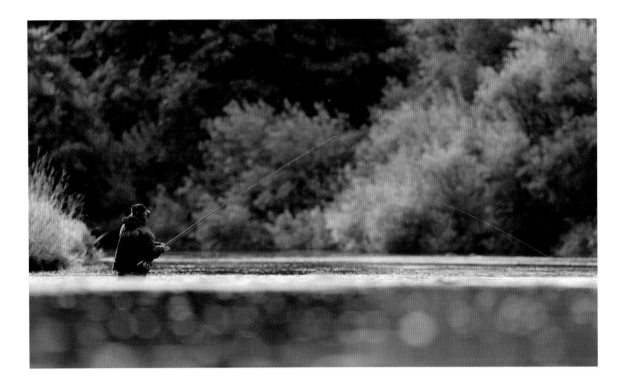

▲ ANGLER Laurie wanted to capture an otter's-eye view of an angler, portraying the sense of how people on the river are being watched and monitored by otters, even if they don't know the animals are there.

He gleans sighting tips from anyone who spends time on the water. As anglers are engaged in an activity that involves standing still in the river for long periods, they have a far greater chance of seeing otters than most dog walkers on the riverside paths.

There's a longstanding running battle between bailiffs and poachers on the Tweed, and to either side, Laurie could look like the opposition! So it's best that they both know what he's up to. They are good sources of otter information, both being out on the river at odd hours.

On Laurie's regular beat, anglers, walkers, bailiffs, poachers and dog walkers alike will go out of their way to update him about otter sightings and compare notes on what they have seen.

▲ RIVER WATER-CROWFOOT
This is the River Whiteadder, which stems from the Lammermuir Hills and swings round the village where Laurie lives on its way to meet the Tweed. He sees a lot of this plant, river water-crowfoot (*Ranunculus fluitans*), lying like long, green flowing streamers in the water, holding up its little white flowers to the sky. It needs clear, clean, oxygen-rich water, and so its presence can be an indicator of the health of the wider environment, like lichens in the western oakwoods. It provides food, cover and habitat for fish and invertebrate life, and it flourishes in healthy, shallow rivers. Laurie explains, 'I was standing in the middle of the Whiteadder in order to capture this, having taken off my boots, rolled up my trouser legs and paddled in – I've been caught out too many times, bending down to take a photo in the river and water flooding in over the top of my wellingtons.'

▶ KINGFISHER Laurie credits kingfishers with his transition from using black-and-white film to colour. Back in the early days, while still working at Edinburgh Zoo, he was home one weekend taking photographs of grey herons on the Tweed when a kingfisher landed on a perch right in front of him. Seeing its brilliant colours, he realised it just made no sense to photograph it in black and white.

These jewel-like birds are reasonably common on the Tweed – though, like barn owls, their numbers fluctuate depending on the severity of the winter. In very hard winters, when the smaller watercourses are frozen solid, Laurie has even seen them on the beach, feeding in rock pools.

You can't miss them once you've tuned in to their high-pitched, whistling call and their low, fast flight over the water – a flash of shining turquoise and bright orange. Laurie can find kingfishers quite reliably, as they will seek out particular fishing sites that meet their requirements: little quiet areas with slack water, out of the main current of the river – the kind of place you'd find shoals of minnows – and with a small branch hanging over the water to provide a perch.

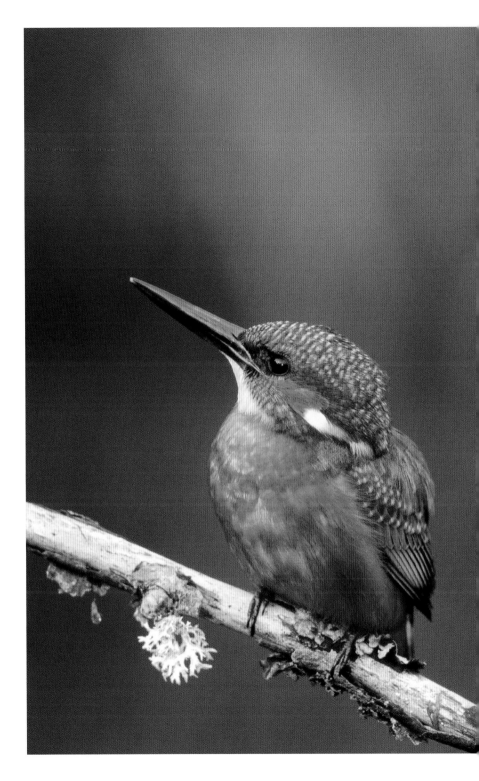

◀ RIVER FLORA Laurie is always alert to other photographic opportunities, including the diverse riverside flora. 'Looking closely at common plants on the riverside, I see forms that wouldn't look out of place in a book about rainforests. If someone asks me what I'm working on and I tell them I've spent hours immersed in photographing branched bur-reed, they don't sound too impressed. But to me that's the challenge – to make everyday things look interesting. I get concerned about people missing things and so it's my way of pointing things out, of sharing what I see – by looking at the details and presenting them in a way that shows the familiar as exotic.'
(*From top left:* branched bur-reed, monkey flower, yellow flag iris and giant hogweed.)

▼ GREAT DIVING BEETLE This species takes Laurie back to childhood days when he would spend his spare time visiting local ponds with a jam jar in hand in the hope of finding something exciting. These 3cm-long beetles were always a prized find.

'I've always loved exploring the small freshwater fish of the river, collecting stickle-backs and diving beetles. Looking beneath rocks underwater revealed a whole other world; I always wondered what else I'd find under the next rock. This was easier in the river than in ponds – the fresh flowing water would immediately rinse away any cloudy silt that had been disturbed by moving the stones. For me, it was like panning for gold.'

More recently, Laurie found otter spraint on the banks of the Tweed that contained the wing cases of great diving beetles.

▸ SNACKING Otters will land a big catch to feed but can eat smaller prey in the water. Laurie often watches otters feeding like this – they throw their heads back high out of the water and crunch down on their prey.

▾ FEAST This otter was hunting eels just below the railway bridge in Berwick-upon-Tweed. Crawling closer, commando-style across the mud beside the river channel, Laurie was able to photograph this otter trying to subdue its writhing, slippery prey.

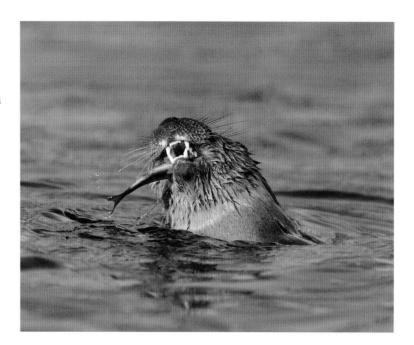

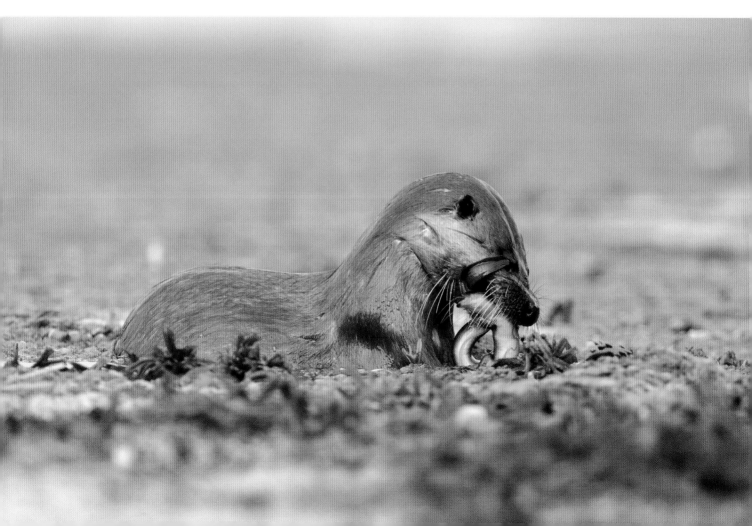

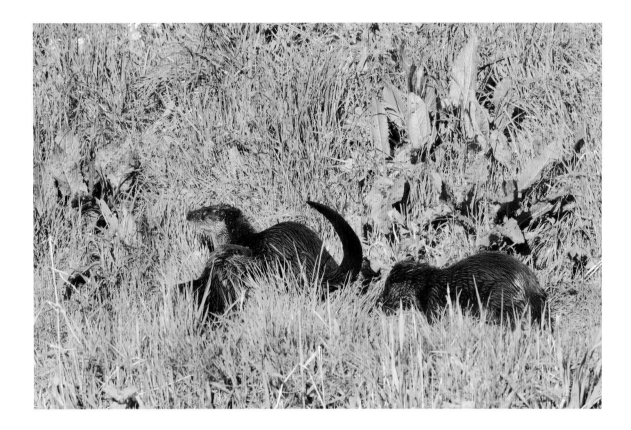

▲ FAMILY OUTING A family of otters out together in early summer, travelling along, alternating between the riverbank and the water. On the riverbank, the mother is lifting her tail and sprainting, the cubs following behind, learning how to patrol their territory.

By this time in the year, the cubs are far more confident: they're still out with Mum, but they're getting older and bolder and becoming more independent as they perfect their fishing skills. There's a lot less 'contact calling' between the mother and the cubs by this stage – the cubs will stray for quite a distance without any of them seeming worried.

ON THE MOVE (*overleaf*) Laurie watched this mother and cubs leaving their holt on a small island in the middle of the river. They set off to fish and seemed to be working as a group, all milling around the same areas. When water levels are low on the rivers, the otters will target small waterfalls and areas of rough water such as small weirs or where a rock shelf creates a step in the river. These areas seem more productive, and they probably find it easier to corner fish in such places.

It's ideal for photography too, with the energy of the moving water. Laurie was able to photograph the mother almost out of the water running over the rocky shelf and pausing there while she waited for the cubs to catch up.

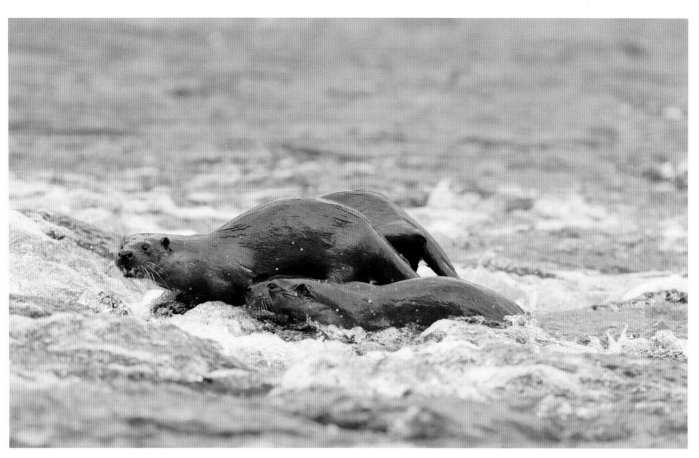
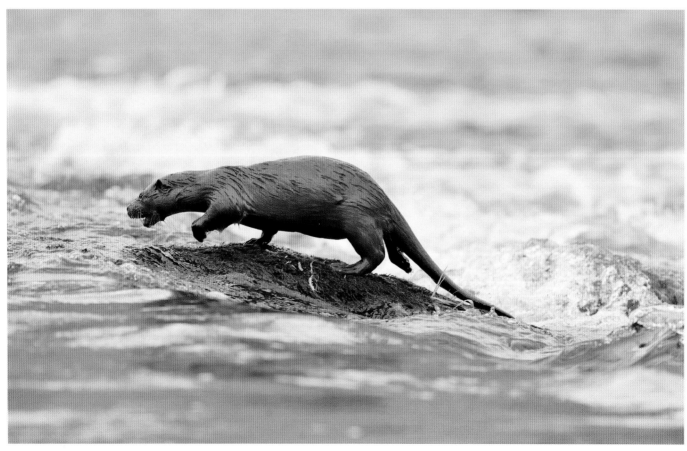

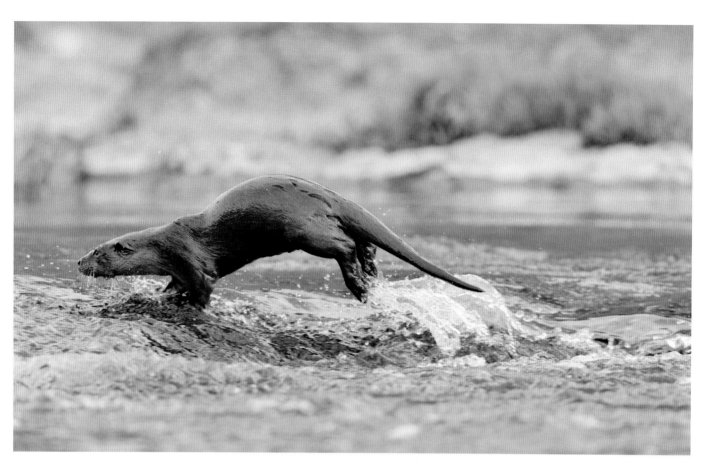

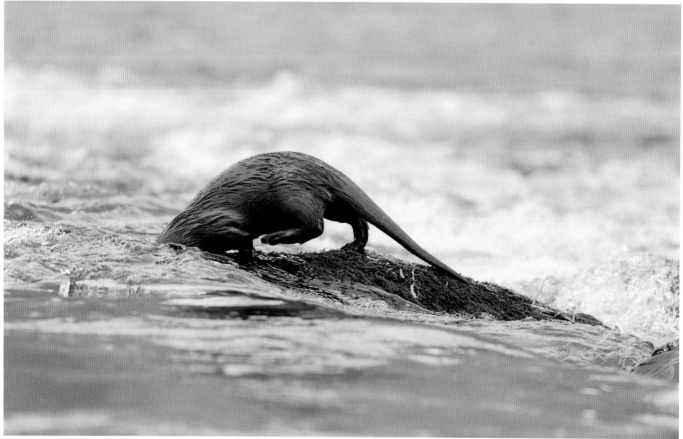

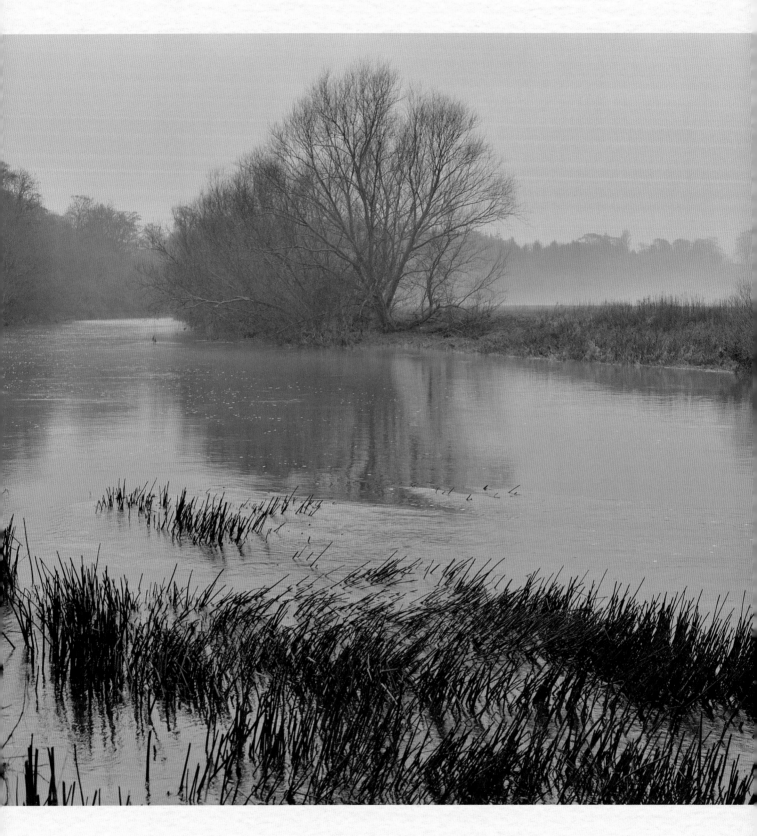

ABOVE Grey days may initially seem uninspiring but can actually beat sunny days for atmosphere.
PREVIOUS PAGES A magical light show created from raindrops on birch branches.

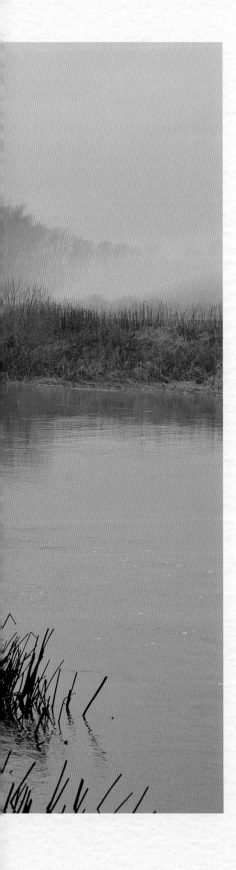

Rain

There's a smudge of silver on the wooden path beside the water. Just a gleam on the wet boards. Laurie stops and crouches down to examine it, like a hunter on a trail.

Fish scales, he says softly, explaining, almost in a whisper, that otters will devour small prey in the water but need to land a big fish to eat it. So any fishy remains suggest an otter's recent presence.

We walk on, following the wide curves of the Tweed along the riverside path, scanning the water and the banks for signs of otters. I notice yet again that Laurie sees more than the rest of us. Even when he's not holding a camera to his eye, he's looking at the world through a wide-angle lens, then homing in on the smallest detail. He takes in the whole span of the river at a glance, yet notices the dew on a spider's web. He points out a tunnel of flattened vegetation where otters have made their way along the riverside, and the nicks in the bank where they slip in and out of the water, and the heron on the opposite bank that takes off, lifting its bulk into the air with improbable grace.

The river is big and swollen, a wide expanse of rolling,

surging, brown water. And we're looking for a small brown head in it about the size of an orange. Laurie says how hard it is to spot them, that 'getting your eye in' is everything: look for something that goes against the grain, something different, like a movement or a sudden splash.

I'm looking. There is movement everywhere and sudden splashes all over the place! The river is taunting me, dancing over rocks that could be an otter's head, flicking up sticks that could be the tapered tip of an otter's tail.

Great big splashes of raindrops start to fall, leaving pockmarks on the water's surface. We take refuge in one of the fishermen's huts along the riverside and stand in silence at the entrance, watching the rain and the river outside.

I'm mesmerised by the body of water rushing past, the way it moves, and I'm throwing words around my head in an attempt to find one worthy of describing it. It strikes me that one of the reasons otters are so difficult to spot is that they're so like the river itself. Each word

I try fits otters, too: powerful, playful, muscular, twisting, turning, flowing, surging, splashing, rippling . . . as if otters are river incarnate.

There's a harsh 'krar krar' from the opposite bank. 'Did you hear that jay?' asks Laurie.

The rain is getting heavier. It's nearly 9 a.m. now, which is late in otter terms – they're likely to have fed and played and looped and curled and headed back to their holts by now. Slowly we make our way back along the wet riverbank, still willing the rolling water to yield up an otter.

It doesn't. Yet I'm feeling strangely elated, despite the rain and the longing for a cup of tea. I'm remembering that lovely title from the poet Alice Walker, *Horses Make a Landscape Look More Beautiful*. It's true. I work from an attic office and from my desk I can see a few distant fields over the rooftops. A tiny silhouette of a horse in the corner of a field lifts the whole view. And otters . . . they make the landscape more exhilarating. I can see the paths myself now, otter-width, flattened grass by the water's edge, closer to the river than our path. The riverbank feels alive, tingling with the promise of their presence.

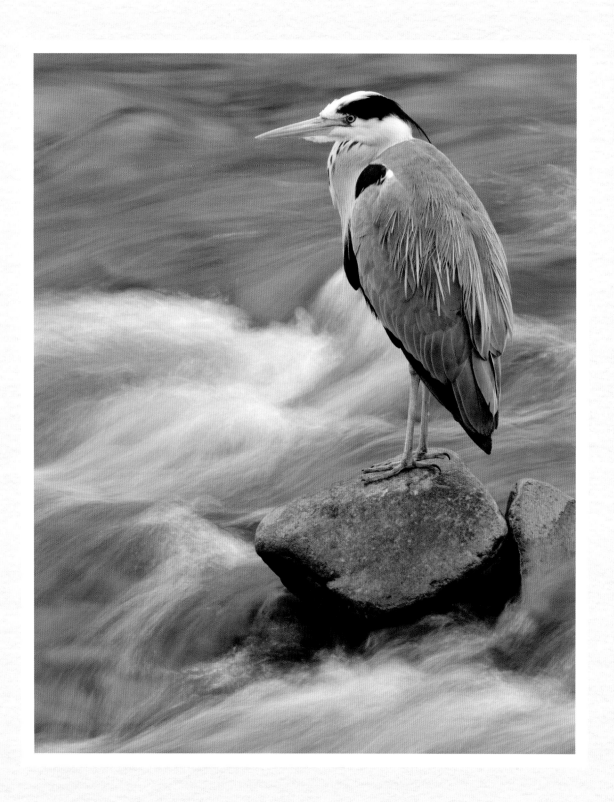

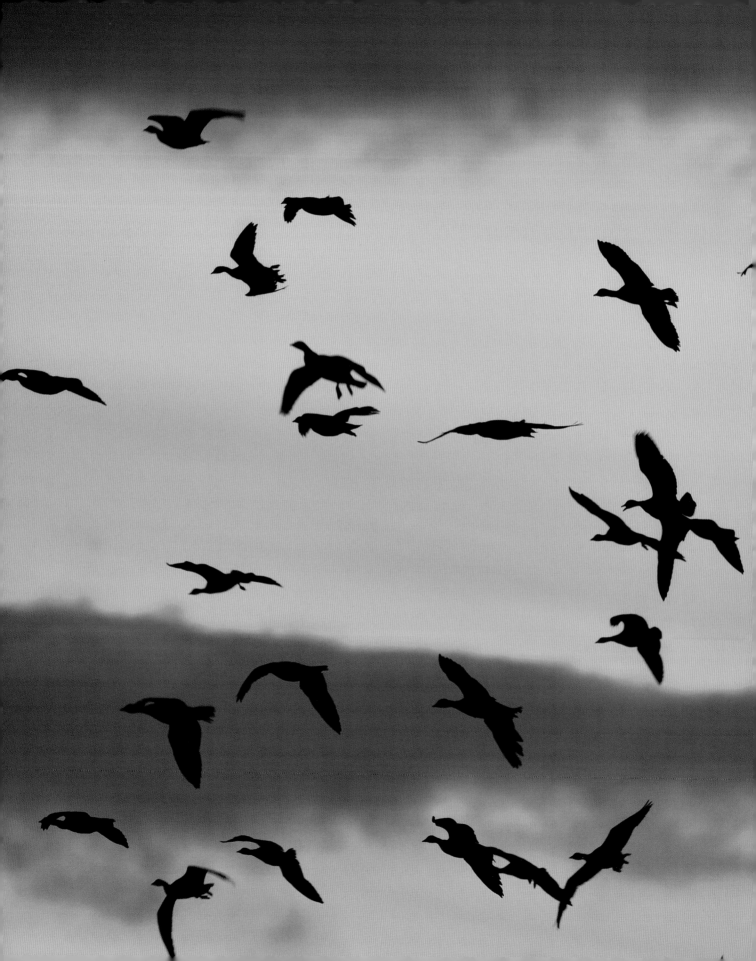

11

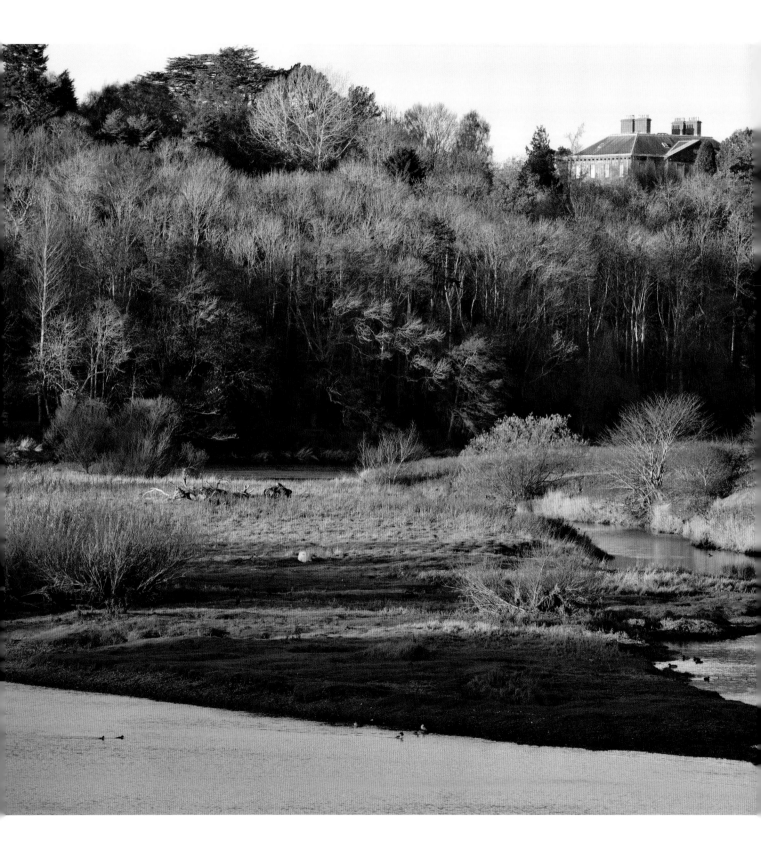

ABOVE Autumn light boosting the last of the autumn colour in the woods surrounding Paxton House.
PREVIOUS PAGES 'Whiffling' geese – tipping and dropping to hasten their descent from the sky to the water.

AUTUMN

THERE'S ALMOST an in-between season before autumn really happens: a quiet, damp, muddy limbo when the birds are looking tatty, and the plant life is dying away. The riverbanks are scented with a sweet mustiness from the decaying leaves of the butterbur.

It's easier to see wildlife on the river now, as the riotous summer growth is reduced to yellowing grasses, nettles and the last of the Himalayan balsam stands – trace your hands over their spring-loaded seed pods and they snap and leap with surprising velocity.

Then the temperature drops and everything lifts; there's a cool, clear, crispness in the air and the bank-side trees begin to blaze. It's a season of migrant birds returning, of dew hanging like jewels in spiders' webs and swirls of mist drifting over the morning river.

This is also the main season for salmon. The autumn rains trigger salmon runs that

draw people from all over the world to the River Tweed in pursuit of this 'king of fish'. It's also an ideal time to visit the Highlands and watch salmon leaping with the spectacular backdrop of autumn colour on the riverbanks. Though Atlantic salmon enter Scotland's rivers all year round, they push upstream in the autumn to return to their spawning grounds.

Laurie makes an annual pilgrimage at this time of year to a moor loch in the Lammermuir Hills to see the pink-footed geese arriving in their thousands at sunset.

Though the days are getting shorter, the light is more usable for photography throughout the day. With the sun low in the sky, the softer, oblique light adds greater depth, texture and richness of colour to the landscape.

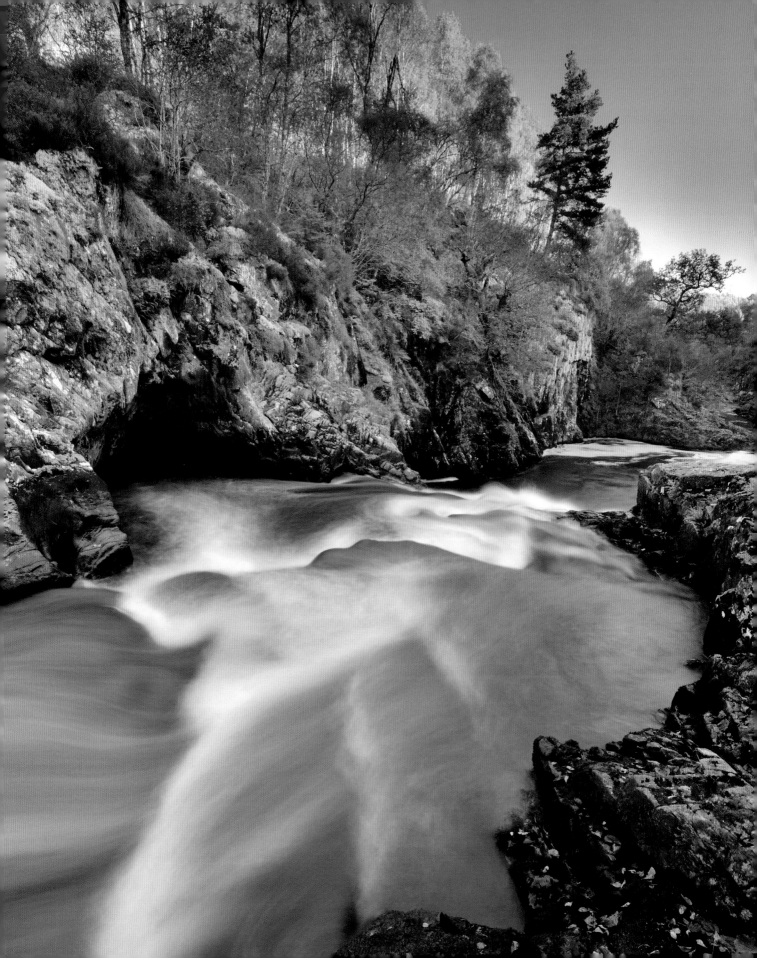

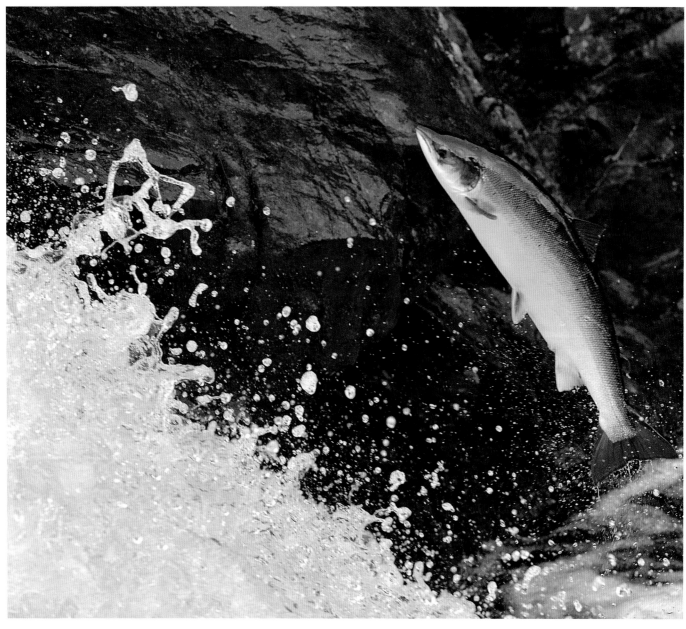

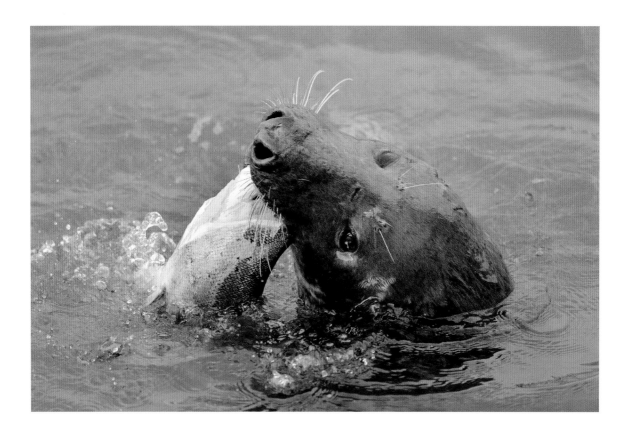

◄ ATLANTIC SALMON Salmon are central to life around the Tweed, to the wildlife in the river and to the local economy. It's said that each fish is worth several hundred pounds to the area in terms of tourism, hotels, restaurants and shops, as well as ghillies and others directly involved with angling.

Otters will go after salmon at every stage in their life, from small parr to huge fish. Fully grown salmon are capable of getting away from an otter, and Laurie has seen some writhing, slippery fights between them!

Poaching is a serious issue around in the area. It's no longer a question of an individual taking 'one for the pot' but big business. There is a sinister side to it, with violent clashes between poachers and bailiffs. Fine, monofilament nets are commonly used, occasionally entrapping and drowning otters and water birds alike. Sometimes poisonous chemicals are used, which affect everything else in the water as well.

▲ GREY SEAL In autumn, Laurie begins to see grey seals coming quite far up the river. The Tweed is tidal for about the first nine miles, and the seals come in with the tide, feeding on the salmon, especially in the deeper pools. This is perhaps a controversial image, as the fingers are pointed at seals for declining salmon stocks. Still, Laurie believes that salmon numbers are affected by far more complex, wider environmental issues throughout the salmon's long journeys from river to sea and back again.

▲ GOLDENEYE The River Tweed is a nationally important site for goldeneye, hosting a significant over-wintering population of these neat, endearing little ducks. They can be seen in larger numbers in the lower reaches of the river, and the whistling sound from their wing beats can be heard when they take off as a flock. They disperse through the winter along the river, but a hardcore remains near the estuary. There are small populations now resident all year round in the Scottish Highlands, but the goldeneye on the Tweed breed in the boreal forests of Scandinavia. Laurie says, 'There's an intrigue about migratory birds; I can only imagine what they've seen or had to contend with – maybe wolverines and bears? The stories they could tell . . .'

▼▶ WHOOPER SWAN Like wintering geese, whooper swans also spend their autumn and winter in the area. They roost at night on the quieter waters of the Tweed and its islands, and frequently stay in family groups. They feel safe from predators in such places, which is probably more of an issue in their northern homelands than here. These birds come from wild areas of Iceland, northern Scandinavia and Russia. They are very wary compared to the Tweed's resident mute swans and can be as difficult as golden eagles to work with. They always seem to have one or two individuals on lookout while the rest are feeding or roosting. Watching through a telescope from two or three hundred metres away, Laurie can tell by their body language when he's too close – one false move and they're away.

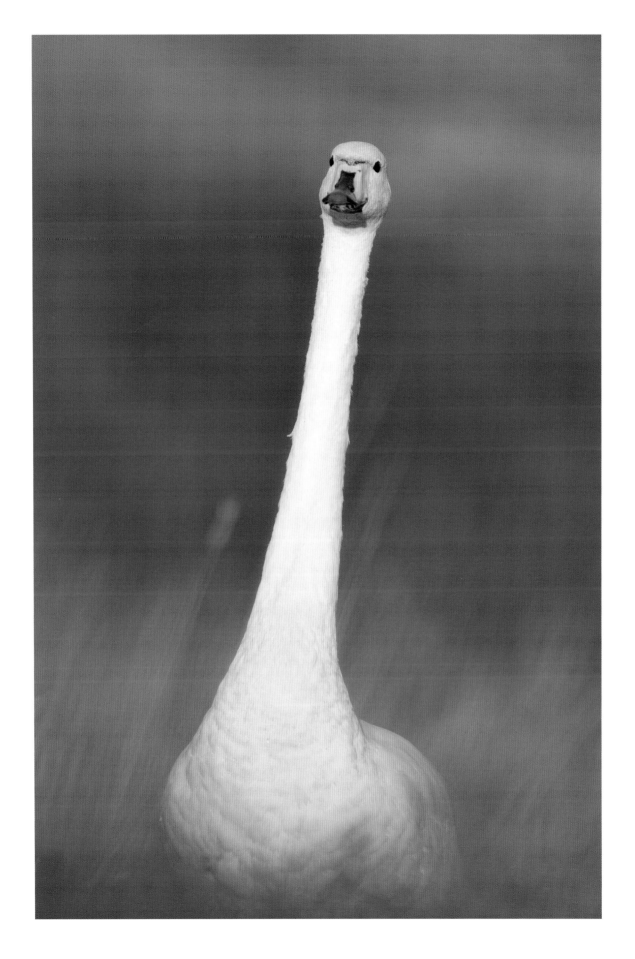

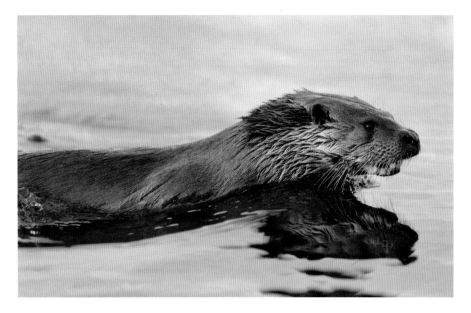

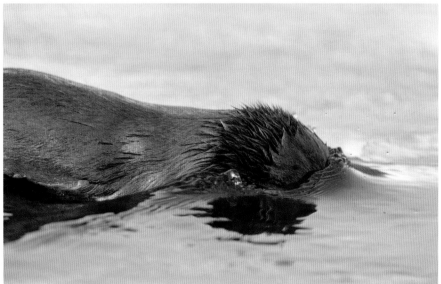

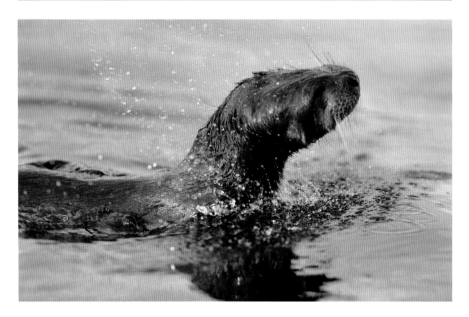

◄ **FORAGING** Laurie spotted this juvenile otter out foraging, working its way along the side of a river, parallel to the bank, so he was able to keep up with it and follow it for more than an hour. Occasional joggers and dog walkers would come along the path where he was working. Laurie remarks, 'Sometimes people see an otter and stand there pointing or holding their mobile phone up to photograph it! They often don't appreciate what a difference it would make if they crouched down to watch, still and silent. They would see so much more. So the otter would disappear when people came by, but not for long. It just retreated for a while and if I gave it a bit of time and could work out its direction of travel, I could usually pick it up again.

The river was really clear this day and the otter was behaving like a goosander, swimming along with its head dipped in the water; goosanders will go for quite a distance like that. This otter wasn't diving – the water was quite shallow – it was just swimming along, looking underwater for prey.'

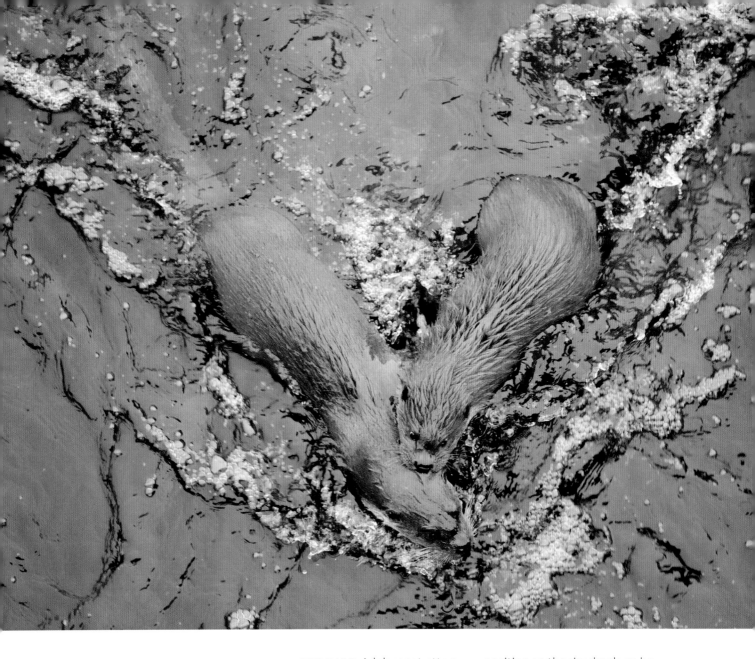

▲ SIBLINGS Adolescent otters will 'hang out' together for a while before leaving to find territories of their own. Laurie was familiar with this pair of juveniles, and he knew that as dusk fell, they would be heading upstream for a night's fishing. On this evening, the prevailing wind precluded his normal position on the riverbank, so he settled for a vantage point on a bridge well above their noses. Like many animals, otters rarely look up, so he could watch undetected for longer periods, enabling him to enjoy these siblings twisting and looping around each other, playfighting directly beneath him.

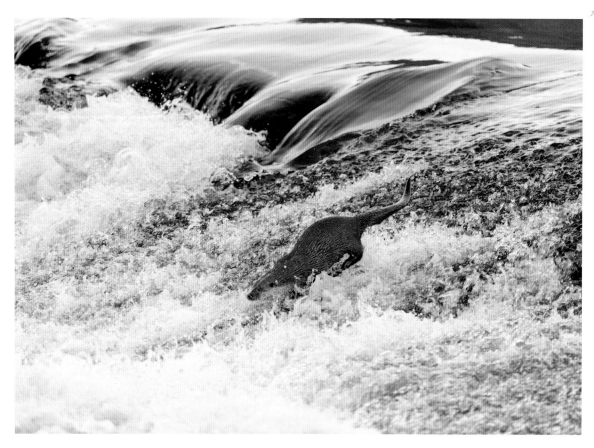

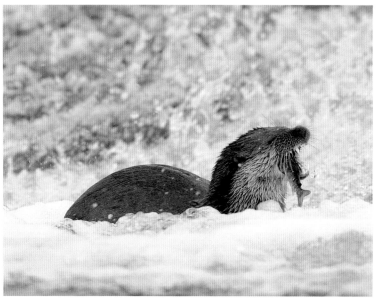

▲◄ **WEIR** Laurie discovered a favoured feeding site on a pool beneath a weir that had once powered one of the many oat mills on the Whiteadder, a tributary of the Tweed. He says, 'I'd been in place behind a tree trunk since the very early morning when this otter came down the weir and then snatched a brown trout and ate it against the attractive backdrop of cascading water. I stayed and watched as it hunted on, feeding on several other trout before disappearing downstream.'

▼ IN THE FLOW Laurie had been watching this otter fishing on the weir for some time and wanted to capture an image of it descending through the rushing water. It shows something of the otter's strength and ease: there was a pretty forceful current, yet the otter was able to go in and pause and rummage around. However, there was just a grazed grass field beside the weir, with no bank-side cover to hide behind or to disguise Laurie's silhouette, so it required some strategic planning.

Laurie says, 'I identified the spot I wanted to work from in order to get close-ups of the otter in the weir and began to gather bits and pieces of woody debris from the river and build it up into a small pile there. Over the following days I watched from a distance to see how the otter would react. It noticed immediately and would keep glancing at the suspicious new shape on the skyline. It took a couple of weeks until the otter accepted it, after which I developed a technique where I would run forward when the otter was underwater and throw myself down behind the heap and poke the camera lens over the top. It only worked this once – many other times I saw the otter but didn't have time to get myself into position and the otter would be over the weir in a flash. But this time something caused it to pause for just long enough and I got the series of pictures I wanted.'

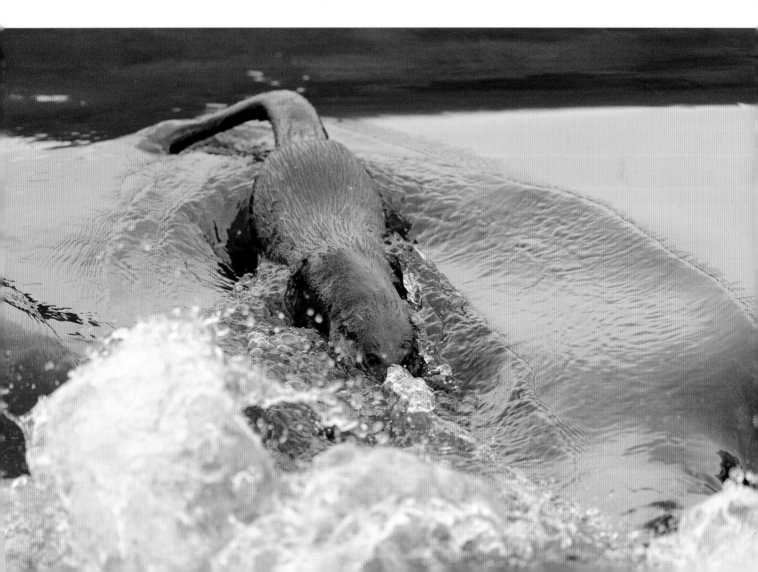

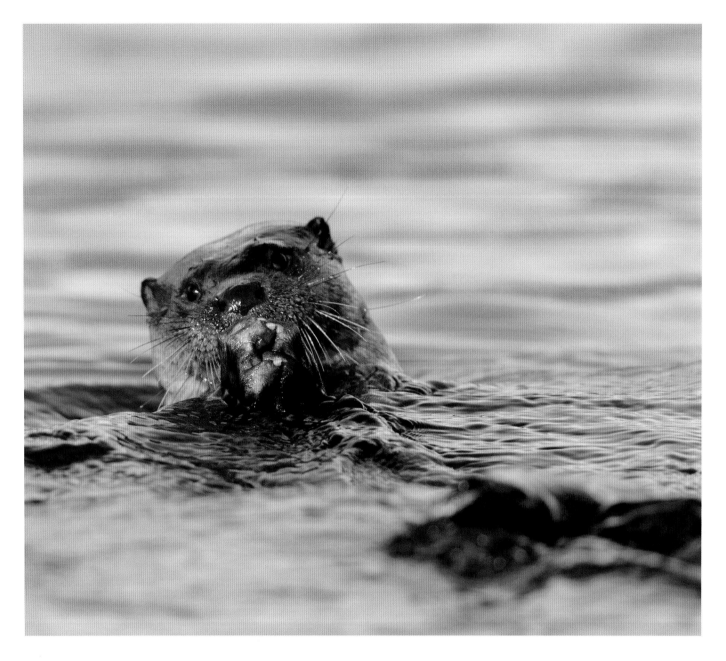

▲ **CLASP** This was the same occasion as the juvenile otter that was browsing goosanderstyle with its head underwater (*page 130*). At one point, it surfaced and lay on its back, holding its prey in its front paws. Laurie has rarely photographed this behaviour and says, 'It's a posture normally associated with the sea otters in the Californian kelp forests. I wondered what it was eating that it had to hold it in this way while it dealt with it. It was impossible to tell as whatever it had caught was tightly clasped in its 'hands'.

Otters on the rivers have a very varied diet, with prey items changing through the seasons.

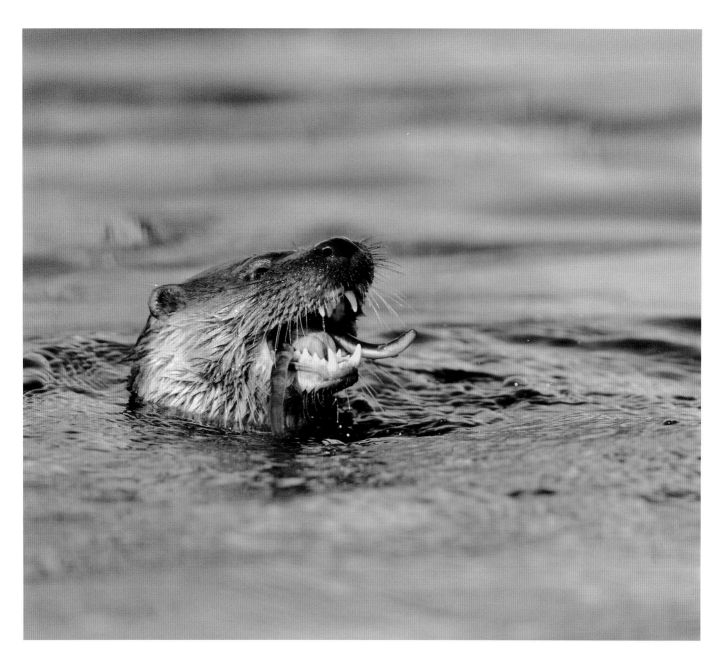

▲ EEL Revealing its impressive canine teeth, this young otter surfaced to chomp on a young eel. Eels are an important food source for UK otters. At this stage in their life cycle, eels are sometimes known as 'yellow eels' because of the colour of their underside. Like salmon, they come into the Tweed and make their way upstream through the river system. They'll negotiate whatever is in their way, such as rocks or waterfalls, even slithering over land, if necessary. But eels are in the river to feed, not to spawn – European eels don't reproduce in Europe, but far across the Atlantic in the Sargasso Sea, and they drift across the ocean as tiny larvae.

Eels have declined drastically in recent years and their conservation status is listed as critically endangered.

12

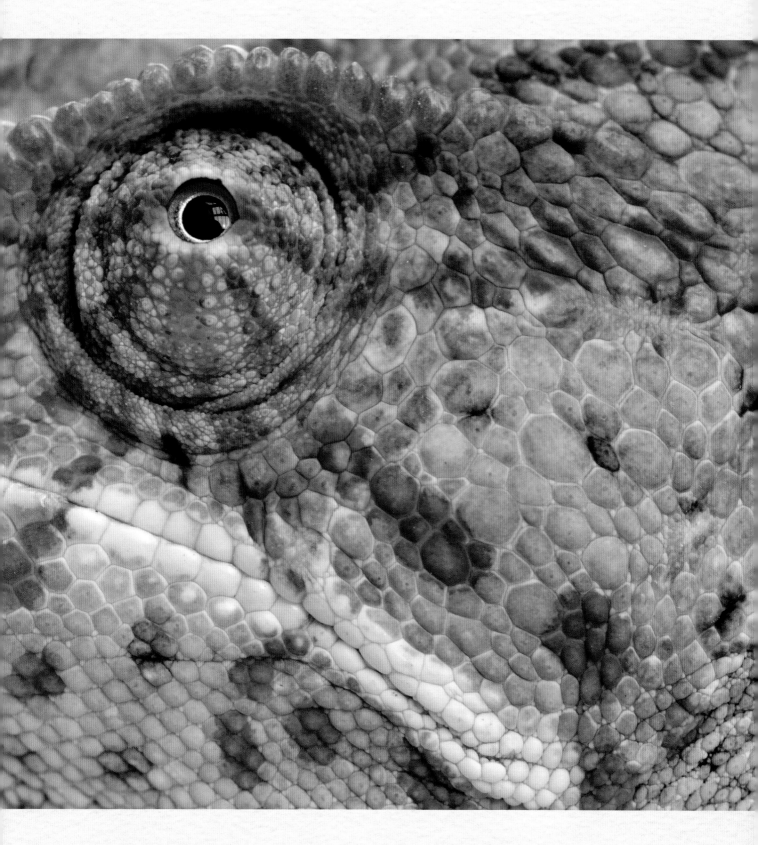

ABOVE Laurie's lifelong fascination for reptiles results in some unusual pets such as this chameleon.
PREVIOUS PAGES A 'cauld' is a local name for a weir on the Tweed, constructed to benefit fishing and divert water to the mills.

Ripples

Kevin the chameleon clasps my wrist with his two-pronged feet, his eyes rotating, mini-turrets in their yellow-green rims. You couldn't dream up a science-fiction creature weirder than this. Kevin shares the Campbell family's bright living room, dwelling in a spacious tank beside an awesome collection of natural history and photography books from around the world. Tom the corn snake lives in the opposite corner, and two geckos share a tank beside the door.

It all stems from Laurie's schooldays and summer evenings exploring the beaches south of Berwick-upon-Tweed. There he discovered exquisite little reptiles basking in the sunshine. He caught one and held it – it was like something from prehistory or storybooks, a miniature dragon or dinosaur right there in the palm of his hand. His natural history books later informed him these were viviparous lizards, also known as common lizards. He caught some to take home – and has been keeping reptiles ever since.

We take Kevin through to the

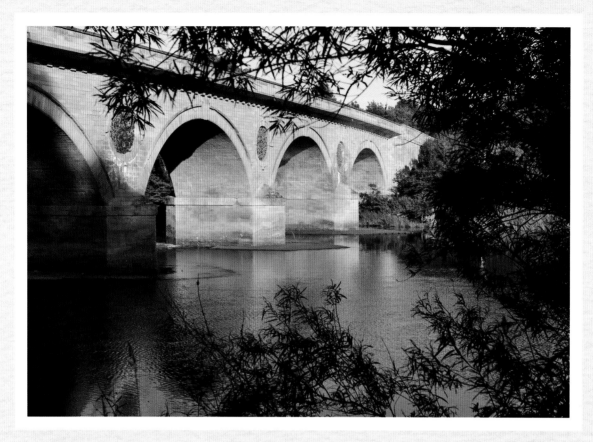

kitchen; he likes to hang out on the umbrella plant, with a view to the world outside. Laurie feeds him locusts while we spread out our notebooks and discuss otters in Ardnamurchan. Outside the light is fading. We need to go soon if we want to reach the river before dark.

We meet up with Laurie's friend Derek on a bridge over the Tweed. Derek is both a geologist and a conservation adviser with deep roots in the Borders; he knows the rivers and landscape and people and history of this area, and meeting him is like finding a rich seam of stories. He and Laurie have spent many evenings and early mornings on this bridge, comparing wildlife notes and watching otters on the river below.

There are no signs of otters here tonight, though, so we walk along the bank-side path for a while and settle on a bench beside the river. The trees around us are black silhouettes now, but the sky behind them is still bright. Derek tells us how the river is the focal point for everything around here, the area's most precious resource, its lifeblood.

We share otter stories. Derek's dad remembers the Dumfriesshire Otter Hounds working the river island in Kelso. He recalls speaking with the huntsmen in the early 1970s and hearing that they weren't catching many otters, and those that they did catch were sick. So it took about 20 years for the pollutants to work their way out of the system, and a

further 20 years for the population to recover to its previous levels. That's my lifetime. Derek is refreshingly optimistic about how much has been, and can be, achieved in one generation. How the wild world can restore itself, given half a chance and a helping hand.

Derek's first otter sighting was of a wee face peeping out of a tangle of gorse and ash and soft rush and meadowsweet. He'd been watching a large gorse stand beside Bowmont Water, one of the Tweed's tributaries on the edge of the Cheviot Hills. There were otter tracks in and out and all around it: 'like Piccadilly Circus for otters'. He reads the tracks in the morning to discover the stories of the night. One morning at Roxburgh Castle, where the Tweed meets the Teviot, there were otter slides in the dewy grass all the way down the 30-metre slope from the castle to the moat. Scientists may frown at the suggestion that otters slide and play for the sheer joy of it, but we agree it's hard to think why else they'd spend the night climbing up and sliding down the castle slope.

On the riverside bench we share silence too, a comfortable and companionable silence, just watching the darkening river. Swans come gliding by; the scruffy cygnets are barely discernible dark shapes, but the adults gleam white in the very last of the light.

The next morning dawns soft and utterly still. I feel a tug of conscience as I pull on my wellies and pack my binoculars. It's time to get this book finished and really we should be working indoors now – sorting photos into folders, checking captions. But the light is sweet and enticing, and the lure of the riverbank is irresistible.

So we're up on the Union Chain Bridge that links Scotland

and England, looking down on the morning mist – a magical, wispy swirl floating over the river and catching the early sun with a glare of white. I can't help smiling as we head down from the bridge and take the path along the veiled river towards Paxton House. The bank-side trees are tinged with colour, just about to turn. Beside us blackberries are ripe and plump and shining in the morning light. I snatch them as we pass, suck their sweetness from my stained fingers.

Laurie carries two large tripods on his shoulder, a heavy bag of lenses as well as binoculars round his neck. The burden of it all is easier to bear than the frustration of a missed opportunity through not having an important piece of equipment to hand. I ask whether he would still get a kick out of just seeing something amazing, even if he couldn't photograph it? He winces at the thought, as if he's in pain.

Then he stops, alert and silent, listening, hands reaching for his camera. There's a clear, high-pitched whistle. Laurie nods in the direction of the sound, alerting me to an elegant silhouette of a long-beaked bird on a rock at the water's edge. 'Kingfishers don't usually perch on rocks,' he whispers, smiling. But this one did, just for a moment. Then it lifts in the air and hovers, its silhouette blurred at the edges by its wing beats, its brilliant colours eclipsed against the celestial white of morning

sun on mist. Then it loops across the river and away.

We wait and watch in silence for a while, but it doesn't return. Laurie takes close-ups of the beech leaves we're peering through. 'It's like the way ospreys build frustration nests when their original one fails,' he explains. 'I need to come back with something.'

Over on the opposite bank, a black-headed gull on a rock looks lonesome and scruffy in its winter plumage, the fine chocolate-brown of its summer head reduced to a smudgy patch beside its eye. A sure indication that the year is moving on.

A bit further upstream we paddle into the still river to check for signs of otters on a secluded stretch of bank. We find otter prints at the water's edge. The thrill of their presence ripples through me. Gilded circles of light flow outwards from our wellies as we walk, and minnows skitter across our shadows in the shallow water.

We walk on, heading homewards now. It's too late to be looking for otters themselves. But I realise, with a flicker of surprise, that I feel no disappointment. I'm smiling at the sweetness of the morning, the joy of being here today.

concentration. I can't figure out what's stopped him in his tracks, and I don't want to ask in case I'm missing something obvious or I disturb whatever it is. There's nothing much there – just long grass and nettles and dying-down plants, like the scraggly, end-of-season dandelion seed heads without much seed left.

Laurie's silent, engrossed. I copy the silence and wait, scanning for clues. Then he starts setting up his tripod, changing lenses, talking about close-up work being all about the precision and placing of the camera, keeping it flush with the subject. It *is* the dandelions. He's peering down at one through his lens, scolding the breeze for moving it, though the day seems so still, and the sun for being too bright already. There's a sharp, rasping bark from the woods beyond the fields. 'Hear that roe deer?' he asks, without moving, still peering through the lens.

Then Laurie shows me what he'd seen. In the camera's screen the dandelion is rendered magnificent, its remaining seeds forming an opulent sculpture of silk and glass, jewelled with beads of dew. Its beauty is revealed because he had noticed it.

I first came to this river longing for otters, searching, yearning to see them. Now something has changed and my focus has broadened, my experience is richer and more textured.

The presence of otters, whether seen or unseen, delights me no less, but somewhere along the way I've become enchanted with the whole of this place – the plants and the birds and the river itself, and the people I've met, and the way it all connects. I'm reaching for blackberries again when Laurie stops. He's staring into the grassy bank with intense

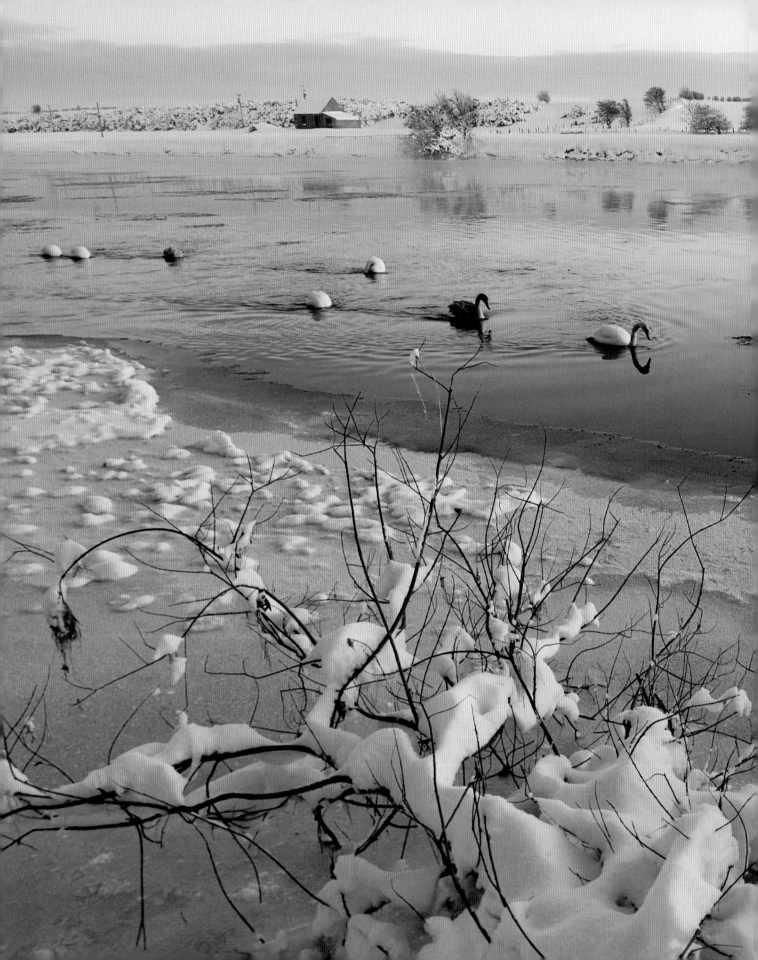

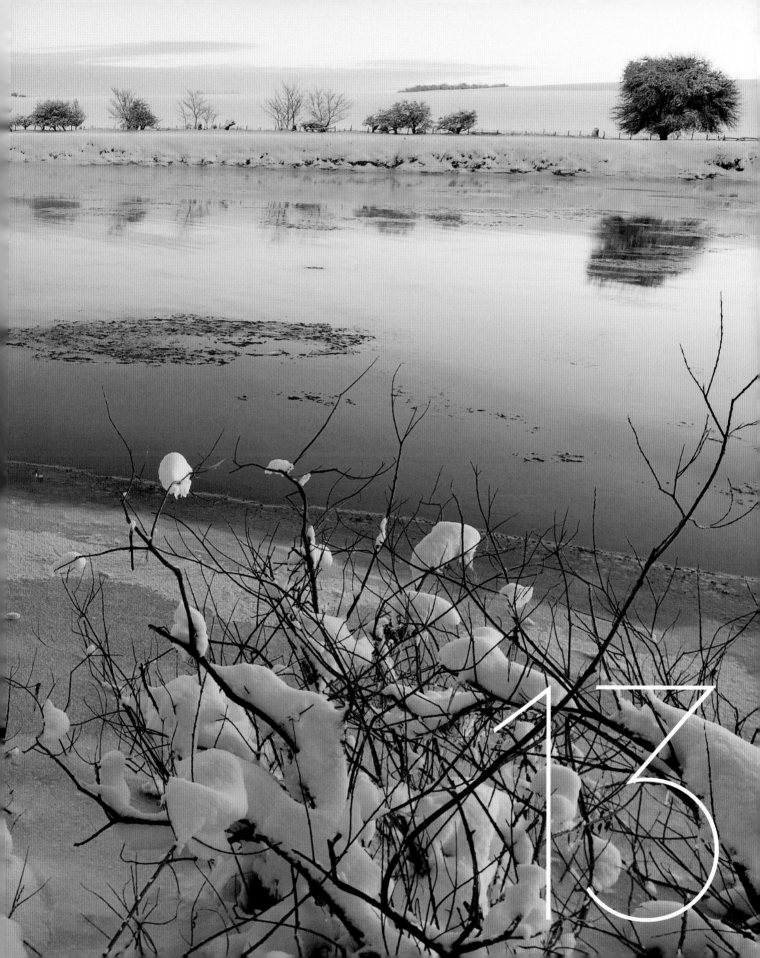

13

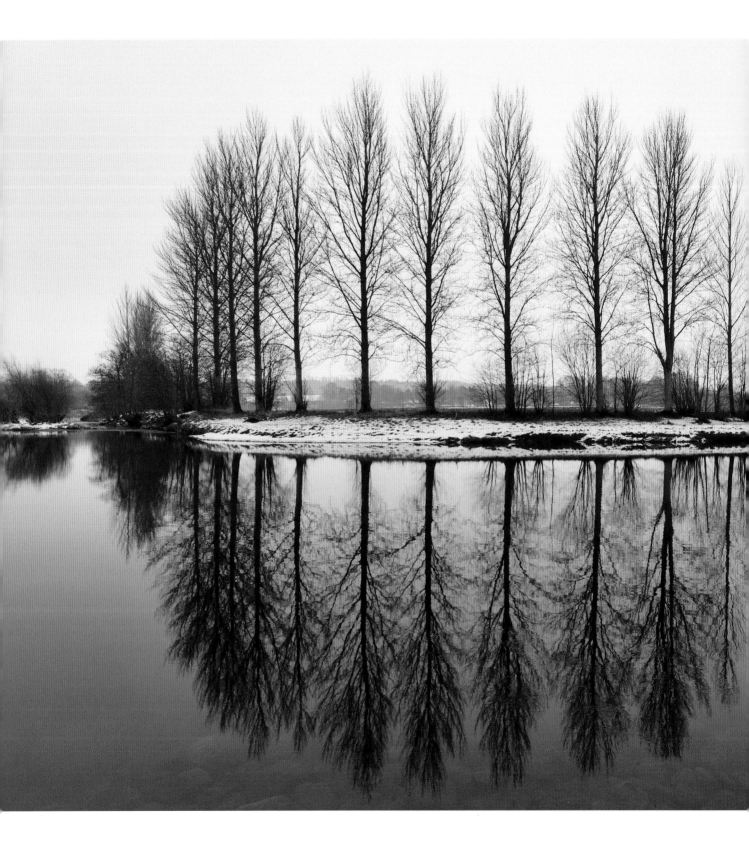

ABOVE The stillness that allowed Laurie to capture this symmetry also creates ideal conditions for otter spotting.
PREVIOUS PAGES People called this a 'bad' winter, but heavy snowfall can be a time of discovery for photography.

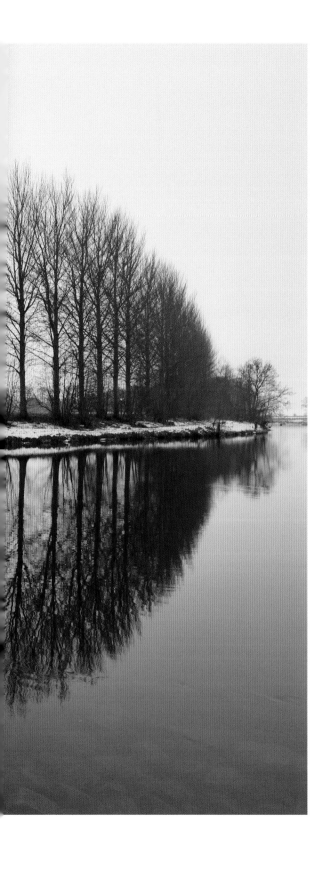

WINTER

WINTER BRINGS a whole new world of opportunity for wildlife watching and photography. Just as the skeleton trees reveal the birdlife in their branches, the lack of vegetation on the riverbank makes it much easier to spot a sleek creature slipping in or out of the water.

While winter weather has its challenges, even the worst conditions can be put to good use for photography, and the advantages of working in the cold are well worth any discomfort. Heavy falls of snow can create magical lighting conditions, acting as a giant wrap-around reflector, enveloping everything in soft, uncomplicated lighting. Clear skies at night cause temperatures to plummet, resulting in mist rising from the surface of rivers at sunrise and early morning frosts that turn simple leaves and grasses into exquisite opportunities for close-up photography.

In one of the coldest, snowiest winters in recent years, Laurie built a hide in nearby

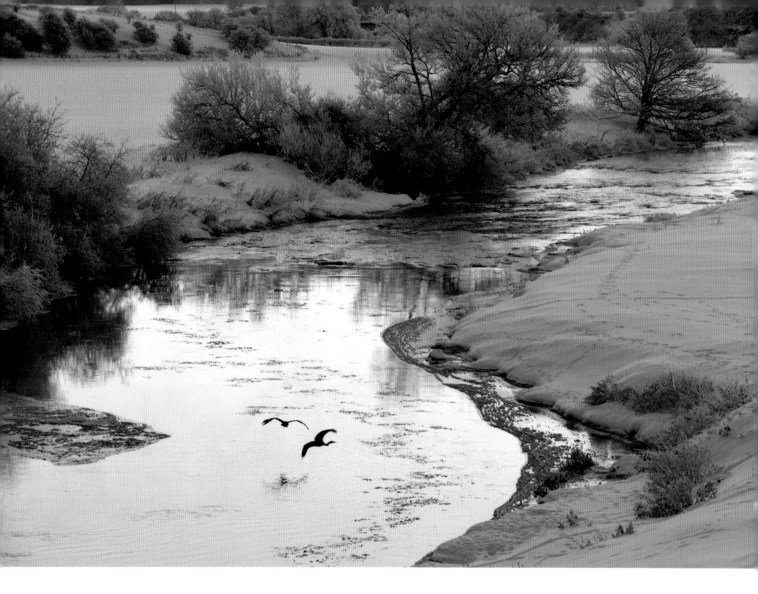

woodland to watch for woodcock – secretive, well-camouflaged birds that are difficult to spot. He entered the hide in darkness for days and waited until eventually he could photograph them against the snow.

On the banks of the Whiteadder, it's quiet before the human fishing season begins on the first of February, but the otters are already feeding well on early runs of salmon and sea trout. By February and March, there's a sense of anticipation, waiting for the young otter cubs to emerge from their holts and for the otters' story to begin again.

► ICE FROZEN MOMENTS

Laurie spends a lot of time waiting beside water, and he doesn't always see otters, but even when he does he rarely manages to photograph everything he sees – as happens with any form of photography. To pass the time while he's waiting, he's always looking out for other things to photograph in nature and these are usually the smallest details, like this hoar frost frozen onto gorse, or the way the stones in the burn became encased in ice one bitterly cold night. As Laurie says, 'There's always a therapeutic value in coming back with pictures of something, even if it isn't the subject you intended.'

▼ THE WHITEADDER Mild, wet winters bring floods that send the river levels soaring, bursting their banks. The Whiteadder was enormous the morning this photo was taken, swollen and surging, sweeping up whole branches and carrying them downstream. Woody debris like this accumulates where the river levels are high; it all gets carried along and eventually gets caught up and deposited somewhere along the riverbank. Some river authorities remove this to clean up the river, but Laurie thinks we need to be careful and wonders if this should be a licensed activity, as he's often found evidence of otter holts where this debris collects and forms shelter on the riverbank. Besides, there are the obvious benefits to the life in the river itself, with the input of this organic material.

Laurie muses, 'When the river is hurtling along like this, I wonder about the mortality of young cubs, especially with bank-side holts – can the mothers cope? And where do they go? On the coast, mothers and cubs can be separated by rough seas; this must be the river's equivalent to a rough sea in terms of the sheer force of the water.'

▲ SPRAINT Sometimes Laurie gets an idea in his mind's eye and goes to great lengths to realise it with a photograph. After investing a lot of time and effort preparing and waiting for a particular shot, he says, 'I get to the stage that I feel if I pack it in it's all been for nothing. But then, of course, there's tremendous satisfaction when you do get that picture.'

Many of these ideas are still very much 'work in progress'. For example, he created a high seat up on the leaning bough of a mature willow where he has spent many, many hours looking down on this sculptural tangle of branches and trees on the shore of a loch below. 'Simply seeing fresh spraint there regularly makes my spirits soar! It's almost as good as seeing an otter – it means they're here, and I'm alert with expectation.' Otters are clearly habitually using this willow as a territorial scent marker – you can see the mounds of fresh spraint and the brown patches where the accumulation of urine has burnt the moss. He has seen otters passing by on the water, but he's still watching, and waiting, to see them climbing around here on their way to the 'toilet' – he hasn't caught them yet.

Another photograph on his wish list is to catch an otter drying itself inside the pipes formed by fallen, decaying hollow trees. Inside, you can see where they have been smoothed by otters rolling around, using the dry, fibrous material like a wrap-around bath towel.

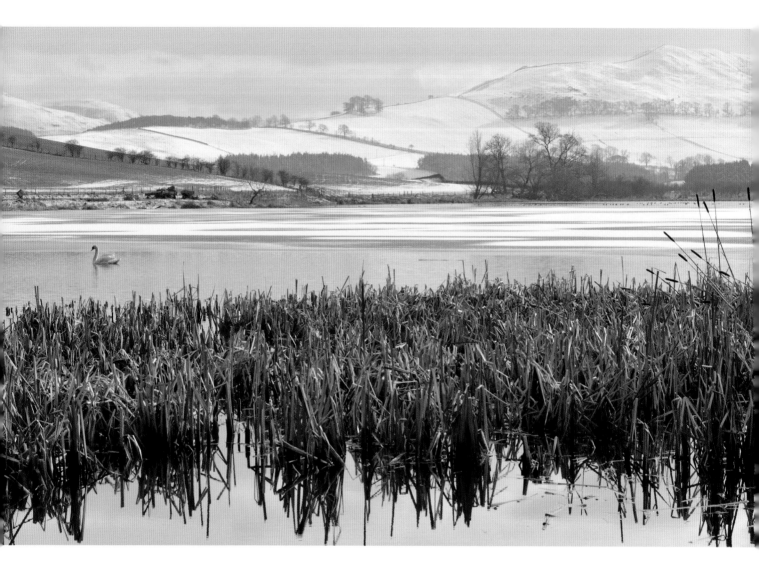

▲ YETHOLM LOCH Watching bodies of still water in winter is a good bet for an otter sighting – the distances can be greater than the breadth of the river, but Laurie's dream image here is of an otter running over the surface of the frozen water. He hasn't got it yet, but he has photographed many other subjects while waiting for it.

When the loch isn't frozen, the otters tend to work around the water's edge, and they can be difficult to spot as they rummage around the reeds and marshy areas. He can't follow the otters as he does on the river; it's more about just being content to settle down at a spot that offers a commanding view. The hide overlooking the water is a perfect place to do just that. Laurie has spent many a comfortable winter's day there, cosseted in his down-filled sleeping bag, with a flask of peppermint tea, just watching and waiting.

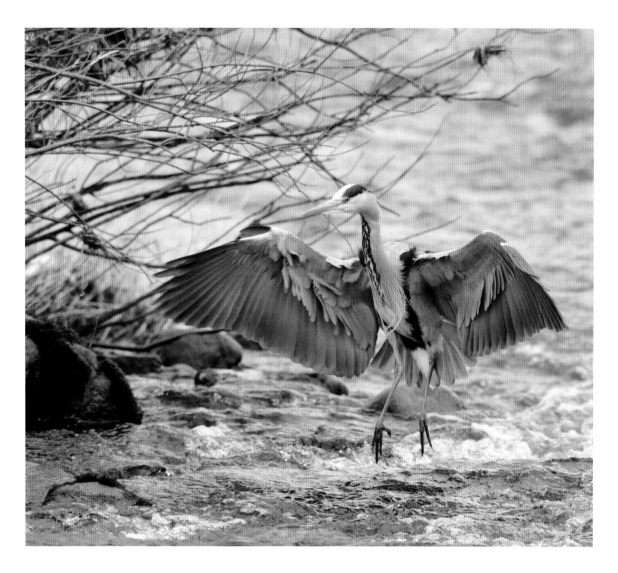

▲ GREY HERON Laurie is often asked if he has a favourite subject to photograph. 'I don't really, but if pressed I would be tempted to say the grey heron. These herons have been a constant on the river all my life and their stately presence, like sculptures on the riverbank, somehow changes the atmosphere and adds a richer dimension to the scene.' In his early days of photography, herons were his focus – they're strikingly attractive and photogenic. They're also very inspiring. Watching them feeding, he realises 'it's all about patience – they're not like waders, darting or rummaging around; they just wait'. They are territorial and Laurie hears their croaking, guttural calls as they squabble over favoured hunting grounds. That's their strategy: find a location that they know works, and watch and wait for as long as it takes – 'a bit like nature photography, really!'

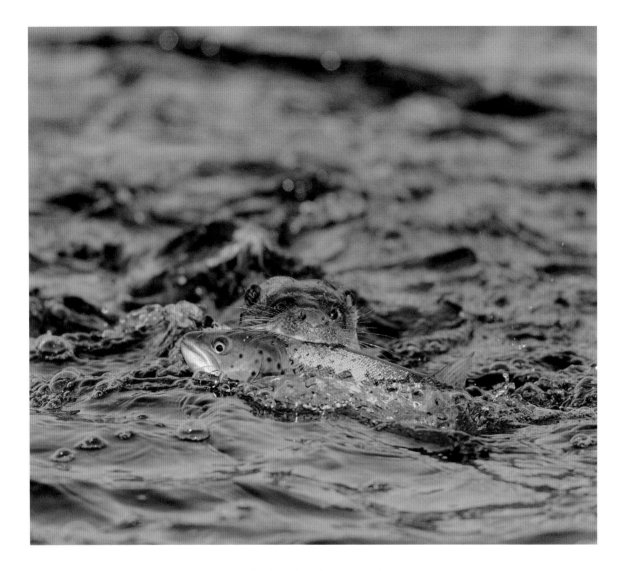

▲ SEA TROUT For some weeks in January, Laurie watched from a distance as the otters landed fish of this impressive size. They'll eat small catches in the water but have to land anything big before they can feed. Suddenly this otter surfaced and swam straight towards him with a sea trout in its jaws. It was in view for less than five seconds before seeing him, then dived and took off to an island in the river to eat its catch. Laurie's camera fires at nine frames a second, but the otter moved so quickly that he just had time to focus and capture three images.

SNOW RIVER Deep snow is a rare event in the maritime climate of south-east Scotland. So when it happens – as it did over two exceptionally cold recent winters – it's extra special and can lead to many new discoveries for Laurie. Heavy snowfall is a gift for tracking otters – aspects of their lives that had escaped his notice were revealed by the snow. He found otter tracks many miles from the water, showing the distance that otters will travel across country to take a short cut from one river to another. He had assumed otters would stick to a watery route, following one river until they reached the confluence and then going up the other river.

Laurie makes sure he is well equipped for the conditions so he can spend long hours staying still even in the snow. Top of his list are his neoprene-lined winter wellies and a down jacket. 'I always believe that the more comfortable you are, the longer you wait, the more you see.'

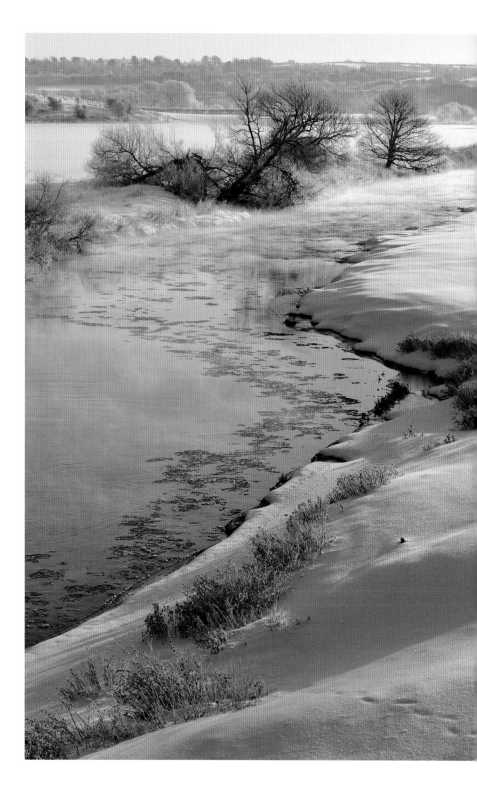

▼ KELT 'Spent' salmon, known as kelts, have spawned in late autumn, laying their eggs in the gravel riverbeds upstream, and then come back down the river, exhausted and vulnerable. In this weakened state, they're susceptible to disease – the white patches on this fish are from a fungal disease that dulls their senses, making them easy prey for a surprising range of other wildlife. They are easy pickings for an otter, and Laurie has seen signs of badgers having waded into shallow woodland streams after them.

▶ ATLANTIC SALMON Sometimes, the otters will eat their fill, starting from around the gill area and leaving the rest of the fish. Crows will pick at remains while it is daylight, and then the night shift comes: foxes and badgers scavenge what is left. On this occasion, Laurie couldn't resist scavenging the otter's leftovers himself. By the time he'd cleaned it up, he had four kilograms (nine pounds) of salmon – more than enough to feed his family of four for two nights.

Laurie says, 'Once I watched an otter struggling with a huge fish. I decided to hide and wait until it had brought the fish to the bank. But that never happened: the fish was writhing away; the otter lost its footing and the two of them then hurtled down the channel right beneath me, rolling over and over in the current. It would have made an incredible shot, but the long lens I had fitted to my camera only had a minimum focusing distance of five metres and they were still too close. Eventually, the otter lost its hold and the fish got away.'

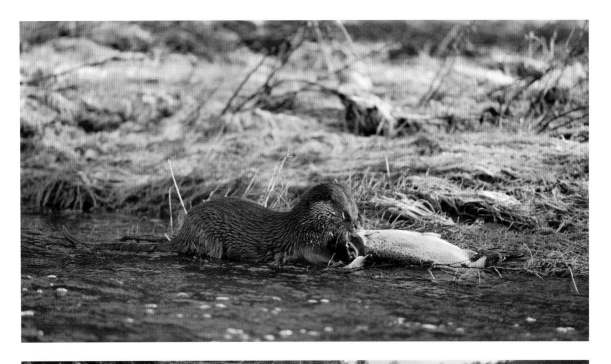

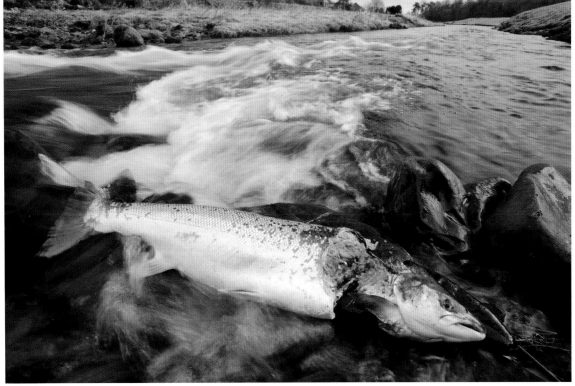

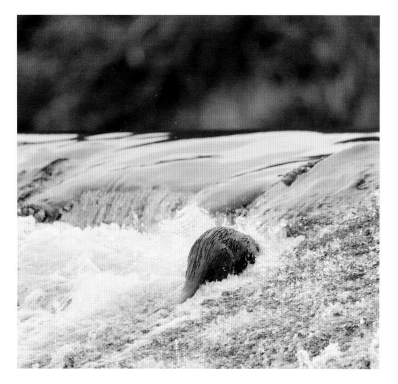

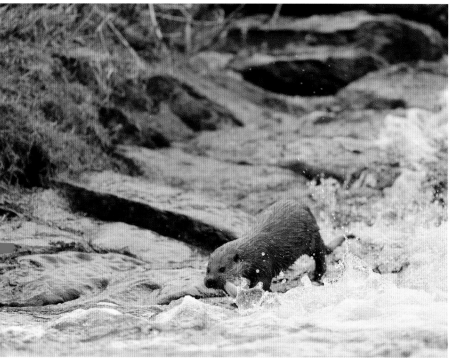

◀▶ **FISH POOL** Once they'd discovered it, the otters frequently targeted this pool beneath the weir to feed on the salmon and trout. It was an ideal location for them, and for Laurie – a small recess in the riverbank gave him a place to hide below the skyline. With a tree trunk dragged into position to form a barrier between him and his subjects, he completed his camouflage with a head net and gloves to cover his pale skin, so he could settle there undetected.

This particular otter was behaving oddly, rummaging in amongst the stonework of the weir, where it seemed there was a small step or ledge. Laurie explains, 'I realised the fish were stalled there, struggling to get up the weir because the water levels were low from a lack of rain. Settled in my hiding place, I watched as it grabbed a brown trout before disappearing into the pool at the bottom of the weir, only to pop up moments later, where it landed its catch, just seven feet from me. It was much too close for my big lens, but I had a second camera fitted with a shorter lens for back-up and was able to lean over and photograph it before it finished its meal.'

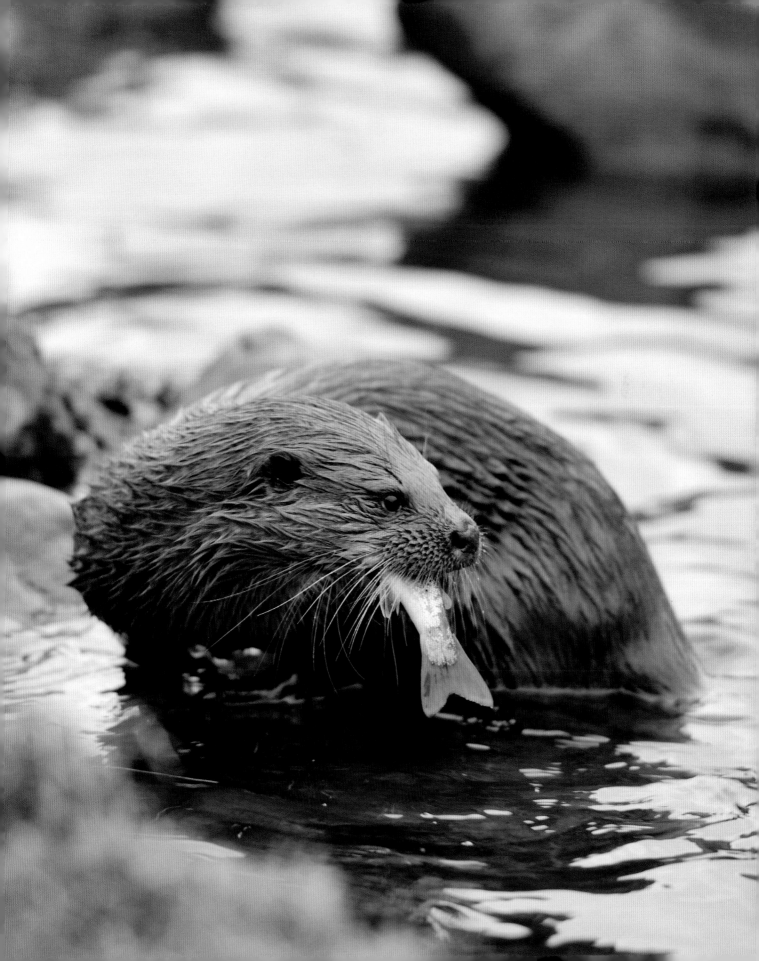

14

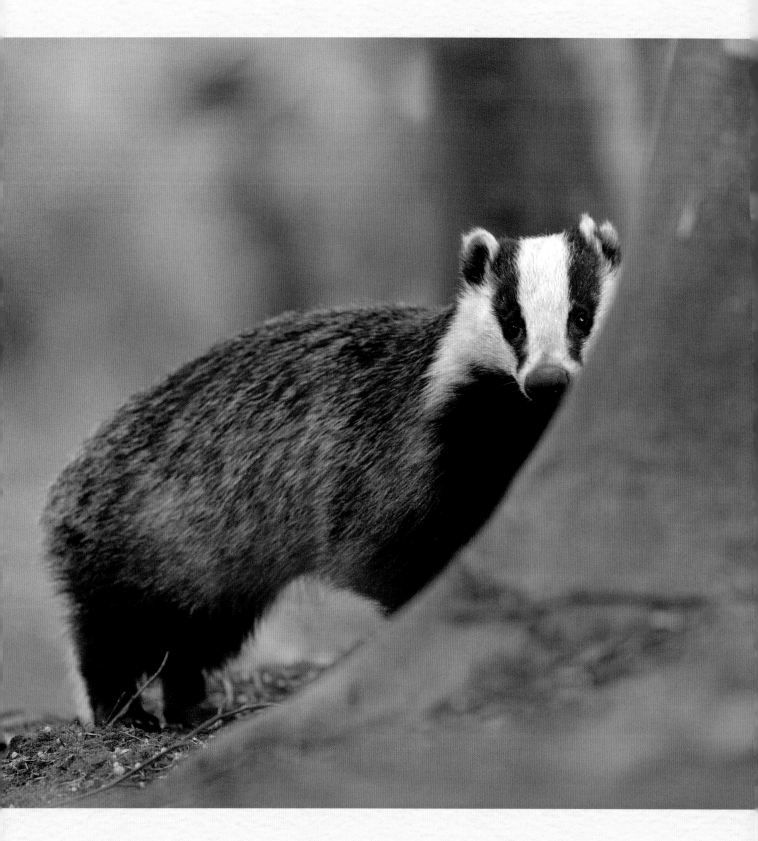

ABOVE Being out at dusk often means encounters with badgers, also members of the 'weasel family' of mustelids.
PREVIOUS PAGES Sitting and watching allowed Laurie time to notice the play of light through the green filter of the forest.

14

Riverside

There is a path, and there are steps, which wind from the car park down to the river where we're going otter-exploring this evening. But that wouldn't be Laurie's way of getting from A to B. You'd miss too much along the way.

So we step over the wooden barrier from the car park straight into the woods. As we do, two young badger cubs come bowling out of the trees, startle as they see us and bound away. We've stepped into badger city. Laurie points out the setts all around us and the mounds of compacted, almost polished earth. He's watched generations of badgers here, seen families grow, work the earth, construct their homes and toilets, develop new entrances and their routes through the woodland and down steep badger-smoothed slopes, shaping their landscape.

We stride downhill through a tangle of undergrowth. There's a movement ahead – a badger upright at the entrance to its sett, nose in the air. It starts and stiffens. Laurie's seen it already and is utterly still. Now we're all three frozen in position, staring at each other, like three

creatures in Narnia turned to stone. I feel a five-year-old's urge to giggle in the silence, but also a profound peace. Through the trees I can see shafts of evening sunlight pouring out from under the clouds, flooding the horizon with a wash of gold.

There's a sharp mewing call from a buzzard circling above us.

'Must be its nest,' whispers Laurie.

I want to ask so many questions – what are the other bird calls, the bubbles of flutey sounds from the trees – but I don't want to intrude on the silence, or startle the badger, or end the staring competition we're engaged in.

Then there's a big crunch and a snap of twigs, loud sounds that feel almost comical

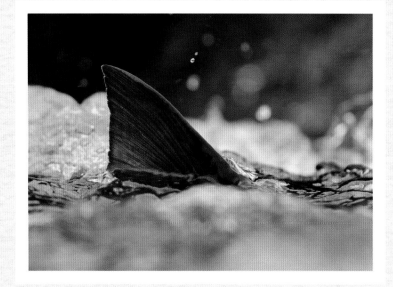

in our silence. Paying no heed to our reverential hush, three badgers come bustling along behind us, a family outing in the woods. We turn to the sound and they see us, pause for a startled moment, then scamper along in their bumbling way to their sett. Our badger seizes the moment and disappears from view. We don't move.

'It's still here,' says Laurie quietly. 'Just at the sett entrance.' But we decide to leave it in peace and carry on through the woods, stepping past nettles, over wires and fences, out of the darkness of the trees and down to the surprisingly light expanse of evening river.

There are voices here. A group of fishermen working at low water, with two wooden

boats and a lot of netting. The boats are known as cobles; these are some of the last of an ancient fishing tradition that once engaged thousands of people on the Tweed. Some of the fishermen recognise Laurie and nod a greeting; we stop to chat and enquire about otter sightings.

George introduces himself. He wears a cap and has a smiling, leathery, tanned face. He tells me about the fishing, how you can see the salmon approaching around the curve of the river, the V of their wake in the water 'coming like wee speed boats'. He says he hasn't seen an otter for a month or so, but one was hanging around when he was building a new landing stage: 'a cheeky fellow playing chicken with the dogs'. The dogs would run into the water and the otter would disappear, then pop up again as soon as the dog was back on land, coming ever closer, as if teasing it. Confident when in the water, the otter wasn't bothered by the men working, and it would remain in sight as they dug into the riverbank.

We leave the men to their boats and nets and the bright river. They're working together in silence, their hands making smooth, synchronised movements as they bring the

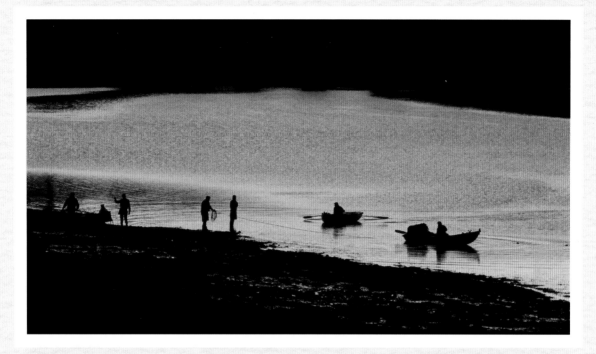

nets in, until there are large, glistening salmon flapping and writhing and smacking their silver tails on the shore.

We walk along the shining river for a while, searching it with our eyes. The surface is utterly still – we'd spot the shape of an otter's wake a long way off in these conditions, but there's no movement at all, just the polished gleam from the golden sky. It's darker in the woods now, as we weave a different route back to the car park, passing a pond, where something has parted the weed on the surface of the water. We find otter spraint here, but it's dusty and crumbly,

not a fresh clue. Still we take a potted tour of otter memories and moments, revisiting the places where Laurie first saw otters here in the early days: the streams they use as culverts down to the river, where he'd catch a glimpse dashing into the shelter of thick undergrowth.

The sky has deepened from gold to indigo by the time we reach the car park. I don't want to break the spell of the evening by returning to cars and houses. But then we're back at Laurie's office, sitting around the computer, poring over a feast of photos, when there's a shuffle outside. Laurie has been habituating the local badgers,

luring them closer with the promise of an evening snack. Through the glass door between his office and the garden, a long black-and-white face is looking in at us.

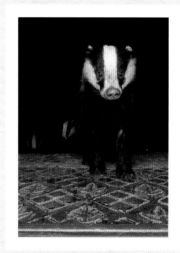

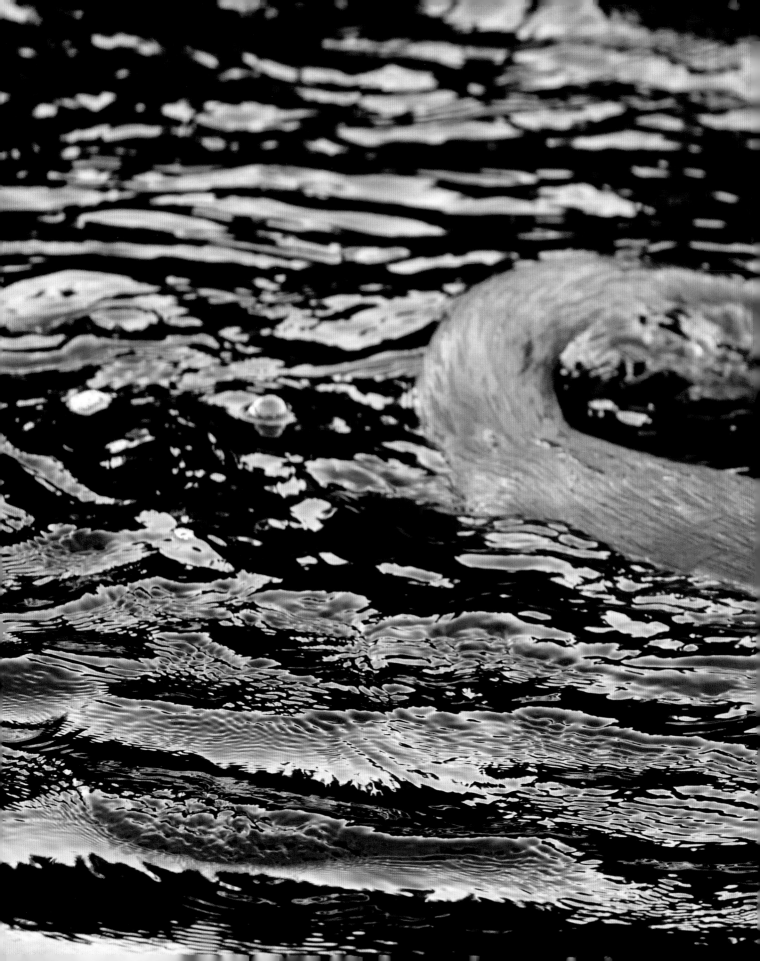

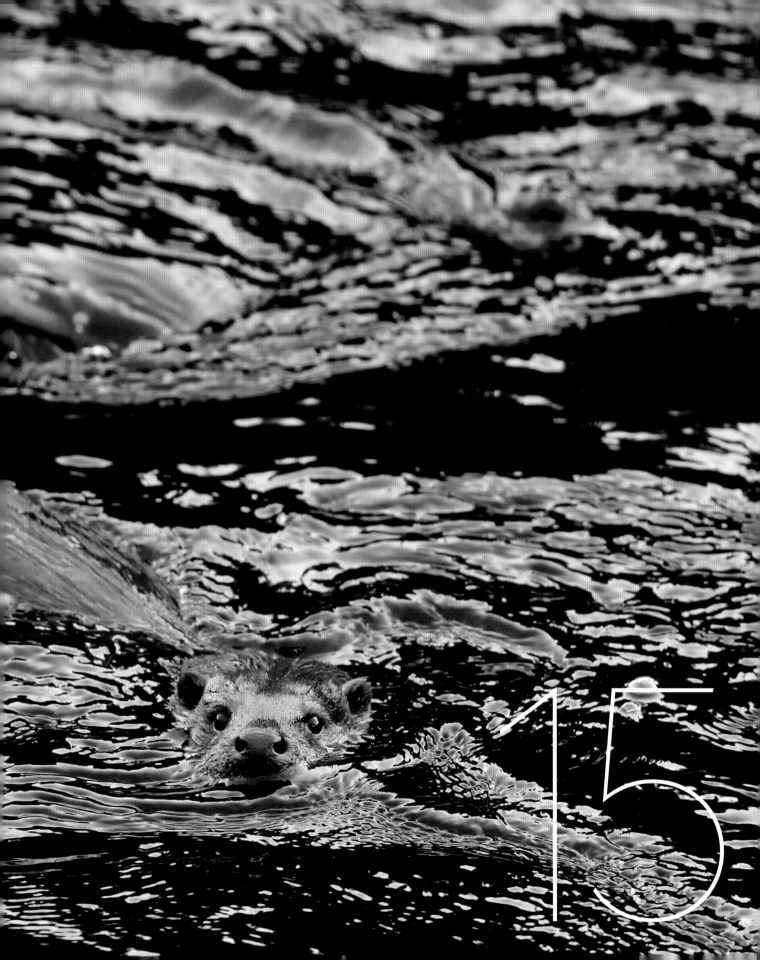
15

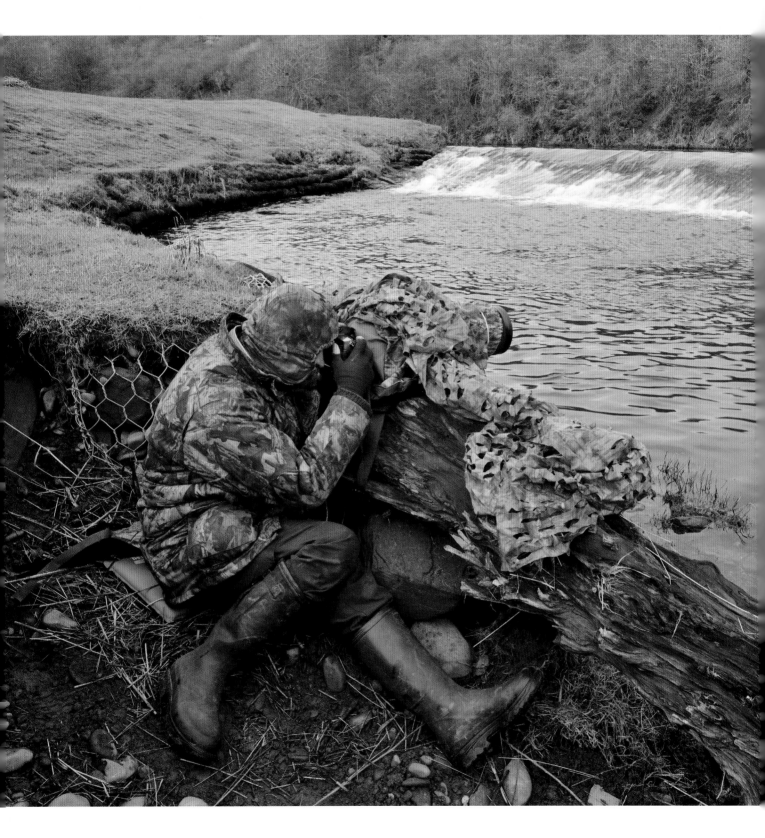

ABOVE Augmented with a tree trunk dragged into position, this recess provided an ideal place to watch the weir.
PREVIOUS PAGES Blue sky ripples on dark and peaty water in the deep shade of a gorge on a Highland river.

OTTER PHOTOGRAPHY

Notes from Laurie

WHERE TO START

Otters have significantly increased their range in recent years and inhabit many suitable wetland habitats, although their presence can be tenuous. Sometimes, they pop up in some unlikely places, such as rivers and canals running though urban areas, or even on ponds in city parks.

Choose sites that are close to home so that you can visit often, returning at different times of day and throughout the seasons. Familiarising yourself with an area is key and puts you in a good position to notice changes.

You may not see an otter right away, but recognising field signs, the tracks, trails and droppings that they leave behind can be very encouraging. Otter droppings, known as spraint, are also used for communication. Deposited on prominent boulders, logs and tussocks of grass above the waterline to ensure they persist, they serve as notice boards where messages are posted to others crossing the same territory.

Otter spraint looks different depending on what the otters are eating. In marine environments, where otters are feeding on

LEFT Water forget-me-not thrives in damp habitat, such as riverbanks and shallows; it's worth getting distracted while otter watching to admire the bright blue flowers in summer.

OPPOSITE Getting your eye in involves close attention to the landscape – here, flattened moss reveals an otter's haul-out site.

OVERLEAF Stories in the snow tell of the unseen activity of wildlife, here capturing the bounding gait of an otter along the riverbank.

crustaceans, it's pale and crunchy – a bit like cat litter. On rivers and wetlands, it's black or greyish in colour, oily when fresh and smells slightly sweet.

Look for further signs in the landscape, such as otter-width paths, and especially those which form tunnels through waterside vegetation. Flattened grass near the water's edge is a clue that an otter may have come ashore to roll around as part of the process of grooming and drying its coat.

Similarly, otters living in marine environments need to remove salt from their fur, so they will have favourite pools above the high-tideline on the shore, or make use of a freshwater stream that flows into the sea.

Otter tracks are quite distinctive and differ from those made by dogs and foxes as they have five forward-facing toes. The fifth toe may not leave a print, but the pads that do leave marks form a more rounded pattern compared to those of the canines. Look for these on fresh wet sand or mud on beaches, the edges of rivers or lakes.

OTTER SPOTTING

There is something very special about being out at first light and knowing you are the first person entering an undisturbed habitat. Sometimes that experience is reward enough, and seeing or photographing an otter is a bonus. Bear in mind:

- Binoculars are essential.
- Don't rush – take your time and scan at least 50 metres ahead before moving forward.
- Be mindful of wind direction.
- Keep below the skyline.
- Try to take a staged approach, aiming to pause at any place that offers a little cover to scan the next stretch of shore or river.

Never be disappointed if you don't see an otter right away or by the time you have reached the end of your planned route. Just remember that when you retrace your steps along the river or shore, whether it's the next day, an hour or even a few minutes later, things will have changed,

and with that change comes the promise of other opportunities for a sighting.

Otters in water present a very low profile, with only a few centimetres of head, body and tail showing above the surface. Add to this the distance between you and the otter, possible low light, and the fact that water surfaces are rarely calm and any motion is caused by a variety of sources, and it's easy to see why they are often overlooked.

The phrase 'getting your eye in' is especially relevant here. It has much to do with looking at the wider landscape and having an insight into the scale of an animal the size of an otter and how it may look within that landscape. Separating the different types of motion on water surfaces gradually becomes instinctive: a fish rising always results in concentric circles, while ducks diving and swimming are much less subtle. Otters tend to move more gracefully when travelling or weaving in and around seaweed or reeds.

Clues to their presence vary according to the environment. On rocky seashores at low tide, the erratic bobbing of kelp fronds is an indicator that an otter is rummaging around searching for prey. The equivalent in a freshwater

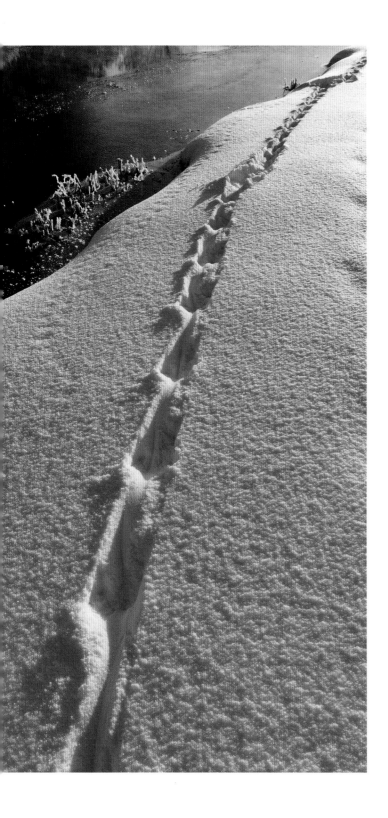

habitat is the jerky, twitching movement of the tops of reeds or other tall marginal water plants.

The responses of other wildlife to the presence of an otter are another pointer. In the nesting season, common sandpipers and oystercatchers that have sensed an otter will make loud alarm calls while flying back and forth over nest sites. Many ducks, such as the ubiquitous mallard, will also call loudly, before erupting from cover to take flight.

The exact whereabouts of an otter in its territory is usually linked to a food source. In freshwater, this can vary according to the season: in spring, for example, a farm pond near my home is visited by otters when it is full of spawning frogs. I have also seen otters hunt in pools beneath river weirs where migratory sea trout and salmon stack up, waiting for changes in weather and rainfall to continue their journey. All these places of course offer good opportunities for photographing otters.

GETTING CLOSE

Once you have found a location where there are obvious signs of otters, then there are two main ways of getting close. The first is simply to wait at one location where there is good evidence that they visit regularly and hope that they pass within range. Depending upon the location, conventional hides can be inappropriate, and may even attract the unwanted attention of passers-by. Begin by choosing a hiding place where the prevailing wind direction means that you are downwind

from the otters' sensitive noses. Make use of any natural features in the landscape such as a wall, tree or boulder to sit against and break your outline. If it is a location that you plan to use regularly, then it may be worth adding a few natural materials such as driftwood or bunches of reeds or bracken. To avoid any disturbance, do this well in advance of when you plan to use it. River bridges are an ideal vantage point, offering a clear commanding view over the river and the possibility of seeing otters beneath the water.

Aside from staying in one place, the second way of getting close to otters is to try stalking them. This method relies upon seeing the animal at a distance, then planning a route, while allowing for wind direction and so on. However tempting it may be, never try changing position for the sake of different lighting for your photograph if there is a risk of your scent blowing from you to them. If the wind direction changes, take a wide arc around the otter to get ahead of it and wait for it to come towards you.

Otters that succeed in catching large items of prey will always have to bring them ashore to feed. With care, it's possible to anticipate their landing point and position yourself close to them with the knowledge that at least they are going to remain in the same spot for a while.

Try to move closer only when the animal is engaged in feeding or diving underwater. Use any available cover and keep low, even if it means crawling forward on all fours. Move as quietly as possible. Small things count, such as only stepping on the larger stones on a shingle beach to avoid crunching the smaller ones together. Windy weather may seem ideal for disguising any noise you make in moving forward but then otters, like all other mammals that rely upon their senses of smell and hearing to warn them of danger,

are actually more skittish and quick to startle in these conditions because those senses are rendered unreliable.

ALLOW YOURSELF TO BE DISTRACTED

If, like me, you have a wide interest in nature, then always look for other subjects to photograph in the landscapes you visit to photograph otters. We may not achieve images of otters each time we visit, but there is often a therapeutic value in returning home from a day in the field with photographs of something. Gradually we begin to appreciate there is a wider story to be told, as in this book, that involves all the other forms of life that share the same habitat as otters. Indeed, through taking a wide interest we can begin to understand how whole habitats work, and we hopefully become better naturalists into the bargain.

ETHICS AND THE LAW

As with all natural history photography, the welfare of the subject must come before any desire to take a photograph. It's sad and somewhat ironic to have to add 'wildlife photographer' to the growing list of challenges that otters still face, but with the exponential growth in nature photography since the advent of digital capture, and given that they are such a charismatic mammal, it's perhaps not surprising that the risk of otters being disturbed is rising.

This is a legal issue as well as a moral imperative. Otters are fully protected by EU law as a European Protected Species (EPS) and also by the UK Wildlife and Countryside Act 1981. These laws forbid the harassment or disturbance of otters. Disturbance is defined as any action

that may change their behaviour and affect their normal activity. Of primary concern is that otters need to eat at least 15 percent of their bodyweight each day, so anything that affects their ability to feed will in turn affect their health and resilience. Otters living in freshwater habitats can simply become nocturnal, but those living on the coast can only really feed around the tides and so are more vulnerable to disturbance in daytime.

Otter holts are defined in law as 'places of shelter' and, like the nests of protected birds, require a photography licence in advance if there is any risk of disturbance. High-pitched 'peeping' sounds are the contact call between mother and cubs that is often heard in the vicinity of a natal holt. It's also a sign that they are dependent on her and so especially sensitive to any disturbance.

One of the few exceptions where there is a reduced risk of otters being disturbed is in places where they have become semi-habituated to people, sometimes remarkably so, such as around urban canals, rivers and other waterways.

TO SHARE OR NOT TO SHARE

I became a nature photographer because I wanted to share what I had experienced, and so it goes against the grain to say that the dissemination of information on social media can result in the arrival and congregation of lots of people at one site, creating what has become known as the 'honeypot effect'. I've watched this happen in so many places throughout my career and sadly, it's usually to the detriment of the subject. Otters can be very sensitive to disturbance.

There is something extra special about going out and discovering new places to watch them for ourselves. All it takes is time and a little fieldcraft.

EQUIPMENT

Successful otter photography is far more about fieldcraft than having sophisticated photographic equipment. In fact, taking too much into the field can be counterproductive. We need to remain mobile and work intuitively without having to think about lens choices or camera settings when we are suddenly confronted with a brief, amazing opportunity.

The basic set-up: a basic set-up would be a main telephoto or zoom lens in the 400mm to 600mm range in 35mm terms. If it has a wide maximum aperture of f4 and image-stabiliser technology built in, then so much the better. Ideally, camera body choice should be one that performs reasonably well at high ISO settings. All of the above allows us to work earlier and later into the day when light levels can be marginal for photographing such an active subject. Beyond that, mirror-less cameras have the advantage of silent shooting, which could be essential when working close.

Tripods: although they may seem cumbersome, tripods really come into their own in situations where we need to wait in one location for long periods, and especially those where a decent working height is needed to see above bank-side vegetation in summer. For rocky shores, bridge parapets or just about anywhere where it's possible to obtain a relatively unobstructed view of a body of water from a low viewpoint, then beanbags are ideal.

Bags: a simple camera shoulder bag is all that should be needed to carry any extra accessories, such as spare camera batteries, memory cards,

teleconverters and perhaps a short macro and wide-angle lens. My own preference is for canvas bags that are silent to access because they have no zipper or velcro fasteners.

Clothing: there is a wide range of camouflage clothing and other paraphernalia on the market nowadays, but simple drab colours that loosely match that of the habitat by season are all that is required. Thin gloves and a midge head-net can be an important addition to cover pale skin as well as provide some protection from biting insects when they are in season. If you don't plan to walk very far, then I find neoprene chest waders are ideal for lying on wet ground for long periods, or when I need to ford a river to keep up with an otter. Lastly, some camouflaged leaf-screen netting over and around a tripod-mounted camera and lens completes my disguise.

I would encourage everyone to explore any wetlands on their local patch to discover if otters are present. It just comes down to time – not easy to find in our busy modern lives, but then nature runs at a slower pace, so be patient. The sight of a wild otter will be reward enough.

ABOVE A male mallard takes off – noting the behaviour of other animals can reveal the presence of a predator such as an otter.

OVERLEAF Otter tracks on the pristine sands of Lewis, Outer Hebrides.